Publisher's Acknowledgements
We would like to thank **Baror International, Inc.**, Armonk, New York for their kind permission to reprint text; and the following for lending reproductions: **Paula Cooper Gallery**, New York; **Lisson Gallery**, London; **Robert Mangold**, New York; **Marian Goodman Gallery**, New York; **Friedrich Petzel Gallery**, New York; **Richard Serra**, New York; **Michael Snow**, Toronto; **Michael-Hue Williams Fine Art Limited**, London; **Bill Viola**, Long Beach, California. Photographers: **Julie Abeles, Eva Besnyö, R. Bramms, Rudolph Burkhardt, S. Colomb, Peter Cook, Angela Cumberbich, Roland Fischer, Dan Graham, Philippe Halsman, John Hedgecoe, Hedrich-Blessing, Richard Landry, André Morin, Peter Moore, Ahikide Musakami, Kira Perov, Roy Rainford, Everett Scott, Harry Shunk, Julius Shulman, Robert Smithson, Retina, Julius Shulman, Philippe Stepczak, Ezra Stoller, Frank J. Thomas, Caroline Tisdall, Rudolf Wackonigg, Peter White.**

Artist's Acknowledgements
Thanks to Gilda Williams, John Stack, Ian Farr, Ariella Yedgar and Veronica Price at Phaidon Press, and to Paul McCarthy, Los Angeles, and Jeff Wall, Vancouver, for making this book possible.

All works are in private collections unless otherwise stated.

Texts appended to captions are the artist's own descriptions of his works.

Phaidon Press Limited
Regent's Wharf
All Saints Street
London N1 9PA

Phaidon Press Inc.
180 Varick Street
New York, NY 10014

www.phaidon.com

First published 2001
© 2001 Phaidon Press Limited
All works of Dan Graham are
© Dan Graham

ISBN 0 7148 3964 7

A CIP catalogue record of this book is available from the British Library.

Designed by SMITH
Printed in Hong Kong

cover, **Row of New Tract Houses, Jersey City, NJ**
1966
C-print
Dimensions variable

page 4, **Video Projection outside Home**
1978/96
TV monitor
Dimensions variable
Installation, 'Homes Show II',
Santa Barbara Arts Forum, 1996

page 6, **Dan Graham** with **Triangular Enclosure for New Urban Landscape**
1988
Two-way mirror glass, steel
400 × 400 × 300 cm

page 36, **Side Effects/Common Drugs**
1966
Printed matter
28 × 21.5 cm

page 80, **Alteration to a Suburban House** (Model)
1978
Wood, paint, synthetic materials
15 × 109 × 122 cm

page 90, **Walkway for Hypo-Bank**
1995–97
Two-way mirror, glass, aluminium
280 × 900 × 5,300 cm

page 144, **Dan Graham**
1970
Photograph by Robert Smithson

Birgit Pelzer Mark Francis Beatriz Colomina

Dan
Graham

Φ

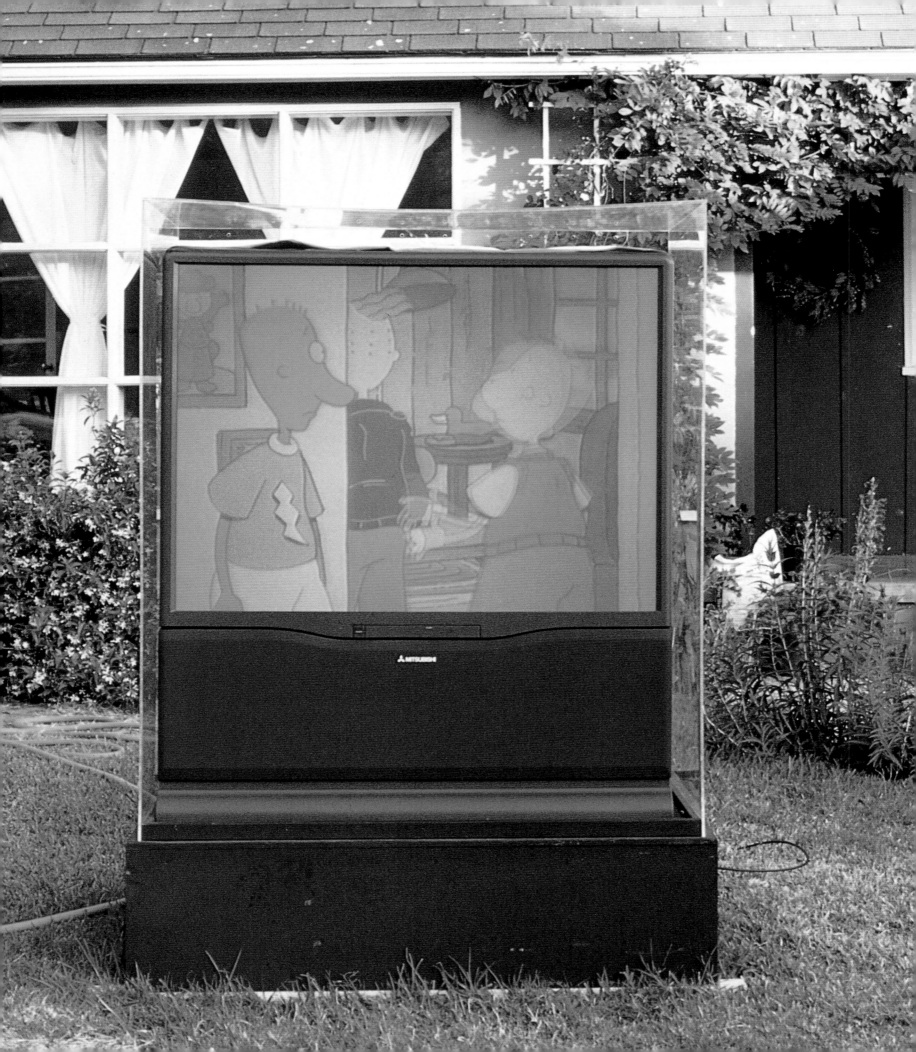

Contents

Contents

Mark Francis I want first to ask you about the ideas behind artists' interviews; since the 1960s this has become a widely used genre with a history of its own. The traditional model was that the artist should remain silent and let the work 'speak for itself' or let the critics and the public interpret it as they wished. However, the explosion of artists' interviews seems to have its origins in artists writing about their own and others' work, as you did early on – and as Donald Judd and Robert Smithson did as well. These two now seem key figures of that period, in terms of cutting out the mediator, the curator or critic.

Dan Graham **The European way of doing things was to separate critic, curator, artist and writer. In America the reason I got into art was because the artists I knew and with whom I showed at my gallery – the John Daniels Gallery in New York – all wanted to be writers, or they enjoyed reading.**

Francis Who was 'John Daniels'?

Graham **There were three people. No one wanted to have his full name used. One was called Daniel, one was called John and the other wanted to remain silent.**

Francis And you knew artists like Smithson and Sol LeWitt?

Graham **We didn't know anyone. We decided, since the gallery opened just before Christmas 1964, to have a Christmas show in which anyone who came into the gallery could exhibit. Sol LeWitt came in and made one of the most interesting pieces (*Floor/Wall Structure*, 1964). He and I were reading the French 'new novel' author and critic Michel Butor, and Sol was also interested in architecture. From conversations with Sol I became interested in the work of other proto-Minimal artists of the time.**

Francis There seems to have been an enormous shift at this moment from expressive, almost visionary, painterly work, such as that of early Smithson or Paul Thek, to minimal structures and architectural forms, which the John Daniels Gallery must have registered?

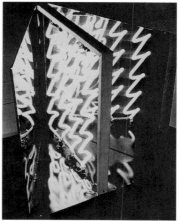

Graham **Well, the paradigms were self-reference and also, in the best work, anarchic humour – the idea that things can be banal, stupid, totally reduced, as in Beckett's writing or early Jasper Johns works – and the notion that symbolic space, like Renaissance perspective, should be cut down.**

Francis Did this also connect with contemporaneous developments in dance and music, like the work of Yvonne Rainer?

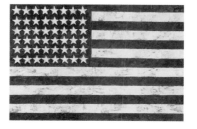

Graham **The great person then was the choreographer Simone Forti, who had an enormous influence on Yvonne, on her husband Robert Morris, and maybe on Bruce Nauman as well. Many of the group, including Forti who formed the Judson Dance Theater in New York in 1962, had started in Ann Halprin's dance workshops in San Francisco. However, I think the biggest influences for us were probably the films of Jean-Luc Godard and – from Pop art – printed matter, particularly in magazines, that could be mass-distributed. We were interested in a kind of cybernetics, an idea that**

everything could be information, similar to what interests many artists in computer art today. But the predominant idea was to reduce the gallery to an empty white cube; I thought this was too simplistic. Sol's early sculptures seemed more about grids in the city, so through that I became interested in urbanism.

The first works I made, such as *Schema (March, 1966)* (1966), were in the form of printed matter and were urbanistic.

Francis What got you into thinking about art even before this period, when you were still a teenager?

Graham Like Smithson and Dan Flavin, I only went to high school. French new writing and cinema were influential at the time and interested us, as did the Pop art that was being publicized in magazines like *Esquire*. It seemed

above, **Paul Thek**
Untitled (Bird and Mushroom)
c. 1969
Gouache and collage on newsprint
58.5 × 43 cm

opposite, top, **Sol LeWitt**
Floor/Wall Structure
1964
Painted wood
244 × 81.5 × 106.5 cm

opposite, middle, **Robert Smithson**
The Eliminator
1964
Steel, mirror, neon
71 × 51 × 51 cm

opposite, below, **Jasper Johns**
Flag
1955
Encaustic, oil and collage on fabric
mounted on plywood
107.5 × 154 cm

right, **Schema (March, 1966)**
1966
Printed matter
28.5 × 21.5 cm
Published in *Aspen*, No. 5–6, New York, 1966–67

DAN GRAHAM

SCHEMA for a set of pages whose component variants are to be published in various places. In each published instance, it is set in its final form (so it defines itself) by the editor of the particular publication where it is to appear, the exact data used to correspond in each specific instance to the specific fact(s) of the published final appearance. The work defines itself in place only as information with simply the external support of the facts of its external appearance or presence in print in place of the object

(March, 1966)

```
       (number of) adjectives
       (number of) adverbs
   (percentage of) area not occupied by type
   (percentage of) area occupied by type
       (number of) columns
       (number of) conjunctions
        (depth of) depression of type into page surface
       (number of) gerunds
       (number of) infinitives
       (number of) letters of alphabet
       (number of) lines
       (number of) mathematical symbols
       (number of) nouns
       (number of) numbers
       (number of) participles
    (perimeter of) page
       (weight of) paper sheet
         (type of) paper stock
       (number of) prepositions
       (number of) pronouns
 (number of point) size type
         (name of) typeface
       (number of) words
       (number of) words capitalized
       (number of) words italized
```

that art was an area where we could do everything and anything, with no education.

Francis Did you first think of yourself as a writer?

Graham **When I was a teenager, instead of paying attention in class I would read Margaret Mead's anthropology books such as *Coming of Age in Samoa*, and later Jean-Paul Sartre. In other words, I was a high school student who thought everything was like Sartre's *Nausea*. I wanted to be a writer.**

Francis So once you had found some like-minded associates in New York, did you turn to writing, for *Artforum* and *Esquire* and so on?

Graham **No, I bought an Instamatic, the cheapest fixed-focus camera. At one point the gallery was running into debt and I had to leave and stay with my parents outside of New York. On the way, the train went through a low-income suburban area. It struck me that with no money I could still walk along the railroad and photograph what I saw.**

I was always interested in 'upper-' and 'lower-class' housing, because I grew up in a similar situation. My parents were scientists, but because of lack of money after the war we moved to an area in New Jersey for government workers, which looked like barracks. When I was thirteen, my parents moved to upper middle-class suburbia, so we could go to a better high school. I totally identified with the poorer community, so I was downward identified. Suburbia was discussed a lot in the early 1960s in magazines like *Esquire*. Sociologists like David Reisman talked about the 'lonely crowd', people who were conformist and unhappy in small suburban towns. In music this was reflected in The Kinks' song *Mr Pleasant* and The Beatles' *Nowhere Man*.

To me, Robert Mangold's relief paintings of the early 1960s resembled facades of suburban houses, as did the materials Judd used. And I thought, why do people have to make things for galleries? Wouldn't it be easier just to take photographs or slides?

Francis You took slides on the Instamatic?

Graham **Yes, the first show I was in was 'Projected Art' (Contemporary Wing, Finch College Museum of Art, New York, 1966). I showed the slides as projections, because I liked the transparency they had, like the Plexiglas in Donald Judd's sculpture, and the fact that they could be thrown away and had no value. *Arts Magazine* asked me to do a piece just about photographs for the December 1966–January 1967 issue. This was *Homes for America* (1966–67). Originally I wanted the pages to read like a suburban plan. I was influenced by an article by Michel Butor which focused on street permutations as a series of designs or arrangements, almost like serial repetition in music. The text replicated the grid and labyrinth of the city, showing how everything was organized in terms of simple permutations.**

I had also read an article by Donald Judd on the plan of Kansas City.[1] Along with his work and LeWitt's, I was interested in Dan Flavin; his fluorescents came from the hardware store, and he said they should go back there after they had been shown, thus getting rid of value. Sol was making wood structures, saying that after a show they should be used for firewood.

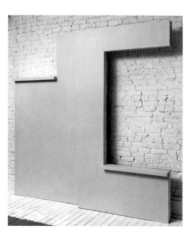

opposite, top, **Dean Martin and Jerry Lewis**
1951

opposite, bottom, **Roy Lichtenstein**
Tension
1964
Oil and magna on canvas
172.5 × 172.5 cm

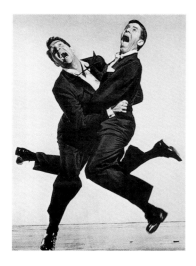

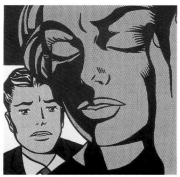

opposite, above, **Robert Mangold**
Gray Window Wall [destroyed]
1964
Oil on plywood
244 × 228.5 cm

opposite, below, **Dan Flavin**
The Diagonal of May 25, 1963
1963
Fluorescent light
l. 244 cm

following pages, **Homes for
America**
1966–67
2 panels, colour and black and
white photographs, texts
101.5 × 84.5 cm each
Revised version produced in 1970
of the artist's original paste-up
for *Arts Magazine*, New York. The
version published in the
magazine's December, 1966–
January, 1967, issue substituted
a photograph by Walker Evans for
the artist's images.

**The idea was that you could produce everything yourself, everything was
disposable and art should have no value. That was the utopian idea.**

Francis All the same, these artists were still making objects for gallery shows,
whereas you were projecting slide images taken with a cheap camera. Your
pictures and writing were not so much about objects as urbanism and the
suburban experience.

Graham **I think my work has always been about the city plan. My love of
printed matter came particularly from Roy Lichtenstein, who took comics
and printed sources from magazines and put them in paintings, thus
destroying painting. He used to think his work would have no value, but it
didn't work out. In works like *Schema,* I was trying to produce something
that was simply a magazine page, disposable, available to a mass of people
and which was also contingent on the nature of the particular issue of the
magazine. In this way it was a little like Daniel Buren's stripes, because it
referred to its context – the magazine – as place, as page, as disposable and as
information.**

Francis *Schema* could be seen as a conceptual work, or mental exercise for
people to figure out, whereas *Homes for America* combined a work of art, a
critique and a parody.

Graham **I just knew the banality of photography. I thought high photography
was such a bad area, so stupid and pretentious, but I could work with it as
'anthro-photography', because I believed my work was like a hobby, and I
was interested in hobbies. It was a time when everything I liked was parody.
Lichtenstein's work was total parody, yet he kept the qualities of the original
printed matter. I thought, why not put Pop art and its sources back into their
original context, but also defeat the idea of value by making the work
virtually free.**

Francis You were doing that in two principal ways, making works like *Schema*,
which could work in a magazine context, and also writing, more or less as a
critic, on contemporaries such as Dan Flavin and Claes Oldenburg and, for
example, on serial repetition in the photography of Eadweard Muybridge
(1830–1904).

Graham **Flavin wanted me to write for the catalogue of his show at the Art
Institute of Chicago (1976).**

Francis As a print-out, as I understand it?

Graham **The museum director decided to do things that were very modern
on a computer. People pushed a button and got a catalogue as a print-out.
My article, which was basically comprised of quotes, was almost unreadable
because computers at that time couldn't do punctuation. Flavin took an
early interest in my writings after reading 'Dean Martin/Entertainment as
Theater'.[2]**

Francis So for you and the artists around you, the relationships between

Homes for America

D. GRAHAM

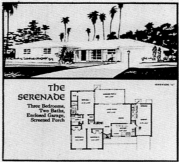

"The Serenade" - Cape Coral unit, Fla.

Set-back, Jersey City, New Jersey

Large-scale 'tract' housing 'developments' constitute the new city. They are located everywhere. They are not particularly bound to existing communities; they fail to develop either regional characteristics or separate identity. These 'projects' date from the end of World War II when in southern California speculators or 'operative' builders adapted mass production techniques to quickly build many houses for the defense workers over-concentrated there. This 'California Method' consisted simply of determining in advance the exact amount and lengths of pieces of lumber and multiplying them by the number of standardized houses to be built. A cutting yard was set up near the site of the project to saw rough lumber into those sizes. By mass buying, greater use of machines and factory produced parts, assembly line standardization, multiple units were easily fabricated.

Each house in a development is a lightly constructed 'shell' although this fact is often concealed by fake (half-stone) brick walls. Shells can be added or subtracted easily. The standard unit is a box or a series of boxes, sometimes contemptuously called 'pillboxes.' When the box has a sharply oblique roof it is called a Cape Cod. When it is longer than wide it is a 'ranch.' A

The logic relating each sectioned part to the entire plan follows a systematic plan. A development contains a limited, set number of house models. For instance, Cape Coral, a Florida project, advertises eight different models:

A The Sonata
B The Concerto
C The Overture
D The Ballet
E The Prelude
F The Serenade
G The Noctune
H The Rhapsody

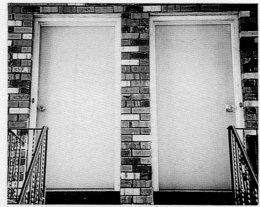

Two Entrance Doorways, 'Two Home Homes', Jersey City, N.J.

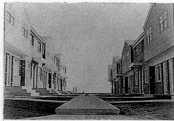

Center Court, Entrance, Development, Jersey City, N.J.

two-story house is usually called 'colonial.' If it consists of contiguous boxes with one slightly higher elevation it is a 'split level.' Such stylistic differentiation is advantageous to the basic structure (with the possible exception of the split level whose plan simplifies construction on discontinuous ground levels).

In addition, there is a choice of eight 'exterior colors:
1 White
2 Moonstone Grey
3 Nickle

LAWN GREEN

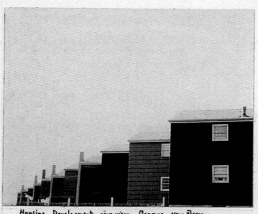

Housing Development, rear view, Bayonne, New Jersey

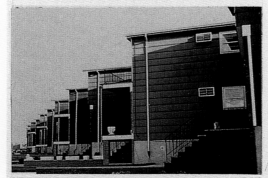

Housing Development, front view, Bayonne, New Jersey

There is a recent trend toward 'two home homes' which are two boxes split by adjoining walls and having separate entrances. The left and right hand units are mirror reproductions of each other. Often sold as private units are strings of apartment-like, quasi-discrete cells formed by subdividing laterally an extended rectangular parallelopiped into as many as ten or twelve separate dwellings.

Developers usually build large groups of individual homes sharing similar floor plans and whose overall grouping possesses a discrete flow plan. Regional shopping centers and industrial parks are sometimes integrated as well into the general scheme. Each development is sectioned into blocked-out areas containing a series of identical or sequentially related types of houses all of which have uniform or staggered set-backs and land plots.

4 Seafoam Green
5 Lawn Green
6 Bamboo
7 Coral Pink
8 Colonial Red

As the color series usually varies independently of the model series, a block of eight houses utilizing four models and four colors might have forty-eight times forty-eight or 2,304 possible arrangements.

Dan Graham

Interior of Model Home, Staten Island, N.Y.

Each block of houses is a self-contained sequence — there is no development — selected from the possible acceptable arrangements. As an example, if a section was to contain eight houses of which four model types were to be used, any of these permutational possibilities could be used:

Bedroom of Model Home, S.I., N.Y.

AABBCCDD	ABCDABCD
AABBDDCC	ABDCABDC
AACCBBDD	ACBDACBD
AACCDDBB	ACDBACDB
AADDCCBB	ADBCADBC
AADDBBCC	ADCBADCB
BBAADDCC	BACDBACD
BBCCAADD	BCADBCAD
BBCCDDAA	BCDABCDA
BBDDAACC	BDACBDAC
BBDDCCAA	BDCABDCA
CCAABBDD	CABDCABD
CCAADDBB	CADBCADB
CCBBDDAA	CBADCBAD
CCBBAADD	CBDACBDA
CCDDAABB	CDABCDAB
CCDDBBAA	CDBACDBA
DDAABBCC	DACBDACB
DDAACCBB	DABCDABC
DDBBAACC	DBACDBAC
DDBBCCAA	DBCADBCA
DDCCAABB	DCABDCAB
DDCCBBAA	DCBADCBA

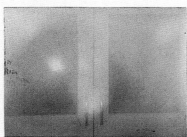

Basement Doors, Home, New Jersey

'Discount Store', Sweaters on Racks, New Jersey

The 8 color variables were equally distributed among the house exteriors. The first buyers were more likely to have obtained their first choice in color. Family units had to make a choice based on the available colors which also took account of both husband and wife's likes and dislikes. Adult male and female color likes and dislikes were compared in a survey of the homeowners:

'Like'

Male	Female
Skyway	Skyway Blue
Colonial Red	Lawn Green
Patio White	Nickle
Yellow Chiffon	Colonial Red
Lawn Green	Yellow Chiffon
Nickle	Patio White
Fawn	Moonstone Grey
Moonstone Grey	Fawn

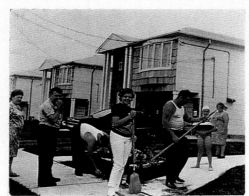

Two Family Units, Staten Island, N.Y.

'Dislike'

Male	Female
Lawn Green	Patio White
Colonial Red	Fawn
Patio White	Colonial Red
Moonstone Grey	Moonstone Grey
Fawn	Yellow Chiffon
Yellow Chiffon	Lawn Green
Nickle	Skyway blue
Skyway Blue	Nickle

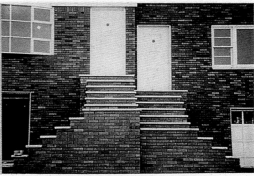

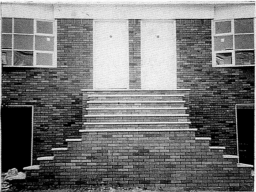

Car Hop, Jersey City, N.J.

A given development might use, perhaps, *four* of these possibilities as an arbitrary scheme for different sectors; then select four from another scheme which utilizes the remaining four unused models and colors; then select four from another scheme which utilizes all eight models and eight colors; then four from another scheme which utilizes a single model and all eight colors (or four or two colors); and finally utilize that single scheme for one model and one color. This serial logic might follow consistently until, at the edges, it is abruptly terminated by pre-existent highways, bowling alleys, shopping plazas, car hops, discount houses, lumber yards or factories.

'Split-Level', 'Two Home Homes', Jersey City, N.J.

'Ground-Level', 'Two Home Homes', Jersey City, N.J.

Although there is perhaps some aesthetic precedence in the row houses which are indigenous to many older cities along the east coast, and built with uniform façades and set-backs early this century, housing developments as an architectural phenomenon seem peculiarly gratuitous. They exist apart from prior standards of 'good' architecture. They were not built to satisfy individual needs or tastes. The owner is completely tangential to the product's completion. His home isn't really possessable in the old sense; it wasn't designed to 'last for generations'; and outside of its immediate 'here and now' context it is useless, designed to be thrown away. Both architecture and craftsmanship as values are subverted by the dependence on simplified and easily duplicated techniques of fabrication and standardized modular plans. Contingencies such as mass production technology and land use economics make the final decisions, denying the architect his former 'unique' role. Developments stand in an altered relationship to their environment. Designed to fill in 'dead' land areas, the houses needn't adapt to or attempt to withstand Nature. There is no organic unity connecting the land site and the home. Both are without roots — separate parts in a larger, predetermined, synthetic order.

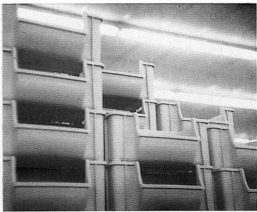

Kitchen Trays, 'Discount House', New Jersey

ARTS MAGAZINE/December 1966-January 1967

popular culture, TV, pop music, urban life, suburban life and the artist's life
were all mixed-up?

Graham **Yes, in a way that was like Godard's early films such as *A Married Woman* (1964). We liked all things French, the way people do today, except that to me the French post-structuralists are rather boring. I used to like reading Claude Lévi-Strauss, or the early work of Pierre Bourdieu, where he was more of an anthropologist than a sociologist.**

Francis Was Henri Lefèbvre known to you at that time?

Graham **No, I hated sociology. This is why it's a mistake to see *Homes for America* as a sociological critique. It's actually a parody of the worst sociologists who were writing then in American magazines.**

Francis After *Homes for America*, architecture increasingly became a part of your work. What was your attitude to Modernist architecture as represented, for example, by Walter Gropius and Ludwig Mies van der Rohe?

Graham **Because I read Robert Venturi's books at the time, which attacked Mies van der Rohe, it has taken me maybe thirty years to realize I am very close to Mies. In the 1960s I liked architecture because I wanted to make art that was hybrid, on the edge between two different disciplines.**

Francis Marcel Duchamp was also an influential figure in the US in the late 1960s, but you were not sympathetic to his work?

Graham **We had no interest in Duchamp. He influenced Bruce Nauman, Robert Morris, just about everyone on the West Coast, but I don't think the readymade had any influence, for example, on Flavin.**

Francis Were you actively against the attitude that he represented, of the dilettante, the *flâneur*?

Graham **Duchamp seemed too aristocratic; he didn't have a social conscience. The big influence, for the New York Minimal artists and myself, was a show of Constructivism called 'The Russian Experiment in Art 1863–1922' (The Museum of Modern Art, New York, 1971). We had a lot of utopian ideas, and took Russian revolutionary idealism seriously. I also became disillusioned with Conceptual art, as it became established through Joseph Kosuth and Art & Language.**

Francis For reasons similar to your disillusionment with Duchamp? Did you feel that it was cynical, still bound up with the market and with high art?

Graham **Yes. As to Conceptual art, I thought this idea of academic art was a bit boring and lacking in humour.**

Francis What did you decide to do, if you weren't going to participate in this kind of art? Teach? Write?

Jean-Luc Godard
Une femme mariée (A Married Woman)
1964
Film, 94 min., black and white, sound

Graham I lived in a very inexpensive apartment and gave lectures, because people read my articles, which meant travel – one of the best things about being an artist.

Francis So you became peripatetic, a lecturer, teacher, writer. Was that also part of the attraction of video and film – that it was not object-bound, nor confined to a studio practice, which you never had?

Graham I think the attraction was that I discovered Nauman's work. I was realizing the limitations of Minimal art, that it was totally about the object, whereas the artists Judd had written about at the start of the 1960s, such as Yayoi Kusama and Lee Bontecou, had been involved with process. It seemed that the subjectivity of the spectator, which both Nauman and Michael Snow were getting involved in, was my position. So I did a critique of Conceptual and Minimal art in an article titled 'Subject Matter' (1969).[3] I thought the perceptual process – and the optics – of the artist and the spectator should be what the art was about. And I was very interested in the drug culture, hippies and rock music, like Neil Young's first album, *Neil Young* (1969) and Bob Dylan's *Nashville Skyline* (1969), about going back to the country. I wrote a lot of rock criticism.

Francis By the early 1970s, were you beginning to make architectural models, or were you making video works?

Graham David Askevold was teaching a course at Nova Scotia College of Art and Design called 'Projects', where Conceptual artists were invited to submit projects for the students to fulfill. When I heard about this I thought it was a great idea for a course, and maybe, since I had no money at all, I could invite myself there to help realize one of the many video and film projects. I began teaching at Nova Scotia, and also invited artists who had never taught before, such as Michael Asher, Dara Birnbaum, Martha Rosler and Jeff Wall.

Francis Can you describe the video projects you were making in the early 1970s?

Graham A lot of the video was time-delay, which you could do with the standard video recorder by making a loop between the two analogue-based machines. With digital video you can no longer do this and it could only be done in black and white. So the work that both Nauman and I had been doing with time delays, which was parallel to the time-delays that Terry Riley and then, later, Steve Reich were doing in music, couldn't be done any more.

My interest in video installation was in using, for example, a mirror, a window and instant time, everything having a fixed point of view. I was interested in the just-past rather than the instantaneous; in frozen time, where the subjective, perceptual process would be part of the way the work functions. Spectators can see themselves seeing and being seen by other people, maybe in a different location. For example, in *Video Piece for Two Glass Buildings* (1976) you could see spectators looking at themselves as seen in a mirror, being looked at by other people on adjacent glass office buildings.

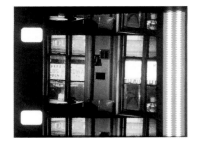

Michael Snow
Wavelength
1966–67
Film, 45 min., colour, sound

Bruce Nauman
Pulling Mouth
1969
16 mm film, 8 min., black and white, silent

VIDEO PIECE FOR TWO GLASS BUILDINGS

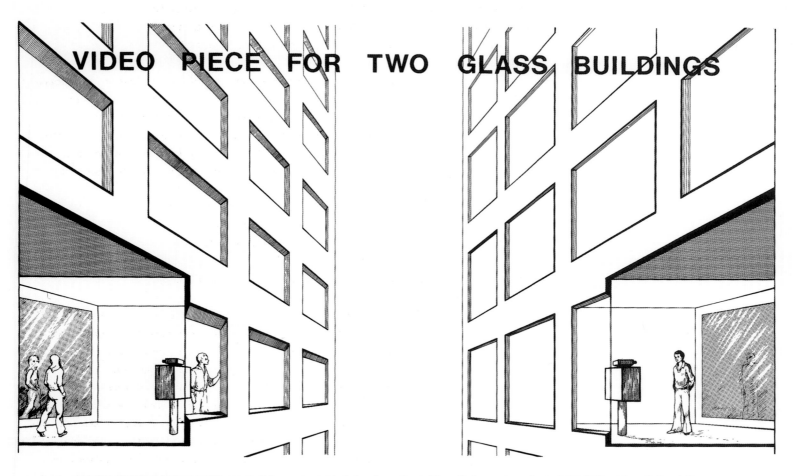

The video situation is for two opposite and parallel rooms located in facing glass office buildings. Each room has a large window looking onto a similar window of the room in the other building.

The sun illuminates the space between the two buildings' windows and, as its position shifts through the day, it alters the relative transparency/reflectiveness on the inside or outside of either window.

Each room contains a mirrored wall opposite and parallel to the window which reflects the contents of the room and the view seen through the window. This view through the window includes the reflections on the inside of the window, the outside facade of the other building, any outside reflections on the window opposite, and also what is observable inside the opposite room.

Each room has a large video monitor placed in front of its window so that the screen faces the mirror reflecting its image as well as that of the observer. A camera placed on top of each of the monitors faces the mirror to record its entire view.

The view from the camera in the left building is transmitted live to the monitor in the right building; but the view from the camera in the right building is transmitted 8 seconds delayed to the monitor in the left building.

A spectactator can either look at the mirror's view or look out through his window into the opposite room. In looking into the opposite it is possible to see that room's monitor-image reflected on the wall's mirror which shows a view of his room's mirror image.

Francis To me, that is the beginning of your fully realized work, where the spectator is so implicated, either as part of an ongoing video or mirror installation/performance, or part of a piece of architecture. What was the earliest piece like this?

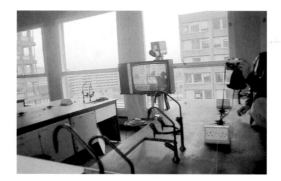

Graham ***Two Consciousness Projection(s)*** **(1972), which was both a performance and a self-contained video feedback loop. A woman focuses consciousness only on a television monitor image of herself and must immediately verbalize the content of her consciousness. A man focuses consciousness only outside himself on the woman, observing her objectively through the camera connected to the monitor. He also verbalizes his perceptions. The audience sees both simultaneously and witnesses an overlapping of consciousness. The piece drew analogies with various ideas in psychology, social anthropology and cybernetics, from R.D. Laing to Gregory Bateson.**

Francis So in the first pieces of that kind, the spectator is the performer and in a way stands in for the artist. It is as if you transformed the lecture situation into a performance. You, the artist, were also a spectator and commentator.

Graham **But I was also contrasting American behaviourism and European phenomenology. When I made a description of the audience or myself, I would talk about myself or them behaviouristically, somewhat like an American sports announcer. However, since the piece was also concerned with a changing past time, I also used the kind of European phenomeno-logical description that was becoming popular in the 1970s art world.**

Francis You would be, as I recall, standing in front of an audience, with a structured narrative in mind, that would then be improvised (*Performer/ Audience/Mirror*, 1977). In that sense it was like music; you would describe yourself looking at the audience, then you would turn around, look at the mirror behind you, and describe yourself and the audience through the mirror, then you would describe the audience, and so on.

Graham **It began more simply, as a way to show intentionality. In the first piece I talked about my intentions, while also describing myself in my intentionality – what I was seeing phenomenologically. But I had no idea what the work would be. This developed into *Intention/Intentionality* (1976) – without a mirror – where I would first look at the audience and describe them, then describe myself as they would see me. I couldn't see myself, so there was always a slight time delay, because I would make an action and then describe it a little later. Putting a mirror at the back implicated the audience more, because I could describe the audience, where they would be seeing themselves in a kind of instantaneous time but my description would be phenomenological. It would also influence how they saw themselves. When I turned and described myself or the audience looking at the mirror, rather than looking at or having the mirror at the back of me, I could move around, which the audience couldn't do. So I would get different perspectival views of myself and the audience that they couldn't have, as they were fixed**

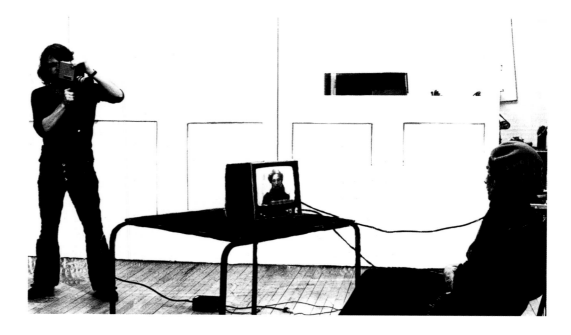

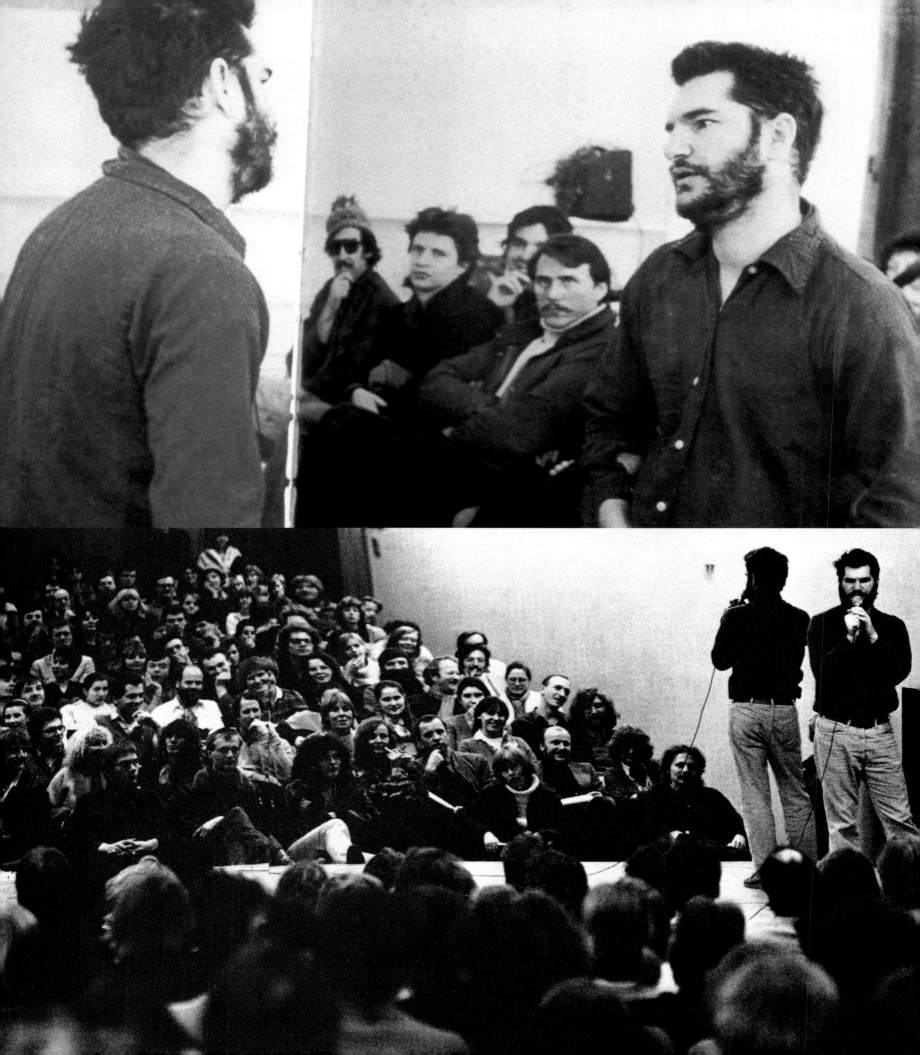

in space. In that sense it was about the audience being implicated in their own perceptual situation, and also about the limitations of Renaissance perspective.

Francis Would you have been historically interested for instance in a painting like Manet's *Bar at the Folies-Bergère* (1881–82), which depicts that kind of interaction: the mirror behind, spatial distortion and the figure of the spectator implicated in a compromising situation?

Graham **No, I hadn't considered the Manet. I think what you describe emerged later in *Public Space/Two Audiences* (1976). I was only interested in philosophical, psychological models, which Sartre described in his existential form of phenomenology, where you would only have identity as an ego through being reflected by the ego and perceptual process of another person. I wanted to make a separation between subjectivity and objectivity.**

Francis By 1976, you were beginning to write about architecture, you were making models – some of which could only be realized on the scale of a house – and you were beginning to make pavilions, or pavilion-like structures. *Two Adjacent Pavilions* was realized as a full-scale work at Documenta 7 in 1982, but began to be conceived in 1978. How did the pavilion works evolve?

Graham **They developed out of my exhibition at the Museum of Modern Art, Oxford, in 1978. After I had done *Public Space/Two Audiences* ('Arte Ambiente', Venice Biennale, 1976) I realized the piece was too perfect. It worked because there was a white wall, and opposite it, a mirrored wall. I wondered what would happen if I took out the white wall. It would become architecture; it would no longer be part of a gallery. I conceived of a series of models that were similar to *Public Space/Two Audiences*, where there would be rooms divided either by mirror or other forms of screen. I made about ten models; some, like *Alteration to a Suburban House* (1978) or even *Video Projection outside Home* (1978) were for suburban situations, a bit utopian, like a filmic fantasy.**

Francis Since that time you've made a whole range of pavilions of different kinds, playing variations on a certain basic formula, and on a consistent human scale. Many are outdoor structures, so they involve walls; transparent, reflective mirrors; cages; sometimes landscape elements, and so on. They are often fairly minimal structures, but they have become increasingly complicated technically, with, for instance, curved walls that create distortions. Can you discuss where the idea of the pavilion comes from historically?

Graham **The origin of my pavilions dates to the time when I first saw Minimal art installed as outdoor public sculpture. It looked so stupid. I wondered how you could deal with putting a quasi-Minimal object outside, and also wondered how these things could be entered and seen from both inside and outside. So I thought of the pleasure pavilions of the Baroque and post-Baroque period. A good example is the Amalienburg Pavilion designed by François de Cuvilliés as a royal hunting lodge in the grounds of the Nymphenburg Palace, Munich. In the pavilion, each of the four windows faces one of the cardinal directions; between each window there are two**

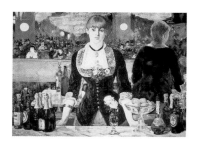

above, **Édouard Manet**
A Bar at the Folies-Bergère
1881–82
Oil on canvas
96 × 130 cm

opposite, **Performer/Audience/ Mirror**
1977
Performance
top, P.S. 1 Musuem, Long Island City, New York, 1977
bottom, Riverside Studios, London, 1979

Octagon for Münster
1987
Two-way mirrors, wood, steel
h. 240 cm, ⌀ 366 cm
Installation, 'Skuptur. Projekt in
Münster'
Collection, Landesmuseum
Münster

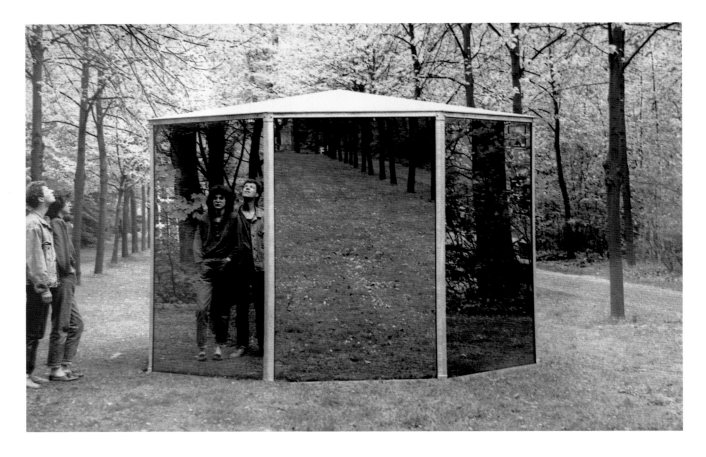

mirrors, with silver-embossed ornamentation of foliage, which relates to the
rococo gardens outside. When the windows are open, a spectator standing in
any one cardinal direction and looking through a window can see the views
from two of the other windows reflected from the mirrors on the left and
right side. So there's a relationship between inside and outside, and also a
power relationship. The king was symbolized as the sun. When he was
present the windows would be opened, and the sun would transform the
silver interior, as if by alchemy, into gold.

I was interested in the two-way mirror because it's usually used in a one-
way mirror fashion; for example, in psychology laboratories, where student
psychologists can watch consultations by looking through a transparent
two-way mirror from the side that is not lit, whereas the patients see only a
mirror-wall. It's a kind of surveillance system, and when it was first used in
glass office buildings, the Bauhaus idea of transparency was replaced by
surveillance. But this was also a time of ecology problems, of corporations
having problems with polluting the environment, so they wanted to use two-
way mirror glass with sun-reflective mirrors on the outside to cut down the
costs of energy-consuming air conditioning. It also creates an identification
of the building with the skyscape, so it becomes ecological symbolically. It's
also interesting that when two-way mirror office buildings came in the glass
was often gold-tinted; at that time everyone was interested in going to the
gold standard. But now these buildings refer more to the sky and to God. It
has a lot to do with surveillance. My indoor video installations generally used
time-delays but brought in issues of surveillance.

Francis When you talk about inside and outside, you don't just mean in a
physical sense, but also public and private. For instance, your early work

brought what was normally private behaviour into a gallery space; and you have reversed public and private spheres, playing on those Modernist ideas about transparency, both physically and symbolically.

Graham **When two-way mirror glass is used in office buildings it's always a mirror for the people on the outside, and transparent for the people on the inside. That's the surveillance aspect, whereas in the glasstower 'show rooms' designed by Mies, people saw only the parts on the ground floor, which didn't show production, because the idea was not to show production. At the very top, from the executive suites and boardroom, you could look down and survey the city. I'm trying to reverse that. My pavilions are always a kind of two-way mirror, which is both transparent and reflective simultaneously, and it changes as the sunlight changes. This relates to the changing landscape, but it also means that people on the inside and on the outside have views of each other superimposed, as each gazes at the other and at the material. It's intersubjective.**

Francis Generally, your pavilions have been made for manufactured landscape situations, urban parks or city parks, rather than for a gallery. Would you say that these works are a response to the issues of the museum as an institution that many artists have been struggling with?

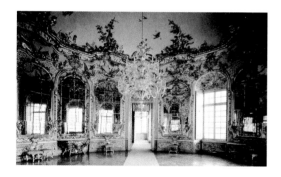

François de Cuvilliés
Hall of mirrors, Amalienburg
Pavilion
1734–39
Nymphenburg Palace, Munich

Graham **Art that tries to be against the museum as a totalitarian architectural structure doesn't interest me. What interests me is that perhaps the first museums were in the parks of the Renaissance period, which were in one sense like Disneyland, with water-tricks, educational puzzles and allegories, and they were always literary in their references, like the English garden later. Of course, this was a private, aristocratic area. Where I use a two-way mirror situation, as in *Two-way Mirror Hedge Labyrinth* (1989–93) the two-way mirror is emblematic of the city's centre, and the pavilion, or let's say the labyrinth situation, is emblematic of the labyrinth of the city.**

** The idea of the primitive hut as a kind of pavilion in a natural or woodland setting contradicts, in a utopian way, the despoliation of bourgeois society in the city. There's also a tradition of pavilions in the nineteenth century as fun-house situations – gazebos, music pavilions – or in German they're called 'lust' or 'pleasure' pavilions. But this was a democratic idea; the folly was probably still aristocratic. I see them as photo opportunities for parents and children, inside and outside, a little bit psychedelic, and with the anamorphic situation very much related to the body, the 360-degree radius of the body and your visual field; the sky, and your relation to the rectilinear plan of the city.**

** I guess in this century we had Mies' Barcelona Pavilion (1928–29), where the structure was emblematic of the new products and utopian ideals of the Weimar Republic. There was very much a mirror situation, a little bit allegorical – something of the English garden in an urban setting. My later work becomes more emblematic; for example, the *Star of David Pavilion for Schloß Buchberg* (1991–96).**

** But I also think museums have some very good areas. The empty lobbies, the gift shop, coffee shop, sometimes the elevators. In other words, they're great places to look at people, who look at other people, who look at other people.**

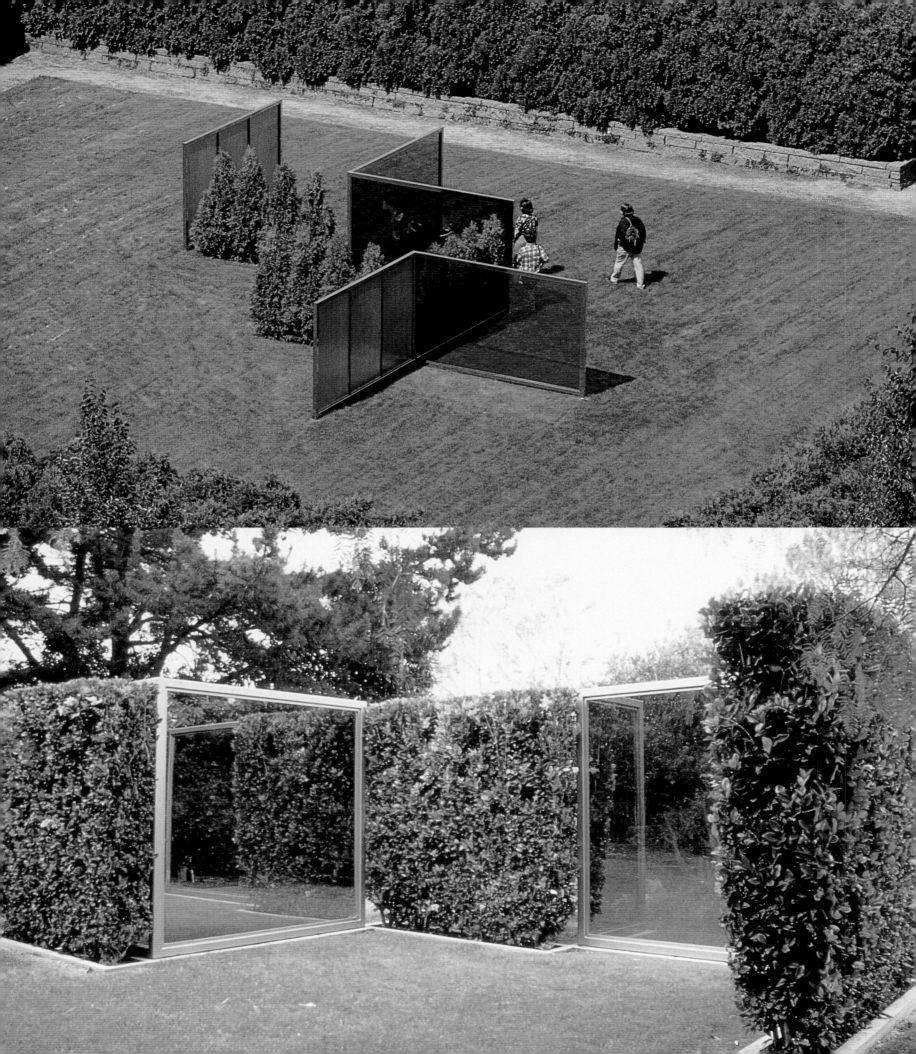

opposite, top, **Two-way Mirror Punched Steel Hedge Labyrinth**
1994–96
Two-way mirror, glass, stainless steel, hedge
Approx. 230 × 520 × 1,300 cm
Collection, Walker Art Center, Minneapolis

opposite, bottom, **Two-way Mirror Hedge Labyrinth**
1989–93
Two-way mirror, glass, aluminium, hedge
Approx. 200 × 900 × 900 cm

below, **Heart Pavilion. Version II**
1992
Two-way mirror, glass, steel
240 × 500 × 400 cm

The pavilion I did for the Carnegie International, the *Heart Pavilion. Version II* (1992), was intended as a romantic meeting place in the empty lobby.

Francis So you're interested in the interstitial spaces between what is identified as an exhibiting space and spaces with other functions or uses?

Graham **Well, there are also non-places related to bus shelters and telephone booths, where people are anonymous, surrounded by the city. These spaces are kind of blank, and thus a bit meditative, like the Californian light spaces of James Turrell, but I contradict the idea of the isolated, meditative subject or artist by making my work very social.**

Francis Your early pavilions seem not to have been referential except to Minimal and modernist architectural forms, but later, as you say, you made a number of pieces that have a consciously symbolic form, like the *Heart Pavilion*, the *Star of David Pavilion* and *Double Cylinder (The Kiss)* (1994), which makes a romantic reference to Brancusi's *Kiss* (1907).

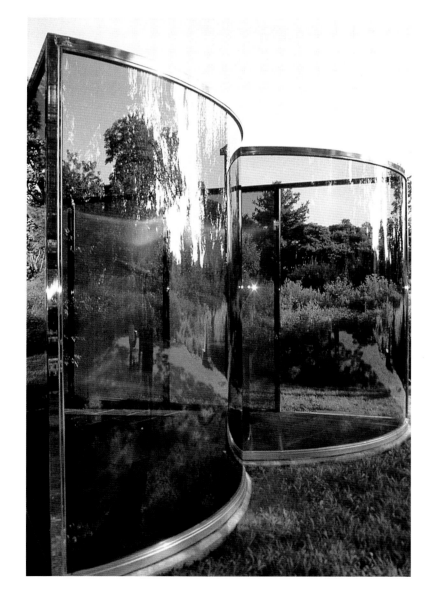

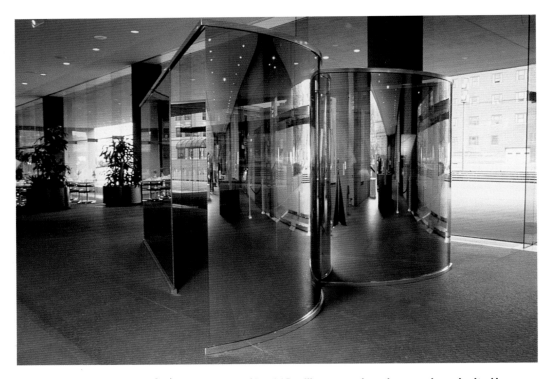

left, **Heart Pavilion. Version II**
1992
Two-way mirror, glass, steel
240 × 500 × 400 cm
Installation, Carnegie
International, Pittsburgh,
Pennsylvania

opposite, **Star of David Pavilion**
for Schloß Buchberg
1991–96
Two-way mirror, aluminium,
Plexiglas
h. 249 cm
Permanent installation, Schloß
Buchberg, Vienna

Graham **The *Star of David Pavilion* came about because I was invited by an art collector who owned a castle, Schloß Buchberg, in Vienna. When I went there I was offended that the Austrians, unlike the Germans, didn't show much evidence of guilt about their role in anti-Semitism. Many ex-Nazis were still in the government; many Austrian artists made work that included the cross and blood. However, I thought that being Jewish, I could do a Jewish star, and as an ironic parody of most Austrian art, something on water (the site was the former moat area of the castle). The structure was designed so that you would walk on water, like Jesus. (Actually, you walk on a grating just below water level.) Also, water became another way to make a reflection, relating to the two-way mirror reflections.**

Francis You've used water in other ways such as in *Two-way Mirror Triangle One Side Curved* (1996), where the waters of a Norwegian fjord, and the surrounding landscape, are reflected in a parabolic curved panel. The reflection becomes like an enormous panoramic landscape painting, reminiscent of the work of the American sublime painter Frederic Edwin Church (1826–1900).

Graham **It's definitely like Frederic Church, but of course, he was influenced by Caspar David Friedrich (1774–1840). I'd like to think that I work as a combination of two Hamburg artists, Friedrich and Philipp Otto Runge (1777–1810).**

Francis Runge in terms of the paranoid representation of the family?

Graham **The child. My work is for children and parents on weekends. Some would call it Lacanian, but I don't know that much about Lacan.**

Francis The *Children's Pavilion* (1989–91) that you made in collaboration with Jeff Wall has picture-windows with images of children …

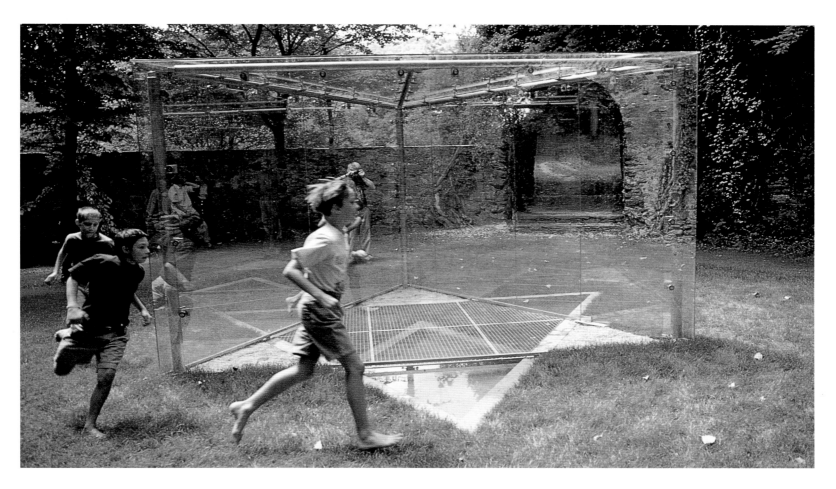

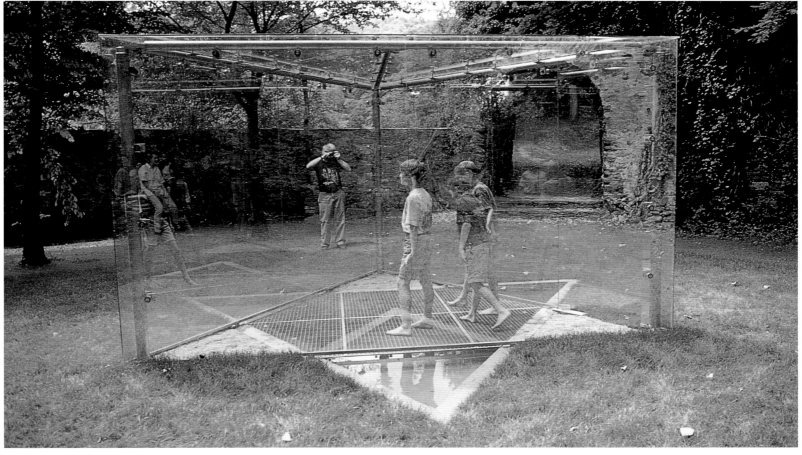

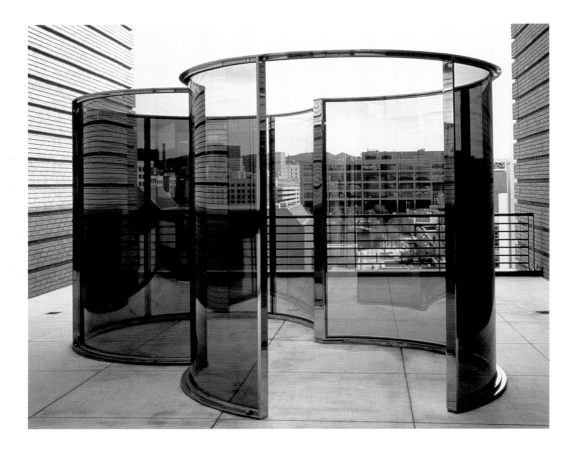

left, **Double Cylinder
(The Kiss)**
1994
Two-way mirror, glass, aluminium
h. 244 cm, ⌀ 244 cm
Collection, San Francisco Museum
of Modern Art

opposite, **Two-way Mirror Triangle
One Side Curved**
1996
Two-way mirror, aluminium
137 × 137 × 152 cm
Installation, 'Nordscape Project',
Norway

Graham **They're actually tondos.**

Francis The children appear as if they're looking through the windows in an aquarium.

Graham **Well, originally Jeff had seen the video tape of my smaller-scale *Children's Pavilion* at the 'Chambres d'Amis' show in Ghent (1986). The video was filmed live from a child's viewpoint. Making the pavilion small was actually a pragmatic decision because it was between two buildings belonging to an architect, his old house and the studio in the backyard. So the idea was to build something that would go through the garage and the yard beyond, and be like a small conservatory. I realized that the structure I had originally planned was very large and would dwarf his two architectural buildings, which would damage his family business. So I decided to make it small and orient it towards the children who used to play in the muddy backyard. When Jeff saw the plans he said, why don't we do something with children? So I started thinking about it.**

 I was influenced by the architect Emilio Ambasz, and wanted to do something underground. Having made curved anamorphic structures, I wanted to construct something that had concave and convex two-way mirror-coated lenses. So the structure is underground, a little like a grotto, and it's modelled on the kind of mountain that children have in playgrounds, where they can see who's king of the 'mountain'. I got the idea for a site from Parc de la Villette, Paris, where there is a science museum and attached to it a mirror-surfaced dome, La Géode, designed by Adrien Fainsilber. Inside it, 360-degree Cinemax films are shown. Nearby was a children's 'mountain', so I thought of putting it on that site. This was in France before Jean Nouvel and Bernard Tschumi; modern French architecture was like a pitiful re-doing of Le Corbusier with a lot of cement – *béton*. It was still the bunker period.

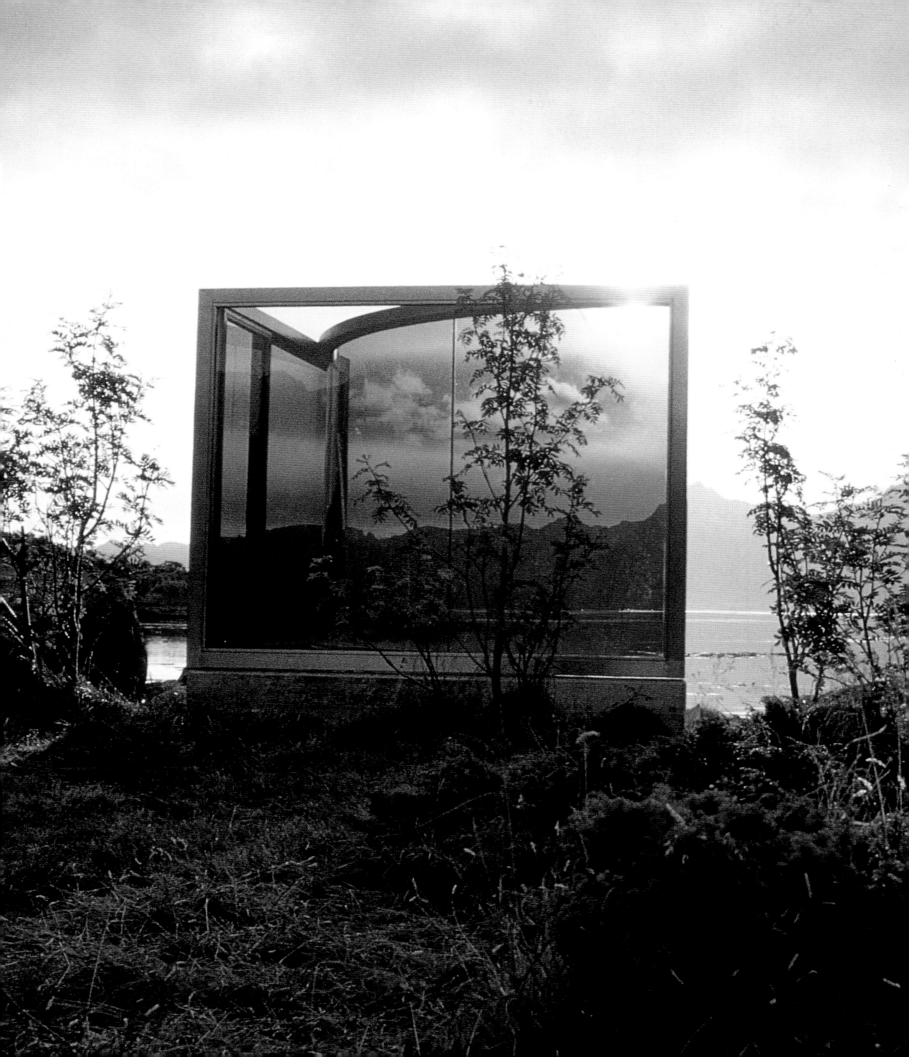

Francis Wasn't it then that I.M. Pei's glass pyramid for the Louvre was being commissioned?

Graham The original idea dates back to before that time, around 1987–88. I wanted to make a kind of grotto, with an entrance from the side, which would make it similar to caves like Lascaux, where there are prehistoric paintings. Also, with its dome, the *Children's Pavilion* becomes like a planetarium and observatory, like the insides of the French Enlightenment theatres or temples to Reason and Nature planned by Étienne-Louis Boullée and Claude-Nicolas Ledoux, except that at the very top, the tondos feature children. Jeff decided it would be children of all countries and all colours, a little like the Benetton ads, against different skies which would be the horizons for each individual child.

Francis Where were the children photographed?

Graham In Vancouver, because Jeff said it was like the whole of America in that it had people of all races. Psychologists said that these giant images might frighten children. So I realized this was a pavilion for adults, and Jeff had emphasized the adult position. I think it's for adults wanting to be children, and I also realized that with the Benetton ads you have the beginning of that 1990s idea that we should all be childlike, in buying things for our children and ourselves – a kind of corporate sentimentality based around children, which I think is also a focus in Jeff Koons' work.

Jeff Wall and I were asked by the French Minister of Culture and Mayor of Blois, Jack Lang, to build another Children's Pavilion for the millennium year. I cut down the size; it's not built of concrete and it's easier to deal with. Whereas Jeff's architect, in the illustrations, made it into a very complex spiral, like the New York Guggenheim Museum, I made it into one ramp with wheelchair access, so that people could also sit on it. The optics are very important; at the top of the dome there's a convex two-way mirror fish-eye lens, which shows everyone, and in the centre there's a small reflecting pool of water, so it's like a grotto. Both reflections show the pavilion's entire interior, the people in its interior, and also the nine tondos. At the very top – and I hope this can work so that they don't fall into it – children can look through the concave two-way mirror and see the real sky as well as (from the back) the depicted skies in Jeff's tondos. They also see a view of themselves, each as an anamorphically enlarged as a giant in relation to the adults and the other children inside, who are looking up. So both gazes face each other, and because it's a coated two-way mirror, it becomes more or less transparent or reflective as the sunlight changes. Very idealistic, like Boullée.

Francis You made another great collaboration with the artist James Coleman at a ruined castle in Galway, Ireland (*Guaire*, 1986). Can you describe this piece?

Graham I've never actually seen it. James wanted to do a piece in this castle, where they normally have tourists sitting at the old wooden tables, drinking mead, as if they were medieval people. Apparently the king who owned the castle was overthrown by his subjects because he wasn't authoritarian enough.

James constructed a play around this, where at one point the king holds

left to right, top row,
Claude-Nicolas Ledoux
Project for the Maison des Gardes
Agricoles, Mauperituis
c. 1785–87
Engraving

Étienne-Louis Boullée
Project for a cenotaph for Isaac
Newton
1784
Ink and watercolour on paper
44 × 66 cm

second row,
Caspar David Friedrich
The Wanderer Above the Mists
c. 1818
Oil on canvas
95 × 75 cm

Constantin Brancusi
The Kiss
1907
Stone
h. 28 cm

third row,
James Turrell
Orca
1968
Light installation
Dimensions variable

bottom row,
Adrien Fainsilber
La Géode
1983–85
Parc de la Villette, Paris

Emilio Ambasz
Private estate
1988–91
Montana, USA

I.M. Pei
Central pyramid, cour Napoléon
1986–88
Louvre, Paris

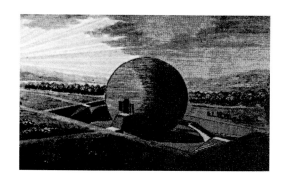 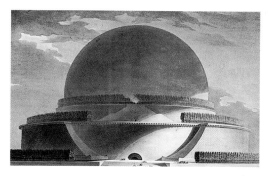

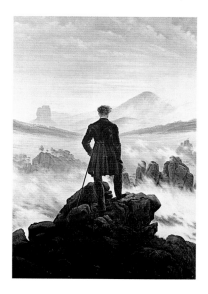 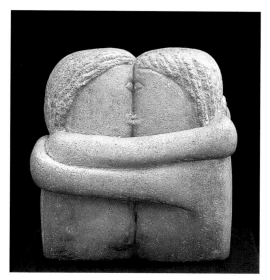

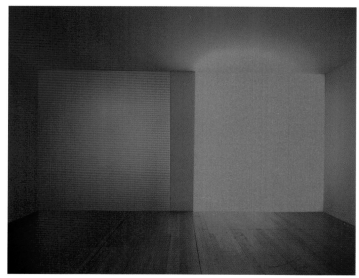

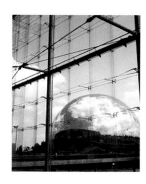 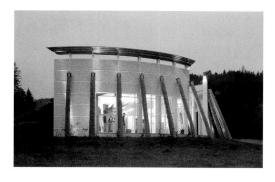 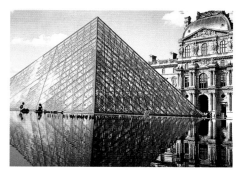

a shield, and this serves as an optical situation where the tourists, who have the role of his subjects, see images of themselves that are more powerful than the king's image. So the shield acts as a mirror, and I decided to make it into a concave two-way mirror, onto which the image of the audience is video-projected. It's also like a ghostly skull.

Francis So it prefigures the mortality of the audience.

Graham **And the king. The king is losing his grip. What I liked about the first pieces James made when he moved back to Ireland was how they dealt with the real culture of Ireland – tourism, cliché, political dreams, history.**

Francis And mythology. Do you think that your work has dealt with these aspects in terms of American history? Cliché especially.

Graham **I was very influenced by Leslie Fiedler, who wrote about American history, and by many of the writers on rock music like Richard Melzer. Also when I was trying Conceptual art, and when the Minimal artists were doing their first pieces, the paradigm was present time, moments, middle history, middle representation. In the 1960s we believed in instant moments, in 'no-time', getting rid of historical and metaphorical time. Moments after moments, with no memory. I got involved in the idea of the just-past, probably through reading Gregory Bateson and also through music that used a short memory-time and time-delay. Also, of course, there was drug-space; I remember thinking about the pop group The Byrds – they were yelling a kind of mythology of the past and a projection of the future. So there was no now, but just these different projections. I also read a lot of science fiction novelists like Brian Aldiss and Michael Moorcock, who were influenced by drugs.**

Francis You've also said that you were interested in The Kinks' use of cliché and hence of mythic, suburban ideas that had a kind of nostalgia for the past.

Graham **Well, I think it's the just-past that we suppress. So the idea – and I got this later from reading Walter Benjamin – was that every time we have a new-now, we're suppressing the just-past. Or, as in the Rolling Stones' song *Yesterday's Papers*, I thought that the just-past was the most interesting area.**

Francis When you're making pavilions now for different situations, do you think they perform the same kind of function as they did when you began doing them?

Graham **I think what has changed is that I started doing things that were half-utilitarian, so that by 1986, because I couldn't use the new digital recording and play-back units, instead of continuing to make video installations I designed a maze-like structure with two-way mirror screens (*Three Linked Cubes/Interior Design for Space Showing Videos*, 1986). It was designed for showing six videos, one in each cubicle, so the viewers would see themselves watching.**

Francis Were the videos shown in a fixed sequence?

Graham **They were shown simultaneously. There would be six different**

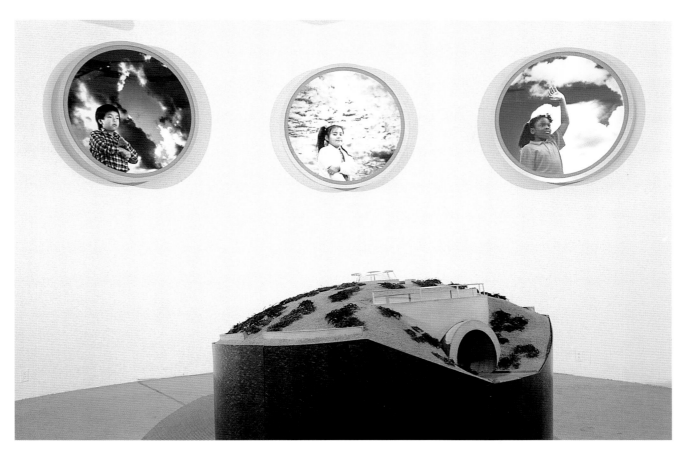

Children's Pavilion, with Jeff Wall
(Model)
1989–91
Wood, metal, plastic, Plexiglas,
transparencies, fluorescent light,
concrete, aluminium, cork, lichen
h. 127 cm, ∅ 282 cm

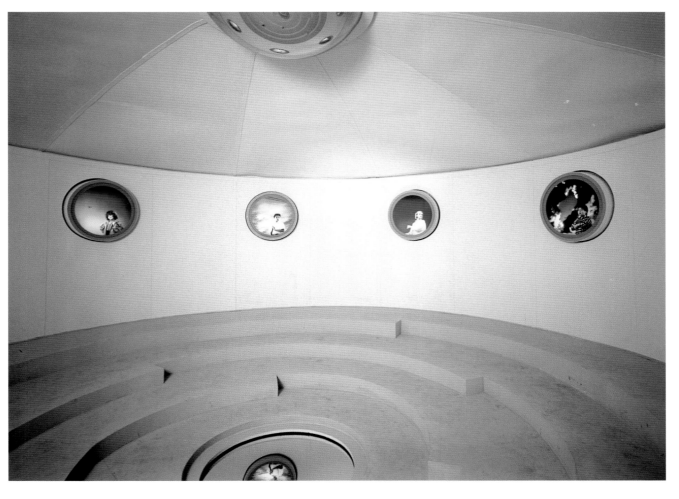

images and six different play-backs in small booths, so people could sit in groups of three or four in each of the booths, and they'd be seeing a different video.

Francis In each of the booths?

Graham Yes, it was a bit like a drive-in cinema where you can see other people looking at the images. The reflectiveness, as against transparency, of your own view would change because the images would change in light. So there's a kind of self-consciousness that I built into pieces like my first video installation, *Present Continuous Past(s)* (1974), where you'd be aware of yourself as an individual in the audience looking and being looked at. But here what you were looking at was normal video tapes.

Francis When you say 'normal' video tapes what do you mean? Video tapes made by artists, or daytime TV, or cable? I guess the question is really, how important is the content of the videos to you?

Graham They should be by different people who have different audiences. The installation should be very comfortable so you can lie down. Too much art is seen instantaneously, and there's too much video art that consists of giant, overwhelming images. This should be small, home-like, an area that I think should be a romantic, comfortable kind of place. More and more I want to situate people on the floor or on the grass. But *Two Adjacent Pavilions* was designed so that each pavilion would have about four or five people inside and two people lying down on the diagonal.

Francis How is that reflected in your current work? You're making pavilions in certain situations, you're writing periodically.

Graham My best recent projects haven't yet been realized. One is a landscape

opposite, **Three Linked Cubes/Interior Design for Space Showing Videos**
1986
Two-way mirrors, glass, wood frames
225 × 300 × 3.5 cm each panel

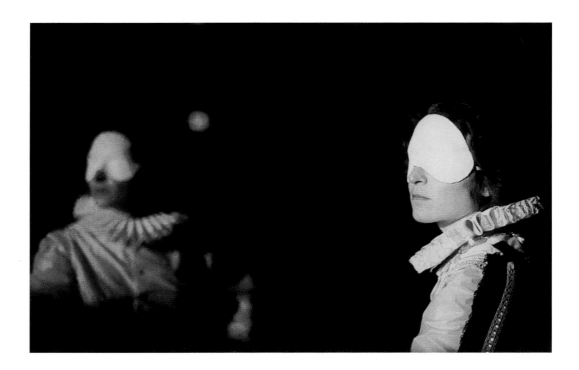

Guaire, with James Coleman
1986
Stage set
Concave two-way mirror with video time delay
Installation, Galway, Ireland

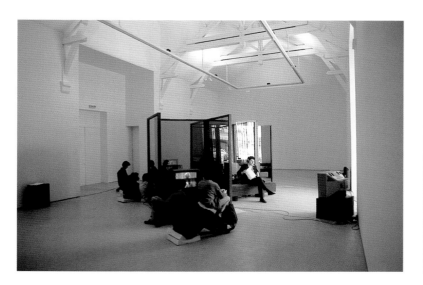

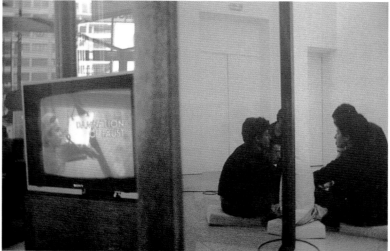

pavilion, *Double Exposure* (1995–96), which was intended to be installed near the Fulda river, at the very end of the sequence of works shown at Documenta X in 1997. It is in the form of a triangle, two sides of which are made of two-way mirror, one side of which can be entered. On the other side is a photograph of a landscape, roughly 50 metres long. It's a transparent Cibachrome print which you would be able to see through on a sunny day. People think it can't be done permanently, but there's now an American company that can coat Cibachromes so the sun doesn't fade them.

When you're on the inside, you see landscape on both sides of the two-way mirror. You also both see and look through the photograph. When you look through it you see the moving, real transparent image and the real environment from your viewpoint. In other words, it's like putting aspects of the *Children's Pavilion* outdoors into a landscape situation. It could only have been done for a large exhibition like Documenta, and enough funding wasn't raised to make it.

Another piece I wanted to do was a version of the *Yin/Yang Pavilion* (1996) for the World's Fair in Hanover in 2000. The idea for this pavilion came from seeing a Bill Viola video where the figure of a man emerges out of a pool, like John the Baptist (*The Reflecting Pool*, 1977–79). I remember watching it in Viola's New York gallery and turning to artist Paul McCarthy who was there. I said, 'This is religious but it's not my religion'. I also thought that the strongest interest in religion in the West now is in Eastern thought, so I decided to do something referring to the yin/yang principle. I'm using a two-way mirror that makes a curve, and every reflection is a curve. So one side is a water basin – I guess the yin side – and the other is raked white gravel, like a zen garden. You enter the gravel section from the outside, and there's a two-way mirror making a half-circle around the gravel area; then between the water and the gravel area is an S-curve. So you have an incredible space – they're all two-way mirrors reflecting the water and reflecting each other, anamorphically. I wanted to make this into a pavilion that you could go underneath, as a café. You'd go under the water; the water would be up on the roof, so you could see the sky through the water. Many different possibilities, but I don't think it'll ever be built.

Francis What do you think about the work of younger artists who are using and referring to design, like Jorge Pardo.

Graham **I think Pardo is looking for a fantasy of the 1960s and 1970s, but his work is luxurious in a very 1990s way. You can see that it comes from a generation that only has vague information about the recent past, which barely even knows Alvar Aalto. I always want things to be utilitarian, and I think this generation want things to be anti-utilitarian, a little fantasy world of art.**

Francis So the younger generation has a nostalgia for the period when your work first emerged?

Graham **I think they want to eliminate hard greediness and the return to painting and sculpture of the 1980s and 1990s. So they're looking back for a utopia. They somehow found it so quickly and it's become so popular that they haven't developed their research or ideas any more; their work seems easy. Dealing with the relationship between art and architecture has become a cliché now.**

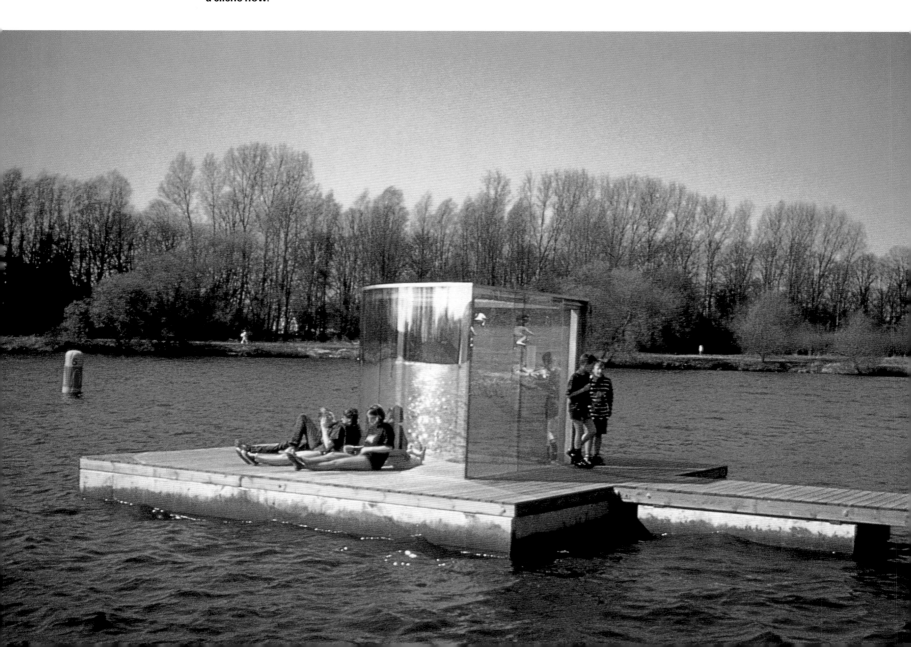

opposite, top, **Jorge Pardo**
Pier
1995–96
California redwood, metal,
cigarette vending machine
Approx. 1,985 × 3,925 × 325 cm
Installation, 'Skulptur. Projekte in
Münster', 1996

opposite, middle, **Bill Viola**
The Reflecting Pool
1977–79
Video, 7 min., colour, sound

opposite, bottom, **Parabolic
Triangular Pavilion** (model)
1995–96
Two-way mirror, transparent glass,
aluminium
58 × 106.5 × 106.5 cm
Nordhorn, Germany

right, top, **Double Exposure**
(Model)
1995–96
Two-way mirror, transparent glass,
Cibachrome transparency
50 × 107 × 107 cm

right, bottom, **Yin/Yang Pavilion**
(Model)
1996
Two-way mirror, white gravel,
plastic
32 × 106.5 × 106.5 cm

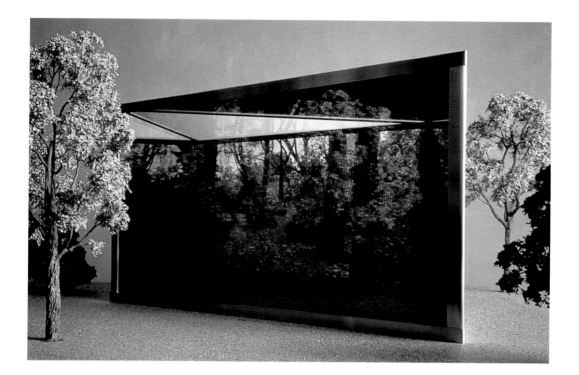

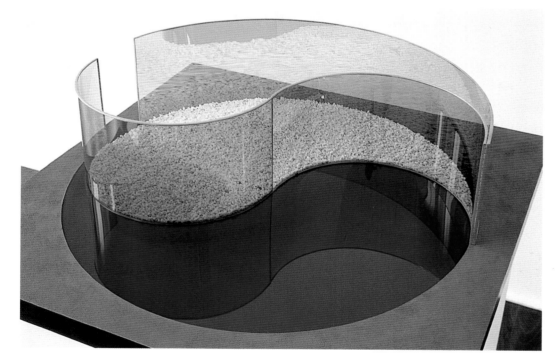

**What I do notice, and this is very important, is that I'm often in very bad
shows, in the middle of nowhere, and see the work of younger artists. For
example, I remember being in a terrible show sited in a small British town
where there was a great piece by Tacita Dean. So the further away I get, into
the most out-of-the-way places, the better the art that I find there, often
better than in the main centres.**

1 Donald Judd, 'Month in Review', *Arts Magazine*, New York, October, 1964.

2 'Dean Martin/Entertainment as Theater', first published in *Fusion*, Boston, 1969; reprinted in *Rock My
 Religion: Writings and Art Projects 1965–1990*, ed. Brian Wallis, MIT Press, Cambridge, Massachusetts, 1993

3 First published in Dan Graham, *End Moments*, New York, (self-published) 1969. See in this volume pp. 112–15.

<table>
| COMMON DRUG \ SIDE EFFECT | Anorexia (Appetite loss) | Blood clot | Blurring of vision | Constipation | Convulsion | Decreased libido | Dermatosis | Depression, torpor | Headache | Hepatic disfunction | Hypertension | Insomnia | Nasal congestion | Nausea, vomiting | Pallor |
|---|---|---|---|---|---|---|---|---|---|---|---|---|---|---|---|
| **STIMULANT also APPETITE DEPRESSANT** | | | | | | | | | | | | | | | |
| Dextroamphetamine (Dexadrine) | ● | | | ● | ● | | | | ● | | ● | ● | | ● | |
| Methamphetamine chloride (Desoxyn) | ● | | | ● | ● | | | | ● | | ● | ● | | ● | |
| **ANTI-DEPRESSANT** | | | | | | | | | | | | | | | |
| Iproniazid | | | | ● | | | | | ● | ● | ● | | | | |
| Trofanil | | | ● | | | | ● | | ● | | ● | | | | |
| **TRANQUILIZER** | | | | | | | | | | | | | | | |
| Chorpromazine | | | | ● | | ● | ● | ● | ● | | | | | | ● |
| Hydroxyzine | | | | ● | | | ● | ● | ● | | | | | ● | ● |
| Meprobamate | | | | | ● | | | ● | | | ● | | | | |
| Promazine | | | ● | | | | | ● | ● | | | | | | |
| Resperpine | ● | | | | | ● | ● | ● | | | | ● | ● | | |
| Thiopropazate | | | ● | ● | ● | | ● | ● | ● | ● | | ● | | ● | |
| **SEDATIVE** | | | | | | | | | | | | | | | |
| Barbitol | | | ● | | | | | ● | | | | | | ● | |
| Phenobaritol | | | ● | | | | | ● | | | | | | ● | |
| **ANTI-MOTION SICKNESS** | | | | | | | | | | | | | | | |
| Dimenhydrinate (Dramamine) | | | | | | | ● | ● | | | | | | ● | |
| Marezine | | | | | | | ● | ● | | | | | | | |
| Meclizine | | | | | | | ● | ● | | | | | | ● | |
| **CONTRACEPTIVE** | | | | | | | | | | | | | | | |
| Norethynodrel (Enovid) | | ● | ● | | | | | | | ● | ● | | | ● | ● |
</table>

Contents

I.

In the early 1960s Dan Graham photographed the suburban houses and diners in his native New Jersey with a Kodak Instamatic camera. He was drawn to amateur photography: it was cheap and it called for no special skill.[1] In his first group exhibition, 'Projected Art' at the Finch College Museum of Art in New York, 1966, his photographs were projected as slides. The process of reducing something to mere transparency was already underway for Graham. He had the idea of publishing his photographs in a mass-circulation magazine along the lines of *Esquire,* which was a focus of the New Journalism in the 1960s. *'In those days* Esquire *was publishing sociological investigations like David Riesman's "The Lonely Crowd", using photographs in the Walker Evans mode, photographs showing lower-middle-class, suburban clapboard houses, but usually from a negative, humanist standpoint. I wanted to take all the same components of meaning and empty them of their pejorative, expressionist connotations.'*[2] In the end, the photographs were published in *Arts Magazine,* under the title *Homes for America* (1966–67) and accompanied by a text that parodied the neutral tone of journalistic reportage.[3]

Homes for America described different types of mass-produced housing in suburban developments that could be ordered from a catalogue. As Graham pointed out, these developments were a response to an emergency situation: they were built to house workers and veterans at the end of the Second World War. The page layout combined photographs and text, which took the form of lists and columns. This in turn echoed the serial logic of real estate development and prefabricated housing. Each house had a basic structure to or from which elements could be added or subtracted. The basic unit could also be twinned: the two halves reflected one another. Graham's photographs highlighted this doubleness: houses, doors, stairways were aligned, adjacent, bracketed together. *'First it is important that the photos are not alone but part of a magazine layout. They are illustrations of the text or (inversely) the text functions in relation to/modifying the meaning of the photos. The photos and text are separate parts of a schematic (two-dimensional grid) perspective system. The photos correlate (to) the lists and columns of serial information and both "represent" the serial logic of the housing developments whose subject matter the article is about.'*[4] The article itself was presented as a standard, modular-design town plan. Serial music and its permutations were to be found in the layout, and different houses bore the names of musical forms, such as Sonata and Concerto.[5]

Homes for America contextualized and expanded Minimalist art. Graham inscribed his 'specific objects' (the term coined by Donald Judd in 1965) and their 'local order'[6] in a precise social context. 'I wanted to show that Minimalism was related to a real social situation that could be documented.'[7]

Opting for news magazines was potentially a means of further reducing reductive Minimalist art, but in the very territory that it obliterated. There was a further reduction involved in not making gallery art. Graham's corrosive interventions in

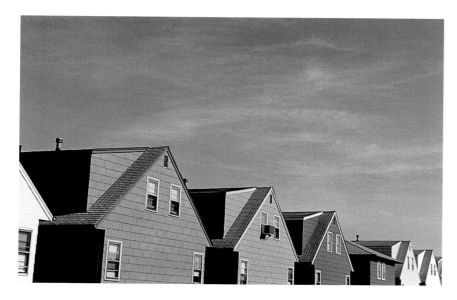
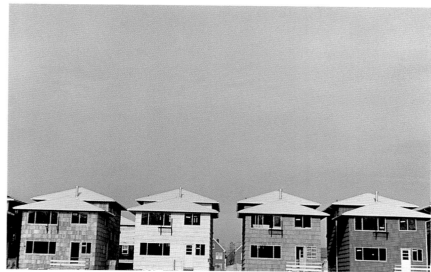

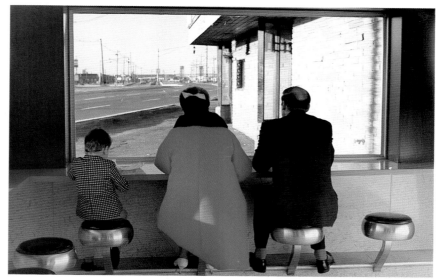
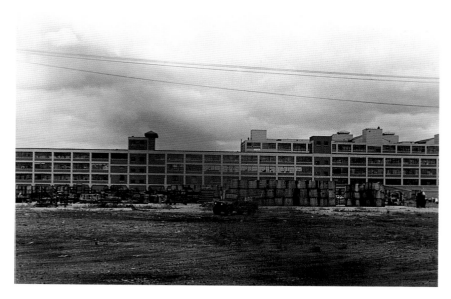
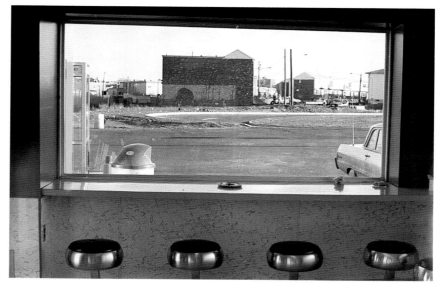

Scheme for Magazine Page
Advertisement
1965
Offset litho on paper
38 × 56 cm
Proposal for an advertisement
published in *Harper's Bazaar*, New
York, March, 1968 under the title
Figurative

magazines subverted the frameworks of reference of Minimal art and Pop art: for Minimal artists, the frame of reference was the white cube of the gallery; for Pop artists it was mass culture, which they transferred to the world of art. Land art was bogged down in a different contradiction: the need to disseminate itself as an ephemeral art, primarily through photography. Graham stressed that the real framework – the socio-economic structure, the apparatus of validation – never appeared. From then on, through his statements in magazines, he saw himself as exposing and thereby undoing one of the frames of reference that supported art – art publications. Today, Graham acknowledges that he was dependent upon one of the ideological beliefs of the 1960s: that exposing structures equalled liberating oneself from them. Indeed, one of the engines driving Conceptual art was this postulate of stripping bare establishment structures in order to dismantle them.[8]

Graham's response to the contradictions he encountered was at first to avoid the gallery structure altogether, instead buying advertising space in magazines. He sought to destabilize the socio-economic coordinates of a work of art, its mode of exhibition. Intervening in the very terrain of economic and social conditions, his magazine pieces brought together the conditions of the dispossession and re-appropriation of the work while cutting across them. Graham took the view that artistic work offered no socio-political solutions, but could pinpoint the artifice of ideological representation.[9] His work studied how artifice is produced, and sought to identify where and how the illusion is made. Starting with the

commodity status of the work of art, dependent upon reproduction, he responded to the closed, interdependent circuit between the galleries, art magazines, advertising financed by galleries, article and sale. He decided to focus on the advertisers, so that his interventions also found their way into marketing strategies. They embraced the sales circuit and its various modes of address with searing irony, culminating in a product that ended up on the printed page. Graham advocated irony and distantiation in the Brechtian sense: 'self-observation, an artful and artistic act of self-alienation'.[10]

Using derision in this way, Graham intervened within the codes of artists' representation. Magazines produce a place and frame of reference for identities. Each magazine has a specific style and tone, reflecting and coinciding with certain social categories. In contrast, Graham's conceptual works cut across the frontiers between art and communication, between identity and the stripping of identity.[11] Art magazines conventionally publish images of art works that have already been created; Graham's magazine interventions invert this process. Their public existence begins only at the moment when they appear in the magazines. In this way Graham exploited the presumption of *present* time and the instant disposability of newspapers. He aimed to annihilate the value system of gallery art and make a throwaway Pop art.[12] Through juxtaposition with the rest of the magazine his interventions were bound to a context that both supported and interfered with their meaning.[13] These works are impregnated as much with the experience of

listening to the music of The Kinks and The Rolling Stones, as to that of Terry Riley and La Monte Young. As Graham conceived it, each intervention undermined a conventional media format: a job ad,[14] the publication of diagrams,[15] an editorial, an advertisement.[16]

Figurative, one of the first works devised for a magazine, appeared in the fashion magazine *Harper's Bazaar* in 1968. It reproduces a cash register receipt, cut off at the top and bottom by the format of the page so that the figures do not add up to a final sum. The parodic title is lined up with the figures. As it happened, the notice

appeared in between an advertisement for Tampax, 'All by Yourself', and one for women's underwear: 'If nature didn't, Warner's will.' The artist's action became a signed advertisement, a form of registration for the artist drowned among other advertisements. Graham was transformed into a brand 'name'.

This relationship between the artistic action and the advertisement was to be more explicitly demonstrated in his last magazine intervention, Graham's *INCOME (Outflow) PIECE* (1969).[17] Labelled as a 'speculative work', it employed a kind of anarchic humour to interrogate the status and

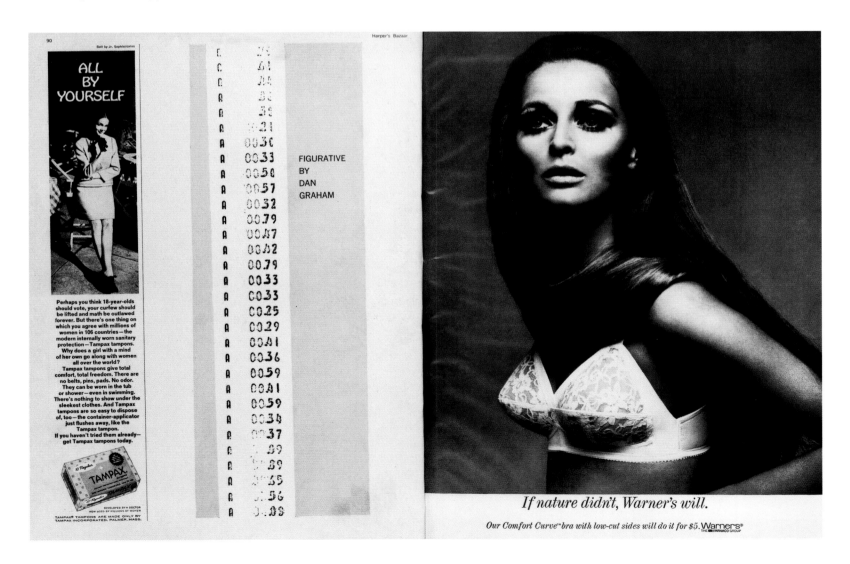

INCOME (Outflow) PIECE

This announcement is under no circumstances to be construed as an offer to sell or as a solicitation of an offer to buy any of these securities. The offering is made only by the Prospectus.

NEW ISSUE June 2, 1969

1,500 Shares

DAN GRAHAM INC.

Price $10 per share

Dan Graham Incorporated (underwriter)
84 Eldridge St., New York, N. Y. 10002
Phone (212) 925-3490

STATEMENT OF THE ARTIST EXHIBITED AT DWAN GALLERY, NEW YORK, "LANGUAGE III"

From April 2, 1969 I have been performing activities required to allow my placing legally an advertisement (termed a 'tombstone') in various magazines offering the prospectus describing a public offering of stock in *Dan Graham, Inc.* The 'object' (my motive) of this company will be to pay Dan Graham, myself, the salary of the average American citizen out of the pool of collected income from the stock's sale. All other income realized from the activities of Dan Graham beyond the amount *will be returned to the investors* in the form of dividends. I, Dan Graham, am to be the underwriter of the forthcoming issue. Advertisements, it is planned, will be placed sequentially in a number of contexts-magazines. These are divided into 'categories' as, first: "The Wall Street Journal" (then in this order), "Life", "Time", "Artforum", "Evergreen Review", "Vogue", "Psychology Today", "The Nation". My intention is to solicit responses to my and my company's motives from a spectrum of 'fields.' Such responses *might* range from: "Mr. Graham is attempting to create socialism out of capitalism" (*political* motive) or, "Mr. Graham is a sick exhibitionist" (*psychological* motive) or, "Mr. Graham is making art" (*aesthetic* motive) . . . all categories of meaningful information feedback. Categories of responses will define feedback in terms of motive. A sampling of responses in print would be printed as additional in-formation as the advertisements progressed in their appearances. Author and place the comments appeared would also be printed. In placing the comments of additional in-formation, I would be motivated solely to induce (through 'come-ons') the greatest response in terms of new stock buyers. The prospectus outlining the terms of the offering will also include a valuation of myself and past activities by a friend, an artist, an astrologer, and anthropologist, a doctor, and others. These individuals will each take a small percentage of shares of the stock in exchange for these services.

1. Money is no object, but a *motive,* a *modus vivendi,* a means to my support; the artist changes the homeostatic balance of his life (environment) support by re-relating the categories of *private* sector and *public* sector; a modus operandi, a social sign, a sign of the times, a personal locus of attention, a *shift* of the matter/energy balance *to mediating my needs* — the artist places himself as a situational vector to sustain his existence and projected future (further) activities in the world. Money is a service commodity: in come and out go while in-formation.

2. The artist will have as his object (*motive*):

a. to make *public* information on social motives and categorization whose structure upholds, reveals in its functioning, the socio-economic support system of media.

b. to support himself (as a service to himself).

c. for other persons to emulate his example and do the same.

reputation of artists, their relationship with the world of money – in other words, their dependency on the organized promotion of art. This is Graham establishing his persona within society. The artist-entrepreneur is reduced to a commodity, an investment open to speculation. In this pastiche, he advertised an offer of shares in the company 'Dan Graham Inc.' on the open market in a variety of specialist publications: *Wall Street Journal, Time, Life, Artforum, Evergreen Review, Vogue, Psychology Today, The Nation*.[18] Each share was offered at ten dollars. The goal of this company was to collect an average American's salary, which would then be paid to Graham. Any revenue produced by 'Dan Graham Inc.' above the calculated salary would be returned to the shareholders in the form of dividends. The notice also set out an evaluation of Graham's skills and his past activities, drawn up by a friend, an anthropologist, a doctor and an astrologer. In exchange for their efforts, they received a small percentage of the shares.

Cutting across the private and the public in a caustic and fictive mode, *INCOME (Outflow) PIECE* obeys the same marketing ploys adopted by artists who use themselves to promote their work in art magazines. The circuit of celebrity and publicity sets up this overlap, i.e. the artist, the work and the representation become one. The artist's fame within this system is an artificial creation of the media and the gallery. Graham challenged the myth of the celebrity artist produced by this circuit, a myth designed to obscure the facts.[19]

Other interventions on the printed page addressed spatial effects over time. These are optical matrices, which urge a reading through the constantly shifting eye, like a camera. *Scheme* (1965) shows a series of numbers, which appear together in two-line groups. The top line of each group is a repetition of the same number; the second line starts at zero and follows a numerical sequence until it shows as many numbers as there are digits in the line above. The visual outcome is a progressive enlargement of the page and of time in the form of a triangle, the base of which is the same width as the sheet of paper.[20] 'Scheme *was designed for use either as a page (to be truncated when the last line nears the base of the sheet of paper) or to be extended indefinitely in book form.*'[21]

Schema (1966) was intended for publication in different magazines. Covering a single page with a two-column list of elements, the intention was that it should be completed by different editors, according to the various elements of the printed page: the typography; the space; the number of adjectives, conjunctions, pronouns and adverbs; the quality of paper and ink. With the formulation of the syntax of the printed words literally defined by the words themselves, *Schema* lines up syntax as arithmetic. An attempt to inventory what is impossible to inventory, it also plays with the limits of formulating a system as such. Graham borrows its inconclusive character from the mathematician Kurt Gödel, whose theorum of incompleteness stated that within any system there are elements that cannot be proved.

II.

The first work in Graham's filmography is not a film but *Project for Slide Projector* (1966). This

INCOME (Outflow) PIECE
1969
Printed matter
54 × 43 cm

```
                    0
                    0

                 1     1
                 0     0

              2     2     2
              0     1     2

           3     3     3     3
           0     1     2     3

        4     4     4     4     4
        0     1     2     3     4

     5     5     5     5     5     5
     0     1     2     3     4     5

  6     6     6     6     6     6     6
  0     1     2     3     4     5     6

7  7  7  7  7  7  7  7
0  1  2  3  4  5  6  7

8  8  8  8  8  8  8  8  8
0  1  2  3  4  5  6  7  8

9  9  9  9  9  9  9  9  9  9
0  1  2  3  4  5  6  7  8  9

10 10 10 10 10 10 10 10 10 10 10
0  1  2  3  4  5  6  7  8  9  10

11 11 11 11 11 11 11 11 11 11 11 11
0  1  2  3  4  5  6  7  8  9  10 11

12 12 12 12 12 12 12 12 12 12 12 12 12
0  1  2  3  4  5  6  7  8  9  10 11 12

13 13 13 13 13 13 13 13 13 13 13 13 13 13
0  1  2  3  4  5  6  7  8  9  10 11 12 13
```

right, **Scheme**
1965
Printed matter
28 × 21.5 cm
Published as illustration in 'Quasi-Infinities and the Waning of Space' by Robert Smithson, *Arts Magazine*, New York, November, 1966

far right, **Scheme**
1965
Printed matter
28 × 21.5 cm
Project for book

opposite, **Project for Slide Projector**
1966
Typewritten pages
28 × 21.5 cm

dates from the same period as the New Jersey photographs. *'I was interested in the interface between speeded-up slide projection and film. It was like the photos for* Homes for America*, I wanted to do the same things that I saw in Minimal and Pop art in a flat, photographic situation. I wanted to re-do the modules of Larry Bell or Donald Judd as slide projections.'*[22]

Graham's immediate approach was to isolate a number of shimmering spaces and reduce them to a transparent, reflective volume. He combined this with speed and sequence. 'Project for Slide Projector *consists of a carousel slide projector which continuously projects a series of eighty slides. The slides were made by rotating a camera around the panes of a glass box. The depth of focus changes with each shot according to a fixed schema. On completion of a full rotation new glass panes are added onto the box structure.'*[23] This work addressed notions that would recur in Graham's work, continuity and transparency; rotating and dividing surfaces; the glass cube and the variable nature of luminosity; mirror and screen. In *Project for Slide Projector* (1966) light enters a translucent glass cube. Gradually, as layers of glass are added, the cube becomes more and more opaque, developing increasingly complex shimmering effects, both inside and outside, until the superimposed panes of glass become mirrors, producing an optical illusion. Seen as a stripping bare of photography's conventions, this device makes objects appear simultaneously solid and transparent.[24]

In his major essay 'Subject Matter' (1969)[25] Graham analyzed his encounters with the artists Richard Serra and Bruce Nauman, the filmmaker Michael Snow and the musician Steve Reich, and developed the idea of time as a continuum. 'So the entire article is a critique of the objectivity of Minimal art. I was more interested in subjective, time-based perceptual processes.'[26] His idea, at the antipodes of Minimal art, was to use the body directly as a medium.

Graham's films experiment with the interaction of time, movement and perceptions of the body, implicating the performer and the spectator in the same continuum. The flow of time is captured by the camera's movements,[27] used as an extension of corporeal identity, approaching the body from a variety of angles. The body is experienced through 360 degrees as an external curved surface with

neither right nor wrong side. Graham explored the dominant mathematical forms and symbols of the day: the spiral, the double helix, the symbol for infinity, the Möbius Strip. The question was how to allow corporeal and cinematic space to interact. Graham has said that he is indebted to Alfred Hitchcock's *Strangers on a Train* (1951)[28] for its use of dual points of view and the movement of the camera in rotation to express what the character is feeling. The resulting effect is a bodily identification with the character: a sensation in the viewer. Graham notes that his objective was the same as Hitchcock's, but with an additional idea: to demonstrate the position of the camera in space. With this purpose in mind, he doubled the space of representation: i.e., the subject is simultaneously looking and being looked at; the subject creates the film within the film. He would often evoke the work of Alain Robbe-Grillet, the films of Jean-Luc Godard, Michelangelo Antonioni and Petri, but most of all he would refer to the cinematic experiments of Michael Snow and Bruce Nauman. He was to analyze Andy Warhol's style of un-edited cinema: a camera filming continuously.[29] Instead of narrative cinema, Graham opted for time inside time, the double point of view and the source and direction of the subject's gaze in the drift of discontinuity.

Graham's first film, *Sunset to Sunrise* (1969), is a mocking return to landscape. At sunset, the camera moves in the opposite direction to the sun, spiralling upwards from the horizon to the zenith. The next day, at sunrise, the camera makes this same movement in reverse, spiralling down to the horizon. Thus, in Graham's world, the sun sets at dawn. A comic gloss on the power of the lens, this panoramic shot of the field of vision inverts the sun's natural course and the vector of time's arrow. It brings to mind the text work *March 31* (1966), which lists the distances between the limits of the known universe and the surface of the retina, like a tabulation.

Alfred Hitchcock
Strangers on a Train
1951
Film, 101 min., black and white, sound

PROJECT FOR SLIDE PROJECTOR

In December, 1966 I devised a project for 35 mm. transparencies and Carousel slide projector designed for exhibition space in-stallation: the Carousel slide projector as object; the message to be the mechanism of the medium in itself an object.

A Carousel slide projector is loaded with 80 slides which are projected on a screen every 5 seconds. The device is in continuous operation. The slides are of transparencies and mirror-images of transparencies which have been obtained in the following manner:

A structure is built utilizing 4 rectangular panes of glass joined to form a box with 4 sides. The top is open and the base is a mirror. A 35 mm. camera takes a shot on a parallel plane dir-ected dead on focused on the pane of glass forming one of the side planes of the box including nothing more beyond its edges in the periphery. Shot #2 is made similarly but of the next side of the box as one rotates clockwise and the lens focused further back - on a point inside the box. Shot #3 is focused further still, nearer the center of the box and an equal distance back from the first to the second one as the camera is aimed at the third side. #4 follows the same scheme, the focused point now at dead center of the box's interior.

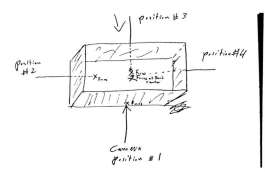

Next, 4 new panes are added to form a box, building up a mirror-ing perspective...

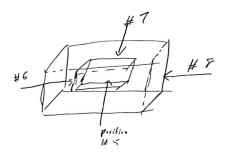

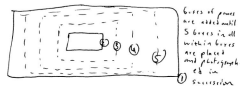

...and the rotation of shots proceeds around the box clockwise, the focus moving back in the same succession until in shot # 8 it has returned to its first position on the outer pane of the structure. This plan is followed as, from the inside, new boxes within boxes are added and photographed in sequence.

...20 shots are taken in all.

These shots as transparencies are copied 4 times. They are in-serted in the Carousel tray for projection in this fashion: the first 20 follow the order of the shooting outlined; the second 20 are flipped over (that is, placed in the tray flipped over in re-lation to the first series) in backwards sequence from the first 20; the next 20 are like the first 20 and the last 20 are like the second 20.

The image - the subject matter - is transparent, illusionistic (mirror) space, developed in cyclical 'movements'. The continuity of time present in the usual walk around the three dimensional ob-ject as well as that three dimensionality is presented 'in' (on) the screen - slide - sequence arbitrarily transposed to the order of the machine's movements; so the mechanics are the product or message....

Two types of movement, two types of space, two types of time relationship which come together in the movement of the struct-ure or mechanism - in its 'workings'.

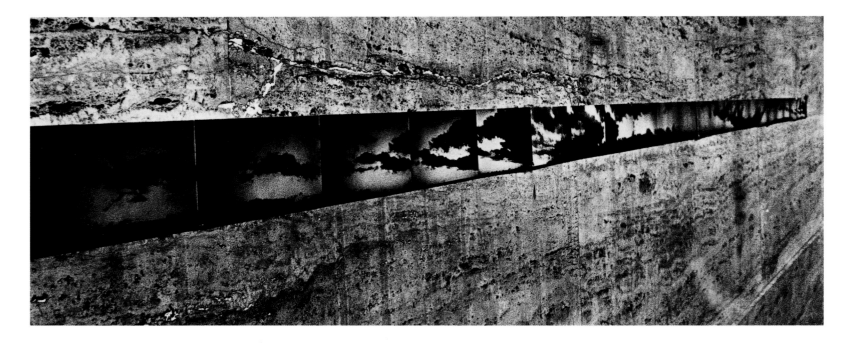

above, **Sunset to Sunrise**
1969
16 mm film, 5 min. 26 sec.,
colour, silent
160 photographs, l. approx. 244
cm

opposite, **March 31**
1966
Printed matter
28 × 21.5 cm

In order to explore uninterrupted movement, Graham doubles his point of focus. More often than not, his film work takes the form of two films projected on screens either facing each another or perpendicular to one another or overlapped on a single screen. *Two Correlated Rotations* (1969) consists of a pair of films projected onto two screens perpendicular to one another. In a room, two people are filming one another in a double-spiralling movement, one of them aiming towards the centre, the other towards the edges of the space. In this reciprocal spiral movement, the point of focus is on the other, reflecting the camera's perspective.

Roll (1970) also consists of two films, but these are projected onto a pair of facing screens. The first was filmed by Graham while rolling on the ground; the second was filmed by a camera placed on the ground, which documented the rolling body. Graham tried not to take his eyes off the fixed camera as he rolled across the room. A contrast emerged between the movement of the body on the floor and the fixed axis of the still camera; a dialogue was set up between static and moving space. The use of double screens and cameras and the movement of the performers, became a search for the axes of the field of representation, which were given physical substance even though in theory they are intangible. It is as if doubling could intercept and conjure up the precise cleavage and secret elision in time and space whereby the field of vision is maintained.

Binocular Zoom (1969–70) shows two films projected onto a single split screen. These were filmed by someone with two cameras, one in front of each eye. The two eyes split the sun they were filming and reduced its size according to the focal point of each lens. By doubling the camera (ordinarily a monocular device) Graham tested the effects of binocularity. The film emphasized the fact that the eye is always a double organ, a point of irradiation and itself a mirror.

Body Press (1970–72) consists of two colour films projected opposite one another on two closely set screens. A naked man and woman are positioned back-to-back in a cylinder lined with concave mirrors in which they can see themselves. The film consisted of a slow exploration of their

```
1,000,000,000,000,000,000,000,000.00000000 miles to edge of known universe
  100,000,000,000,000,000,000.00000000 miles to edge of galaxy (Milky Way)
              3,573,000,000.00000000 miles to edge of solar system (Pluto)
                       205.00000000 miles to Washington, D. C.
                         2.85000000 miles to Times Sq., New York City
                          .38600000 mlies to Union Sq. subway stop
                          .11820000 miles to corner of 14th St. and 1st Ave.
                          .00367000 miles to door of Apartment 1D,153 1st Ave
                          .00021600 miles to typewriter paper page
                          .00000700 miles to lens of glasses
                          .00000098 miles to cornea from retinal wall
```

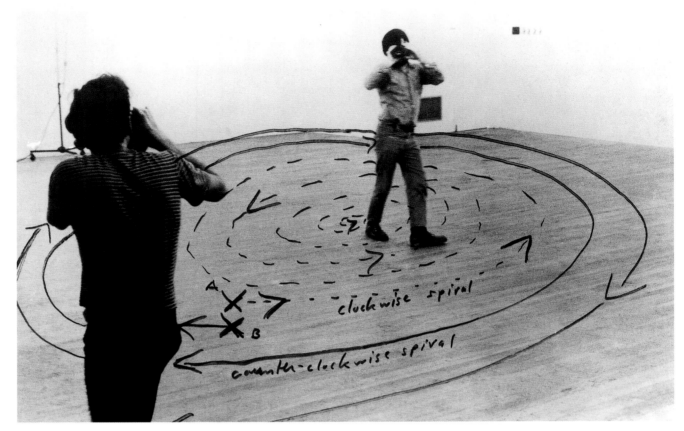

Two Correlated Rotations
1969
2 Super-8 films, 3 min., black and white, silent, to be projected simultaneously
Collection, Tate Gallery, London
'Two performers with camera's viewfinder to their eyes are each other's subjects (observed) as they are simultaneously each other's objects (observers) and subjects to each others' objects in the filming of each other; the process is a relation of dependent, reciprocal feedback.
'In the gallery, the spectator "sees" the feedback loop in a very close time between the cameras' recorded images: two object/subject "I's" in relation to his "I" on 2 screens at right angles to the other.
'The two cameramen spiral counter-directionally, the outside performer walking outwards while his opposite walks inside towards the centre. The filming ends when the inside performer approaches the inward limits of the centre of his spiral. As they walk their "objective" is as nearly as is possible to be continuously centring their camera's view on the position of the other. This is more complex at times for the inside performer who, in order to maintain a continuous view of the outer walker, would have to swivel his neck a complete 360 degrees. So it is necessary for him to shift at times his vantage from over one shoulder to over the other side of his neck (the movement of this seen in the film as a rapid, approximately 100-degree pan along the horizon line).'

bodies through the eye of the camera as they passed it to and fro behind their backs. Pressing and sliding, the camera climbed slowly up the body and down again. Capturing the bodies reflected in the mirror, it also captured itself. The film documented both a fusion and a fragmentation of the images of the body. By conjugating anamorphic effects, it announced the further explorations of mirrorings in Graham's work. It asked the question: to whom does this body belong?[30] In what process of identification or eroticization does the body of the spectator watching the film become involved?

III.

The performances of the 1960s and 1970s accompanied and expanded on the films. They provided a subtext that encompassed the philosophical and psycho-sociological models of their day: the psychology of consciousness, ethology, phenomenology, states of modified consciousness, the cybernetic theory of mass media, drug-induced experiences, meditation techniques and feminism's critique of patriarchal society. The belief in some communitarian ideal also played a part. Graham makes it plain that he was interested in both the utopias of the age and in experimental psychology.[31]

He has also stated that his interest in rock music is fundamental to his performances.[32] Like the rock star, Graham gives priority to the here and now, to the presence of the eroticized body. Nonetheless his performances elaborated on the setting up of a simple structure: the performer, the space in which he acts, the audience. The point, made explicit in the essay 'Subject Matter', was to transform the common space between viewer and performer. Many of Graham's films and

performances came into being while he was teaching at the Nova Scotia College of Art and Design, and were put together in a relationship with the audience. In Graham's words, these are 'models to define the limits of an idea of representation as the conventional limits which necessarily define the situation between the artist and spectator'.[33]

The first performance of *Lax/Relax* goes back to 1969. Graham stood on a stage facing the audience and talked to a pre-recorded tape. The tape emitted the sound of a female voice which at intervals repeated the word 'lax'. Graham answered speaking into a microphone repeating the word 'relax'. His voice and breathing became alternately louder or fainter, playing with the eroticization of the voice. Distinct at the start, the voices and breath of the man and woman became increasingly undifferentiated until they merged. Graham claimed that *Lax/Relax* was related to the post-hippie ideas of the time. The word 'relax' was positive, connecting to being at ease, while in contrast the word 'lax' was a negative word, imbued with puritanical connotations of laziness or indifference. *'One cannot be lax (relaxed), nonchalant, without concentration. In addition it has both feminine and masculine overtones. In my opinion American culture has always been very puritanical when things should be positive. Relaxed and positive, although lax (not paying attention) carries a moral judgement.'[34]*

The performances stage the register of reflection and reciprocity, specularity and complementarity. *Likes* (1972) is a play on echoing words. In a doubling that is visual as well as aural,

a couple attempt to persuade one another that they are alike. Everything is a mirror, provided that some correspondence is established within the space between two fixed points. In *Past Future Split Attention* (1972), recorded on video, one performer predicts the behaviour of another, who in turn copies it. There is a double form of mimicry through the play on the spoken word. A time delay is created by swapping near future and recent past; the performers become mirrors. In his performances, Graham experimented with different temporal modes of perception and interaction,[35] however there was nonetheless a risk of falling into a kind of theatricality through his stress on repetition and anticipation. Graham's

Binocular Zoom (Parallax, Distance between the Eyes, 'Distance')
1969–70
2 Super-8 films, 1 min., black and white, silent, to be projected simultaneously
'Two Super-8 cameras with identical zoom lenses are placed with the viewfinder flush to each of my eyes. Each of the cameras' images are focused on the sun somewhat obscured by a cloudy sky. The image of each camera corresponds to the double retinal images of the right and left eyes. Filming begins with both cameras simultaneously. Initially, the images synchronously are extreme close-up views – maximum disparity between the right and the left images being caused as they "halve" the sun. The two zoom lenses open their respective fields of view at the same rate until reaching their fullest extent. Both images diminish in size to a "distance".
'In viewing, the films made by the two cameras are simultaneously projected on adjacent, "split screens".'

right, **Lax/Relax**
1969
Performance, Lisson Gallery,
London
'A girl is instructed to say the
word … "lax" … to herself and
then to breath in and out, then to
repeat the word … and to
continue this pattern for thirty
minutes. This is tape-recorded.
The girl may be hypnotizing
herself.
'In front of a live audience, I say
the word … "relax" … to myself,
breath in an out, then repeat this
pattern for the length of time of
the recorded girl's voice tape. I
speak into a microphone
connected for amplification to a
tape recorder whose self-
contained speakers are playing
(on one side) the girl's pre-
recorded voice and (on the other
side) my voice. Through
absorption, the girl's recorded
voice and my voice are tending in
vocal intonation and in my body's
posture to "identify" with our
particular phrase.
'In the initial stages of
performance my awareness is
focused upon: myself (self-
relation), the voice of (and my
relation to) the girl, and the
audience's responses. My initial
outward responses, my timing and
phrasing, reflect my
consciousness of all three inputs.
But as I concentrate, gradually my
awareness shifts to only myself
and relating to the girl's voice;
then finally I am centred in only
self-absorption.
'The performance begins with
both words spoken in phase: the
breathing reflects my (and the
girl's) "distance" as the words
move in and out of phase with
irregular breathing modules; as
the piece continues and the
breathing regularizes in phase.
'The audience may become
involved in its own breathing
responses and thus locate the
surface of its involvement; its
attention is somewhere between
"inside" my breathing and its
relation to the girl's or its own
breathing. It may become
hypnotically affected.'

opposite, **Likes**
1967–69
A proposal for *Aspen*
Published in *Halifax Mall-Star,* 11
October, 1969
Designed by George Maciunas

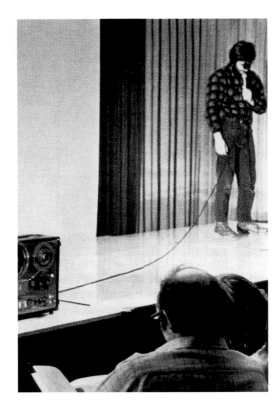

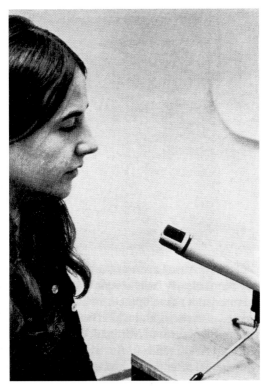

works challenged the petrified omnipresence of
the artist, the mediatized spectacle of *his* image as
artist-hero, aiming to set himself apart from
artistic dramatization, to steer clear of the
charismatic image projected most notably by
Joseph Beuys in his performances. In relation to
this, Graham's sharp analysis of Dean Martin,[36] the
American actor and singer of the 1950s and 1960s,
stresses the extent to which Martin points out the
duplicity of the role he is playing, and the lengths
to which he will go to encourage complicity with
his audience.

In *Performer/Audience/Mirror* (1977), Graham
stood in front of a real mirror, which effectively
doubled the space of the stage. Facing the
audience he used direct address, speaking in a
descriptive mode that combined phenomenology
with the style of sports commentary.[37] The
performance was divided into four 5-minute slots.
First, the artist described himself; then he
described the audience; then, turning towards the

mirror, he gave an account of his image; followed
by an analysis of the reflected image of the
audience. This experiment prefigured Graham's
later discovery of the two-way mirror and the
multiple uses he made of it. In *Performer/
Audience/Mirror,* descriptive speech is
supplemented by yet another – silent –
information mechanism: the mirror. The audience
sees itself and in turn becomes a mirror. In these
doublings and repetitions, present time is
simultaneously expanded and experienced in all its
fleetingness. The urge to hold on to the present
underlying the performance is a *de facto*
demonstration that the present cannot be pinned
down. Moreover, once the description has been
made, the spectators have an idea of themselves
as a group, as a social body. *'So it was the social
group that I was giving them that was continuous
and then they could look at themselves and see
themselves in another social group as a portrait.
That also goes back to the Renaissance idea of the*

minute rush and
on Wednesday.
paper and heard
ral Manager Bill
and cleaning in
ossible on Wed-

e important job.
erstanding about
re Parkade. I've
at the basic rate
That is wrong:

... 15c
... 25c
... 40c
... 50c
urs 65c.

Parkdale for two
r each additional
hours, the charge
m. So, if your car
hours the charge

king in the park-

o driving around
spot on the street
c an hour with a

s to the shopping
The rain won't
low you, the sun

elements . . . one
ls to me, is that
when I slide onto
an oven on a hot
ted from the rays

ut so-called free
better and I hope
ys for paving the
w? acquiring the

t things that are
then. Now it's me

. a growing living
d of Shopping, of
. . . A city within

R BIG

ENING

She instructed her children,
ages five, seven and ten, to
walk on lawns — which are
city property — instead of the
roadway, "but people just
chase them off."

The question of sodding the
portion of land from the street
to the property line in place
of sidewalks outside city
homes was the subject of dis-
cussion earlier this week at a
meeting of the Dartmouth
town planning board.

Ald. Daniel Brownlow said
the city was not in the finan-
cial position to install paved
sidewalks. Ald. L. W. Gran-
field said the time was com-
ing when the city would only
install sidewalks where there
was a definite hazard to
children.

The matter was referred to
the city clerk and engineering
department for a detailed
study.

No accidents involving
children have occurred as yet
in the Mount Edward Road -
Spring Avenue area, said
Mrs. Dewar, "but we've had
a few near misses."

Irving Keddy spent part
of yesterday "just painting
around." His job was to

mental fence around Christ
Church Cemetery, Park
Avenue. A car had dam-

when it rolled from its
parked position on Victoria
Road. (Horner)

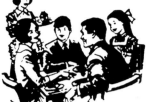

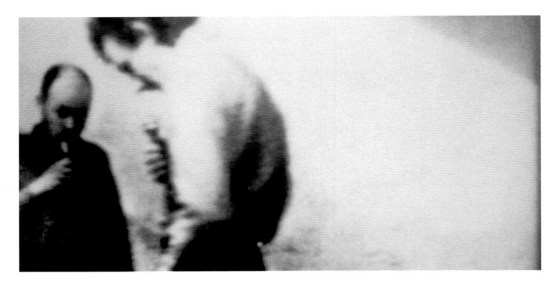

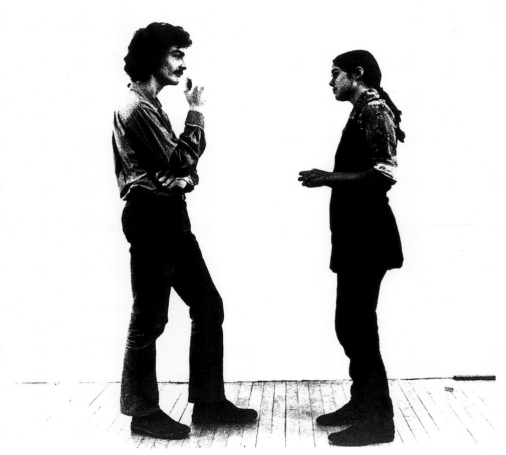

One person predicts continuously **the** other person's future behavior; while the oth er person recalls (by memory) his opposite's past be-havior.

Both are in the present so knowledge of the past is needed to con-tinuous deduce future behavior (in terms of causal relation). For one to see the other in terms of present attention there is a mirror-relflection (of past/future) cross of effect(s). Both's behavior be-ing reciprocally dependent on the other, each's information of his moves is seen in part as a reflection of the effect their just past behavior has had in reversed tense as the other's views of himself. For the performance to proceed, a simultaneous, but doubled attent-ion of the first performer's 'self' in relation to the other('s im-pressions) must be maintained by him. This effects cause and effect direction. The two's activity is joined by numerous loops of feed-back ⟵⟶ and feedahead words and behavior.

portrait.[38] In Graham's works, the time frame of the traditional Renaissance portrait shifts, to exist in the recent past (through feedback) and in cybernetic space.[39] The image is integrated with what impacts upon it: duration and movement.

IV.

Graham's films and performances were gradually replaced by video installations. These interacted between the vantage point of the window, the mirror and the video – the visual transmission across these. The use of mirrors and glass as wall, spatial divider and screen could create a single, double or triple space. Sometimes Graham split sound with the gaze; with voices; with time and place. What existed before, during and after became spatial. What was behind me faces me; it appears and disappears. Elements in the recent past return as time supplements the image. For Graham, video made it possible to invert the model of the mirror. By recording images of bodies and their movements displaced in time, by doubling surfaces through reflection, his installations crystallized the fact that the position of the subject depends fundamentally upon a field given by another, by a field of fiction. Instantaneous video replay produces a fictionalization of the present. The system of projection itself was made clearly apparent. Video in the 1970s was not digital; experiments using time delay were limited by the mechanical processes of the equipment. The progression of a motif, its repetition at 6- or 7-second intervals, produced the simultaneity of two time levels: internal time and an extended present. The process of perception assumed a presence in

itself.[40] Graham also experimented with musical feedback; he provoked the experience of being inside the optical process and its visual plane in exactly the same way that one may experience being inside the production of sound and its materiality. He created a tension between architecture, sound and vision.

The technique of recording with time delay and feedback was deployed for the first time in 1974 with *Present Continuous Past(s)*.[41] This was a paradigmatic work, which led to other video installations. The audience is at the centre of the installation, in a constructed space in which two adjacent walls are covered with mirrors. The third wall supports a video camera mounted above a monitor; the camera records the spatial field and the mirror reflections in real-time; the monitor displays the recorded images after an 8-second time delay. The spectators see an image of themselves as it was recorded 8 seconds previously on the video monitor. At the same time they see a reflected image in the mirror, of themselves, their surroundings and what is taking place on the monitor. In the present moment, spectators can perceive the movements they performed 8 seconds earlier, and the image of themselves mirrored at different angles. They can see the moment and the displacement of time simultaneously. By spatializing time, Graham creates a space within space. It is a play of convergences on the perception of the specular image and short-term memory, the images of oneself and others producing a replay of an immediate past that appears inexhaustible. The interval, which is both a gap in time and a gap in identity, becomes

simultaneously established and cancelled out.

Graham operates by a principle of union and disunion. He multiplies pathways in time, which is no longer linear but exists in a loop. The installation contrasts the experience of two different systems of visual capturing: the static image in the mirror and the fluid video image. By juxtaposing them, the artist gives materiality to the impalpable gap between an illusory totalization and its dissolution. The installation highlights the experience of looking/participating in a retroactive video loop, isolating the peculiar link between an active and passive state. The work tests the subject's division – the split between the eye and the gaze.[42] Through repetition, Graham locks the spectator into the fiction of a closed and self-contained time loop where everything is retained, recorded and controlled, producing a distinct unease in the viewer. What the work sets out is that there is no possible experience of one's own self that is not mediated. These installations construct paradoxical metaphors for the impossibility of immediate presence.[43]

Developing the idea of doubling and inversion further, Graham began subdividing the installation space. The seven *Time Delay Rooms,* also made in 1974, expand the range and complexity of *Present Continuous Past(s)*.[44] These are installations without mirrors, which consist of either two or three spaces, sometimes using a performer. The audience is always at the heart of the installation. The artist joins, disjoins and inverts two modes of perception: immediate perception, and the deferred perception of recorded images and sounds. These *Time Delay Rooms* effect mirrorings,

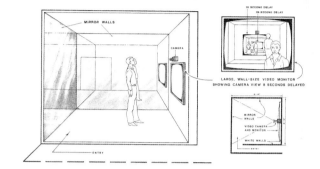

opposite, **Past Future/Split Attention**
1972
Performance, Lisson Gallery, London

above, **Present Continuous Past(s)**
1974
Installation diagram with artist's notes

following pages, **Present Continuous Past(s)**
1974
Two-way mirror, 1 black and white monitor, 1 black and white zoom camera, 1 microprocessor
Mirror, 320 × 320 × 279.5 cm
Monitor, 30 × 40.5 cm
Installation, John Gibson Gallery, New York, 1975
Collection, Musée National d'Art Moderne, Centre Georges Pompidou, Paris

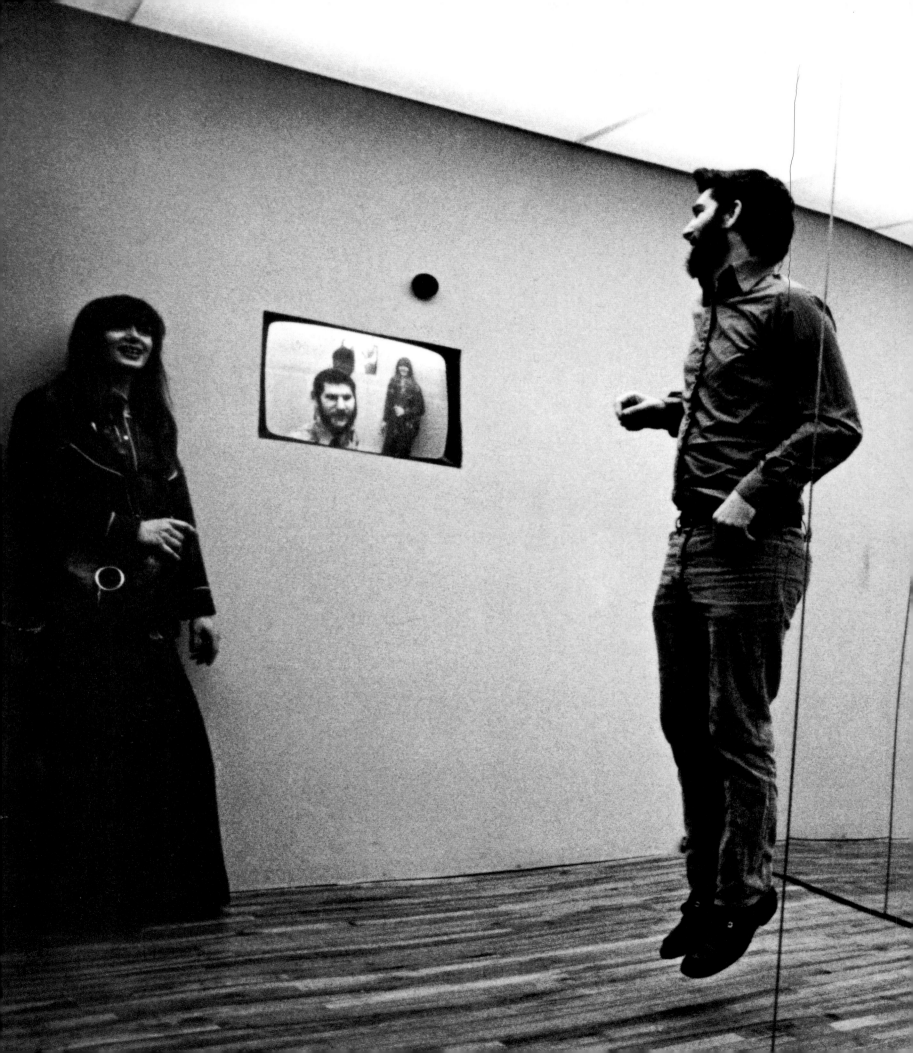

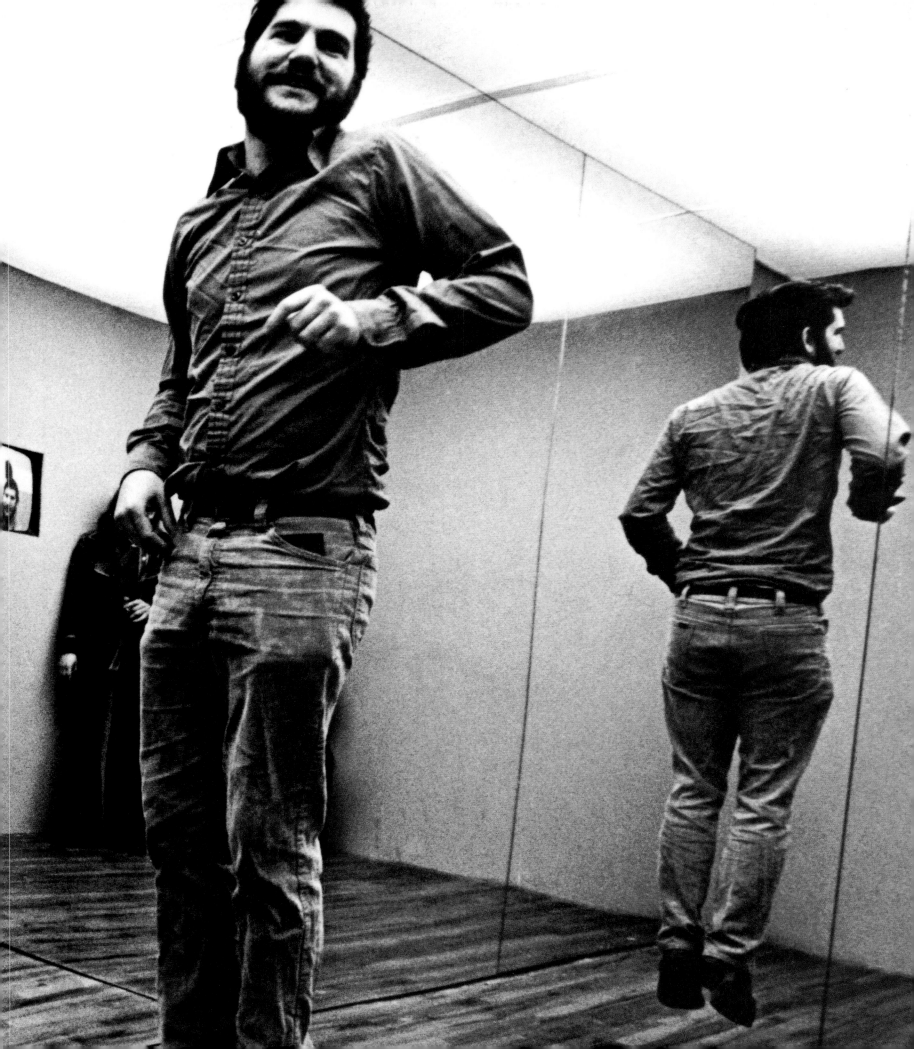

Time Delay Rooms No. 6
1974
Installation diagram
'The Audience (A or B) first sees itself as it is seen and described by the Performer. Second, later in time, and delayed by 8 seconds, it sees itself as it is seen by the other Audience.

'Audience B sees Audience A on Monitor 1, which also shows them the view of 8 seconds earlier seen by Audience B on their monitor. Audience A cannot see itself on a present time monitor. It hears the performer's live description of its behaviour 8 seconds before seeing it.

'Audience B sees Audience A on an 8-second delay on Monitor 1 and sees Audience A's monitor view of them, Audience B, 8 seconds delayed. Audience B cannot see itself on a present-time monitor. It hears and responds to the Performer's live description of its behaviour 8 seconds before seeing it. Audience A also hears and responds to this. Audience B hears how it is affected by the responses of Audience A and of the Performer.

'The Performer, seeing both audiences live, alternates between describing one or other's behavioural reactions. He follows this by describing how Audience A affects Audience B and *vice versa* and how the Performer affects Audience A and Audience B. Relations and effects described by the performer anticipate the audience's experience of the connections.'

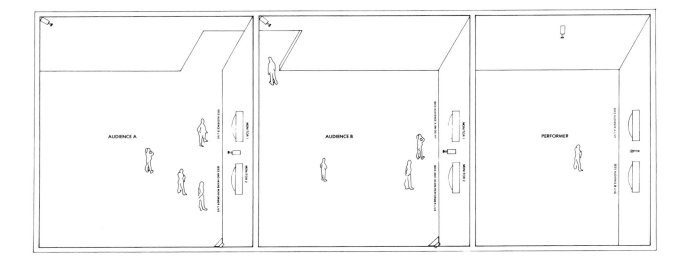

drawing attention to the mechanisms of surveillance, intrusion and alienation. Who is controlling whom: the performer or the audience? What delay is involved in the transmission of information?

Graham's video installations produce specific forms of spatial organization, which redistribute visibility and invisibility, access and non-access. These installations demonstrate that in the architectural ordering of space and in the views and accessibilities resulting from that order, these are privileged places. That is, a hierarchy is created, resulting in prioritized spaces and a sense of subordination – more or less internalized – in the visitor. The *Time Delay Rooms* make ostentatious play with the co-ordinates of a form of domination by means of watching: mechanisms of control, of self-control and reciprocal control. By provoking the redundancy, inversion and equalization of these mechanisms, Graham's works parody and cancel out the controlling impact of their power.

The video installations are directly linked to architecture, to social space as it structures and assigns people's roles, reactions and positions.[45]

First presented at the John Gibson Gallery in New York, it was in these terms that the installation *Yesterday/Today* (1975)[46] set up an intersection and displacement between two institutional spaces: the exhibition room and the semi-private office of the gallery owner. The work played upon the division and return of displaced givens. In the exhibition space a video monitor transmitted in real time the soundless images of what was going on in the gallery-owner's office. A loudspeaker attached to the live video image broadcasted the conversations recorded in his office twenty-four hours earlier. Thus Graham inverted the situation whereby it is the gallery owner who avails themselves of video observation. What once took place backstage on the business front came to the fore, becoming visible in the exhibition space. While a temporal dissociation was brought about on the acoustic level, at the visual level the two separate spaces were combined in real time. Graham joined and separated the two recordings: yesterday was reduced to sound and returned today; today was reduced to images. Graham broke up instantaneity in the same spirit as Godard, overlapping the images of the present with a

soundtrack from the past. This double intersection gave access to what was neither visible nor audible, given that the two spaces were split; it was like eavesdropping on the institution. Video is therefore linked to architecture and to the information that it can or cannot transmit. This work, which has been installed many times principally in museum cafeterias, is always relative to the art world. Graham has nicknamed it 'an institutional soap opera'.

The installation *Video Piece for Shop Windows in an Arcade* (1978)[47] is a more complex investigation into the effects of illusion. The work displays the interaction between the frame, the expected view, the optical focus and the vanishing point in two shop window displays. Using two department store windows which faced each other across a corridor in a shopping arcade in Groningen, The Netherlands, Graham placed mirrors against the back walls behind the window displays and parallel to the window panes. He installed a video camera in each display, opposite one another. The reflective glass wall of the window frontage created a further plane of reflection. The shop window with its merchandise is a small theatre, a view within a view. In this stage device, Graham set up a transfer, a proliferation of spectacular images. The window display and its mirrors captured what was outside, in front of it. The passer-by saw his/her own image fragmented by the displayed merchandise. The viewer's reflection in the glass window was also faintly visible, superimposed on the merchandise behind the vitrine. An additional layer of reflection was provided by the facade of the shop on the other side of the corridor. The flux of shifting reflections, of close and distant images, of objects and bodies, amplified the viewer's sense of alienation and incompleteness. The constant interchange of different reflections from both inside and outside the vitrine introduced a yawning gap, an insecurity about the image. There was no pre-established harmony or order, no certainty, just lack. By separating out the specific relationship of alienating tension from the image of oneself, Graham aimed to pinpoint the effect of imaginary subordination and induced inertia, the fallacious quest for plenitude.

V.

Further pursuing his contemplation of the conventions of the optical and its effects on inter-subjectivity, Graham produced *Public Space/Two Audiences* (1976)[48] for the 37th Venice Biennale. He isolated the relationship between a glass wall and a mirrored wall, producing a deceptive space in which the sense of mirage and incompleteness is exacerbated. Connecting art, shop window and exhibition pavilion, Graham conceived the institution – the Venice Biennale – as a shop window displaying the artistic currents of the day. Each country's exhibit can be seen as a shop window of its nation's culture, and its artists use the designated spaces as shop windows for their work.

Public Space/Two Audiences is organized as a golden rectangle divided in two by a sound-proofed glass partition. The wall parallel to the glass partition in one of the spaces is a mirror, while in the other it is an ordinary white wall.

Yesterday/Today
1975
Video camera, black and white monitor, microphones, audio
First installed, John Gibson Gallery, New York
Collection, Stedelijk Van Abbemuseum, Eindhoven

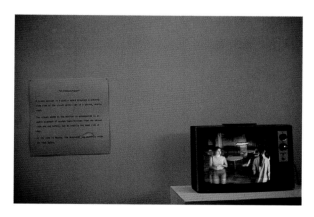

right and opposite, **Video Piece for Shop Windows in an Arcade**
1978
Installation diagram

opposite, **Video Piece for Shop Windows in an Arcade**
1978
Mirrors, TV monitors, vdeo cameras
Dimensions variable
Installation, Groningen, The Netherlands

VIDEO PIECE FOR SHOP WINDOWS IN AN ARCADE

There are separate entrances to the two spaces; the two audiences are exposed to one another as if displayed in a shop window. In the double space, divided by sound-proofed glass which produces ghost reflections, the audiences become the silent mirror of one another, a soundless perception. This extremely simple installation, which has no technical devices, nevertheless demonstrates complex relationships between self and other, between the image of the other and of oneself. The reciprocity produced by the transparent division involves an asymmetry of perspective; depending on whether the viewer was in the white-walled space or in the space with the mirror, there was an alteration of perception. Visual proximity, the direction in which the visitors are more or less compelled to look, the degrees of reflectiveness and sharpness of the images in the glass and in the mirror are altered. These interactions set up strange inversions and equivalences between visual proximity and distance. The *mise-en-scène* pointed to the supports on which this mode of transmission operated, and the reciprocity to which these supports were urged and compelled. Viewers could see themselves as a body that is not static but caught in a process of flux. Graham reduced unity; the addition of strange visibilities and reflections once more highlights the modes of specular misrecognition, the mechanisms of an alteration.

The artist has said that *Public Space/Two Audiences* is a homage to Mies van der Rohe and to El Lissitzky's double spatial displays. The sound-proofed glass partition also refers to specific social realities such as airport control towers, customs areas and children's nurseries. The materials – glass and mirror – work on an aesthetic level as well as on the functional and social level of intrusion and surveillance. Graham's proposition which is 'not completely abstract nor completely

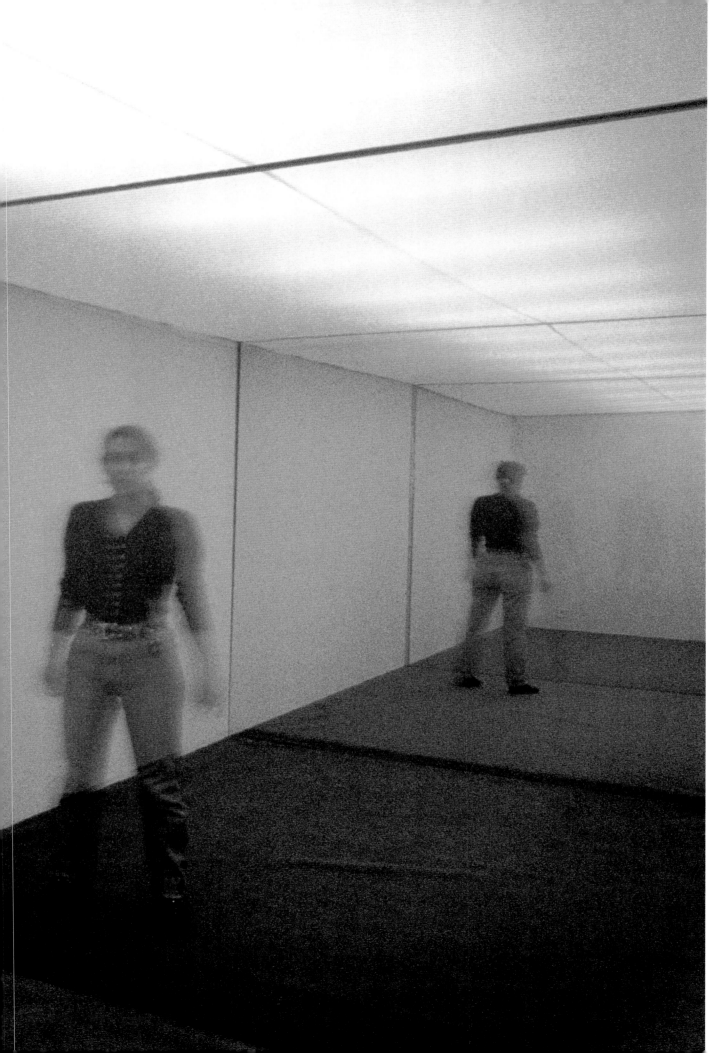

Public Space/Two Audiences
1976
Acousta-Pane glass, mirror, wood,
paint, muslin, fluorescent lights
305 × 701 × 289.5 cm
Installation, 'Arte Ambiente',
XXXVII Venice Biennale
'The piece is one of many
pavilions located in the
"ambiente" at the 1976
International art Venice Biennale
with a large and anonymous
public in attendance.
'Spectators can enter either of
two rooms.
'Through the utilization of the
sound-insulations glass divider,
each audience can see the other
audience's visual behaviour; at
the same time each audience is
made more aware of their own
verbal articulation.'

material' can be seen as a critical response to Minimalist art and the environments of West Coast artists such as Robert Irwin and Maria Nordman, who exploit the psychological effects of light.[49]

VI.

Public Space/Two Audiences is a pivotal work. It presents the first architectural model in Graham's output, as he left installation behind and opened up the white cube. He began to realize that the cube, already transformed by the mirror, could be further transformed if the white wall in the second room were removed and turned into a window. His idea, 'to open up one, the white side and make that into a glass sliding door'[50] became a kind of architectural displacement.[51] This premise led to the model for *Alteration to a Suburban House* (1978), which transformed a suburban house into a shop window. Graham replaced the entire facade with a glass panel and replaced the back wall of the front room with a mirror. The maquette was not only reminiscent of Dutch Calvinist architecture, but also of the picture windows of American ranch houses – large panoramic windows at the front of the building, which is separated from a more private area at the back. It also brought to mind the architects Richard Neutra and Rudolf Schindler, who had made the first designs with facades of sliding glass. Since the 1950s the picture window has become standard in architecture, and Graham suggests that he just reproduced this enlargement.

By fitting his model with a mirror parallel to the glass facade, the artist seemingly places the inside on the outside and doubles the reflection. The occupants and their surroundings are displayed as if in a shop window, but so are the passers-by and the external environment. In the mirror, the facades opposite are seen anew. The family, the passers-by, the street and the outside setting are all displayed along with their reflection, their descriptive image. Everything turns into decor. 'One could also see the cut-away facade as a metaphorical billboard.'[52]

The apparent fusion of interior and exterior heightens the relationships of inclusion and exclusion. The sense of being shut out is made even more obvious to the passers-by since they see themselves reflected inside. For the house's occupant, shelter and separateness from the outside will be annihilated in a never-ending flux of reflections and relentless social exposure.

Graham had in mind a combination of antithetical references to the architects Robert Venturi and Mies. *'Venturi's houses often inflect towards details of surrounding, already existing vernacular architecture and incorporate into their compositions the signs and symbolism of these nearby buildings, rather than mere semiotic allusion to surrounding vernacular architecture.'*[53] *Alteration to a Suburban House* is also an ironic reduction of the glass houses designed by Mies and Philip Johnson, in both of which the merging of interior and exterior brings about an optical fusion with nature. But what is a testament to the privileges of a patriarchal property, transparent and standing on its own in parkland, is nothing more than savage cruelty to its inhabitants on display within a suburban environment. Transparency creates a spectacle, a piece of stage scenery, a studio set-up.[54]

The status of the models has varied within Graham's work as a whole.[55] As tools for thinking, they play a part in the emergence of the work. Graham has also said that he decided to use architectural models as a publicity device to bring in commissions. They are located somewhere between art and architecture. Seen as art, they are sculptures, filmic fantasies, utopias; seen as architecture, they could become real buildings, but, once functional, they require adaptation to use, debate with a collective. The models are often accompanied by texts, suggesting that there is a difference between making his ideas tangible and visual, even in miniature form, and describing them in writing. Giving his ideas concrete form in a model stirs various playful resonances, memories, reveries and a distancing force.

Further investigation into generating illusion led Graham to devise the model *Cinema* in 1981,[56] which he called a utopian metaphor. It is a system of screens at once reflective and porous. The cinema auditorium is placed on the ground floor of a two-way mirror office building set at the corner of two streets. The two sides of the cinema which face the street are made of two-way mirror glass, and the screen, placed diagonally at the corner, is a two-way surface, which allows passers-by to see through the dark areas of the screen's filmic image to the spectators inside. The materials, both transparent and reflective, produce double meanings; the architectural boundaries are rendered permeable. The phenomenon of seeing and being seen in the course of seeing or not seeing is amplified.

Interrogating the interaction between architecture as a system of screens and a technology of created illusions, Graham imagines two possibilities: either the film is projected in darkness, or the lights are on. When the film is projected, it can be seen both by the spectators and passers-by, but the latter will not be able to hear it. They will see the reverse image of the film through the areas of shifting transparency on the screen. An interface of screens, transparencies, visions and contexts is thus made and un-made.

If the film is not being projected and the lights are on, the screen and the lateral walls of semi-reflecting glass become mirrors, which reflect the curve of seats to form an amphitheatre. As if trapped inside a window display, spectators can see their own reflected image and that of others, together with their respective positions in relation to each other. Through this reflective reverberation between the specular images of bodies and the real bodies, Graham accentuates the interaction and division between places and their transitives. Everything that is strictly speaking illusory, is not subjective; there is a perfectly objective and objectifiable illusionism.

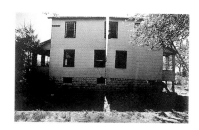

above, **Gordon Matta-Clark**
Splitting
1974
Documentary photograph
322 Humphrey Street, Englewood,
New Jersey

below, **Matta-Clark Museum**
(Model), with Marie-Paul
MacDonald
1984
Cardboard
7 parts, 50 × 30.5 × 51 cm
1 part, 50 × 30.5 × 72 cm
Collection, Le Consortium, Dijon

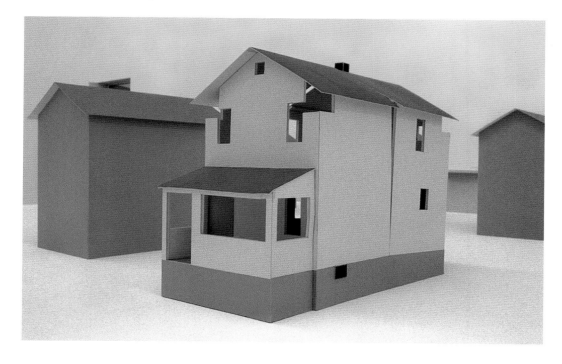

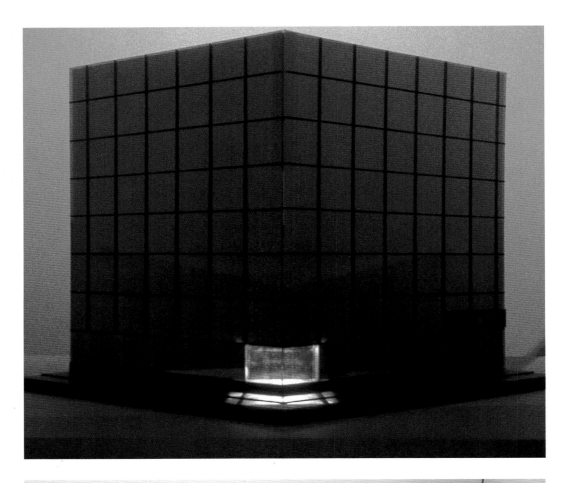

Unlike Johannes Duiker's transparent Cinema (1934), which urged the passer-by to look with scientific eyes in order to uncover the mechanism that produces cinema, Graham places the emphasis not on the machine but on the screen and the system of identification, projection and illusion triggered by films – the play of reflections. How is the passage from specularity to the elusive double pinned down? Graham's *Cinema* correlates the different paradigms of the optical mechanism, the window display, the facade and the screen. The uninformed spectator can read the cinema screen as illuminated advertising, as something fluid, or as a video-surveillance screen.

Five years later Graham produced *Cinema/ Theater*,[57] combining the *Cinema* model with a baroque garden theatre. In the model, the two architectures are joined and separated by a common partition of mirrored glass. On the cinema side, it forms the screen; on the theatre side, a backdrop. The project includes the screening of an extract from Roberto Rossellini's film *The Rise of Louis XIV* (1966), in which the King is walking around the gardens at Versailles surrounded by his court. The King orchestrates a theatre of absolute power in which he is the chief protagonist. The guests in their turn play out a role as metaphors for the rest of world. Graham pointed out the mutation of representation of power, noting that today's legitimation of power comes about through the imperative of entertainment. Television, cinema and culture as an industry have modified the status and impact of images. Authority is linked to propaganda.[58]

Cinema/Theater is supplemented by a

suggestive analysis of analogies. Historically the garden existed in a scenic dimension and contained one or more theatres, which themselves held garden decors replicating the landscape of shrubs, box hedges, rocks, fountains and statues. Formal gardens, like theatres and later cinemas, are conceived like a set design. According to Graham, *Cinema/Theater* refers both to European culture and history – Renaissance gardens, Italian and French baroque and rococo gardens, English country gardens, city parks of the nineteenth century, as well as modern ones such as Parc de la Villette in Paris – and to American culture – Hollywood cinema and special effects, science fiction and theme parks such as Disneyland. The perspective of representation within representation is one of Graham's driving notions: to create a view within a view, a decor within a decor. The reflective work he constructs aims to actualize a 'theatre of memory'. In his models and his glass and mirror architecture works, Graham picks up and overturns the alienating representation of daily life brought into being by artifice, illusion and decor. His models dissect and re-join frontiers and excisions. They retrace the

divisions of nature/culture and major/minor, which define spaces, reference points and the shared symbolic fabric.

VII.
What happens if instead of the white cube or the window display, the work becomes a small-scale solid with all its surfaces transparent – a glass cube? The result is a reduction, a reflexive glass structure, an abridgement – what Graham calls a pavilion – a basic construction that allows him to focus on a topology of projection.

Pavilion/Sculpture for Argonne was built in Chicago in 1981 from a maquette made in 1978.[59] It was the first of Graham's pavilions to be constructed in a public space, and generically condenses the lexicon of the later pavilions. The square base is divided diagonally by a panel of transparent glass, resulting in two equal triangular units. These spaces are continuous and contiguous as well as mirror images of one another; they can be experienced from the inside as well as from the outside. They simultaneously integrate and exclude.[60] The walls are a combination of back-to-back mirrors, transparent glass and openings. The

opposite, **Cinema** (Model)
1981
Two-way plastic mirror, Super-8 projector, Super-8 film, Plexiglas
$61 \times 57 \times 57$ cm
Collection, Musée National d'Art Moderne, Centre Georges Pompidou, Paris

above, **Johannes Duiker**
Cinema
1934
Amsterdam

left, **Cinema/Theater** (Model)
1989
Wood, two-way mirror Plexiglas, two-way mirror mylar
$60 \times 120 \times 200$ cm

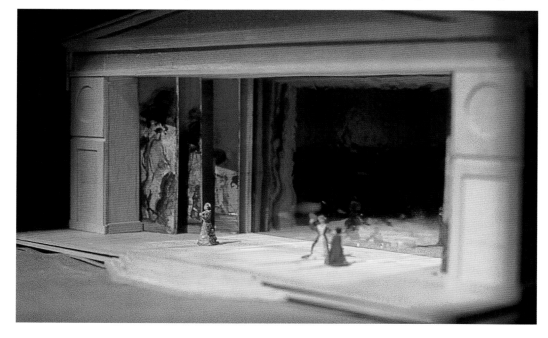

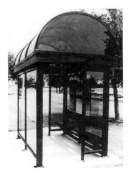

Marc-Antoine Laugier
Primitive hut from *Essai sur
l'architecture*
1753

Bus shelter
c. 1985

reflections in the mirror and glass are subject to constant variations of light, which cause the walls to become alternately transparent, reflective and opaque. So the continuous and contiguous spaces are also reversible.

Graham's video work had allowed the experience of deferred time and the disjunction between time and place, while his performances had centred on the reciprocity between the performer and the audience. With the pavilions, the discovery of double-sided, semi-reflective, semi-transparent mirrored surfaces led Graham to treat the double space and its intersection in an even more multiple, split and operative mode. '*It was then that I discovered double-sided mirrors and I wanted to use them in my work and in architecture. I think that the mirror was of interest to me because I was always doing doubles.*'[61]

The 1978 maquette *Two Adjacent Pavilions* was built for Documenta 8, Kassel, in 1982.[62] It is the first pavilion set in a landscape, and the first in which Graham deploys two-way mirror glass. Two twin volumes are separated by a gap that 'holds' the landscape within its void. The glass modules are identical except that one has a dark ceiling, while that of the other is transparent; thus, in one module the spectator is more visible than in the other. The installation creates a paradoxical structure between open and closed, an ambiguity between reflection and self-reflection. Viewers can enter and move about among the artifices created by these optical constructions, finding themselves merged in an objective illusion made of reflective glass and opacity. The unstable movement of images takes place within an ambiguously stable,

geometrically defined system. The artist uses both the internal and external faces of a volume's surface. Made reversible, the surfaces filter and amplify the movements of light and water, the flux of specular images. Bodies and objects are spatialized through their least tangible effects – reflections – which are essentially the result of doubling. Graham also frames what lies outside the two modules. The city, the suburb, the park and nature are edged by four sides of glass. At the same time, his de-materialized, almost invisible panoptics – linking the inside to the outside in a permanent fluctuating geometry – are always associated with places beyond spaces physical actual places, places that refer to a history, a memory, a community.

Graham is continuously activating and varying elements in a long chain of associations around the pavilion: the Greek myths of Arcadia, the refuge, the country garden with its origins in the ancient cemeteries, baroque and rococo pavilions, Marc-Antoine Laugier's primitive hut and Jean-Jacques Rousseau's concept of a return to nature, allegories of the English garden, the nineteenth-century belvedere, temporary pavilions constructed for the world exhibitions, De Stijl buildings, urban parks and bus shelters. Steel and semi-reflective glass, with their monolithic effects, are materials related to corporate buildings, to the city as a kinetic, self-reflective space. Graham's pavilions give substance to the paradox of the modernist myth of transparency: that glass hides as much as it reveals.[63]

What connects the outside to the inside? The mirror, the window, the screen and the decor each

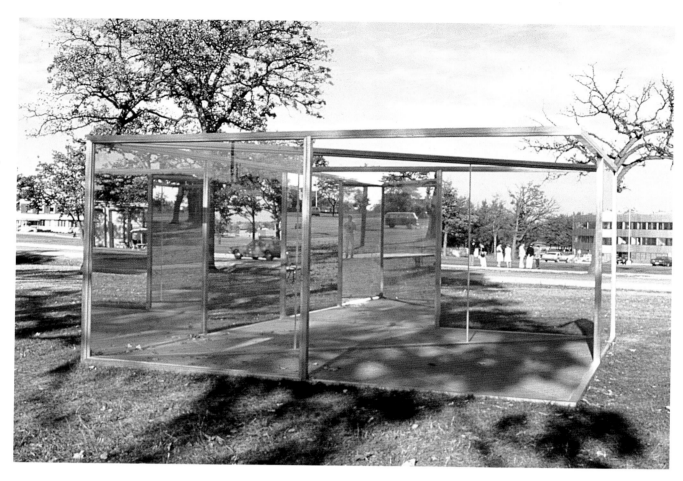

Pavilion/Sculpture for Argonne
1981
Two-way mirror, glass, steel
229 × 457 × 457 cm
Collection, Argonne National
Laboratory, Illinois

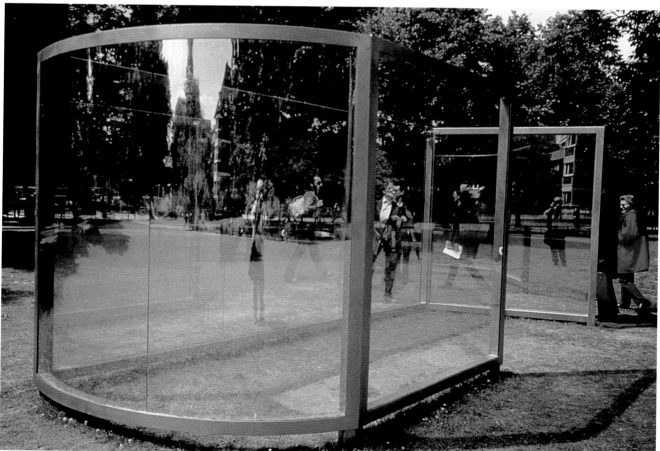

Fun House für Münster
1997
Two-way mirror, glass, steel
construction
230 × 500 × 200 cm
Installation, 'Sculptur. Projekte in
Münster'

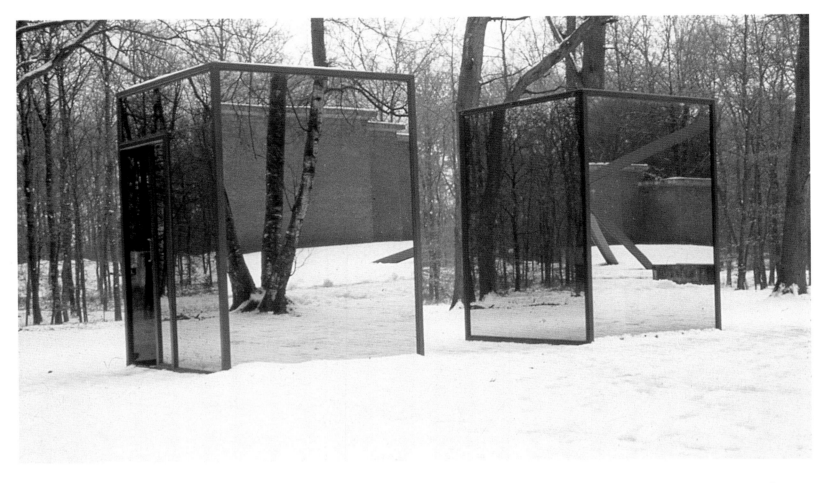

Two Adjacent Pavilions
1978–82
Two-way mirrors, glass, steel
2 units, 251 × 186 × 186 cm each
Installation, Documenta 7, Kassel,
Germany, 1982
Collection, Kröller Müller Museum,
Otterlo

have a place, and give rise to spaces that are at once combined and distinct, doubled. In a visual field of 360 degrees, exchanges take place between static and shifting spaces. The pavilions fulfill a functional role and are situated in public places, rest areas, an urban square, a landscape, in a playing field. They have also been designed for institutional and private places, as well as for waiting or transit areas[64] and concourses. They have been erected in museum entrance halls, airports, shops, bookshops, cafés,[65] children's playgrounds. They can be found in the open and underground, adult- or child-sized.[66]

Graham has also experimented with different geometric forms following the increasingly complex formula. These have been simultaneously transparent and reflective, and are activated in different ways according to the presence of passers-by, the light, the context of the city, suburb or countryside. The forms include: a cube, a parallelepiped, a tetrahedron, a polyhedron, a sphere, a spherical segment,[67] a prism, a pyramid, a truncated pyramid, an oblique or truncated cone, a cylinder, a diamond. Sometimes Graham pivots one form in relation to another – for example *Two Cubes, One Rotated 45°* (1986). Alternatively, two forms may be subdivided and added to another such as, a cylinder placed inside a cube – or revolving planes may be integrated and superimposed on inverted axes. Edges, angles, surfaces or parts of surfaces are added and removed. Ruptures are introduced in the surface, piercing it with rectangles or circles, as in *Pavilion Proposal Using Chinese Moon Windows* (1989).

Sometimes Graham combines mirroring prisms with water (*Pavilion for Domaine de Kuergennec*, 1987, and *Star of David Pavilion for Schloß Buchberg*, 1991–96, see page 25). Some open pavilions have unfolding partitions, while others simply present an intersection of axes and screens with no enclosed physical space (*Two-way Mirror Hedge Labyrinth*, 1989–93, see page 22). Entrances are modulated by the introduction of sliding or revolving doors. Some of the pavilions are doubled, one fitted into the other, so that the interaction of rectilinear and curved, concave and convex planes is concretized (*Two-way Mirror Triangle One Side Curved*, 1996). The clarity and stability of the reflections vary. The reduction to surface reflection highlights the gap between the here and now and the specular image, or virtual image.

The pavilions are inscribed within a tradition, a potential for suggestion (*Triangular Pavilion with Shoji Screen*, 1990, see page 102), in the mode of the allegory (*Octagon for Münster*, 1987), but also the romantic cliché (*Heart Pavilion*, 1992, see pages 23, 24), the emblem (*Star of David Pavilion for Schloß Buchberg*).

In his interior pavilions, Graham established an interaction between a play area and the exhibition space. *Three Linked Cubes/Interior Design for Space Showing Videos* (1986, see page 53), built among other realizations, for Documenta X in 1997, is a mobile, open pavilion that can be folded out into different transparent/reflective spaces. Each contains a television set and a cushion. This ensemble allows various programmes to be broadcast simultaneously for a number of

different viewers. Each spectator can see the other people watching videos in different booths. Perceptions reverberate as images. Once more the image is boxed inside other images, the screen inside a series of screens, in a play of de-centred reflections.

Another project, *Altered Two-way Mirror Revolving Door and Chamber with Sliding Door (for Loie Fuller)* (1987) was designed as a homage to the dancer Loie Fuller (1868–1928). Inspired by her invention of 'a system of mirrors for use on stage', Graham isolated a revolving door within a space intended for movement, a space in which to present Fuller's films and dance. The double entrance was a cylinder within a polygon, both of which were two-way mirrors. The revolving planes of the door created particular kinetic effects, a volatile, weightless sensation. The door was devised with only half the usual number of panels, so it turned faster and more freely than an ordinary revolving door. In this way spectators felt their bodies and the bodies of others rise physically as if they were Fuller herself.

Model for Gift Shop/Coffee-Shop (1989–91), a bar/pavilion/sculpture project for an airport, provided two continuous spaces for social use as meeting areas, refreshment and rest areas. A parallelogram was divided into two triangular spaces by a wall. All the walls were made of reflective glass, each of which was opened by sliding door. The spaces contained comfortable seating and provided the tranquility of a quiet haven in the midst of a busy thoroughfare. This set up an intrigue of gazes of complicity, evasion and disguise.

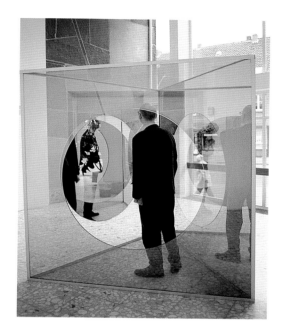

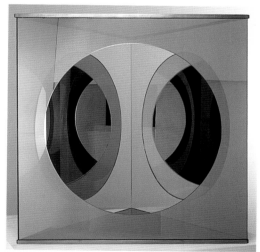

Triangular Pavilion with Circular Cut-outs
1989
Two-way mirror transparent glass, aluminium
213.5 × 213.5 × 213.5 cm

Triangular Solid with Circular Inserts - Variant D
1989
Glass, mirror, two-way mirror, aluminium frame
94 × 92 × 81 cm

Two-way Mirror Cylinder inside
Cube and Video Salon. Rooftop
Park for Dia Center for the Arts
1981–91
Transparent glass, steel, wood,
rubber
244 × 1098 × 1098 cm
Collection, Dia Center for the Arts,
New York

Just as Graham has created pavilions in museums that act as meeting points, he has also devised areas in which people can meet outside. *Two-way Mirror Cylinder inside Cube and Video Salon. Rooftop Park for Dia Center for the Arts* (1989–91) is an urban panopticon that transposes the atrium onto the rooftop of the institution, with a view of Manhattan and the Hudson River. For Graham the atrium characteristic of many corporate buildings represents a world within a world, a temporary refuge that brings the outside into an inside of transitions. In a peculiar shift, it brings back to the city the Utopia promised by the suburban haven, away from yet close to the city.[68] The city park created by Graham's pavilion proclaims its social function. In the spirit of the alternative spaces of the 1970s, it offers a coffee bar and a place for viewing videos and for performance events. Forming a 360-degree horizon, it turns the city into a cinematic panorama. Like his films *Sunset to Sunrise* and *Body Press*, the structure and its site combine and loop revolving movements, given shape by the cylinder and the horizon's circularity.

Double Exposure (1995–96) spelt out again the staging and capturing of nature. The project set up a photographic panorama within that of the corresponding landscape. The triangular pavilion was entered through a sliding door. Two of the wall panels were of mirror-reflective glass, while the third was formed by a 50-metre-long Cibachrome transparency, depicting a sunset as if seen from the pavilion. The spectator would therefore have seen the current, unstable landscape through the screen of a static image, a Cibachrome of a view in the past. Playing on the image's delay effect,

Graham manipulates time. Like *Two Adjacent Pavilions*, *Double Exposure* transposed and expanded the duplicated outside to the inside.

Numerous pavilions have been created for integration into urban parks. Graham's observation that the planning of parks rarely includes leisure areas for teenagers, led to the project *Skateboard Pavilion*,[69] conceived in 1989. A semi-spherical bowl of cement was to be sunk into the ground, extending an open invitation for graffiti. The pavilion was to be surmounted by a canopy of two-way mirror in the form of a four-sided pyramid, the top of which was cut flat. This open pyramid would send a kaleidoscopic image of the skater merged with the sky and the prismatic reflections from the truncated pyramid back to the skater as she or he headed for the edge of the bowl. The skater's movements would trace and echo the multi-faceted image, enhancing the sensation of weightlessness. The kaleidoscope, amplified by the centrifugal force of the skater, imparting an overabundance of visual pleasures.[70]

In the model *Swiming Pool* (1992), Graham heightened the prismatic reflections from a truncated pyramid in two-way mirror glass by placing a pyramid-shaped roof over a swimming pool, which is itself surrounded by two-way mirrors. The maquette for another of Graham's unrealized projects, *Swimming Pool/Fish Pond* (1997) shows the swimming pool as a double-sided, faintly reflective glass cylinder. This is subdivided into two unequal parts of one-third and two-thirds by a partition in the shape of an S, made of mirror-reflective glass. The larger of the two sections is intended for people, the smaller for

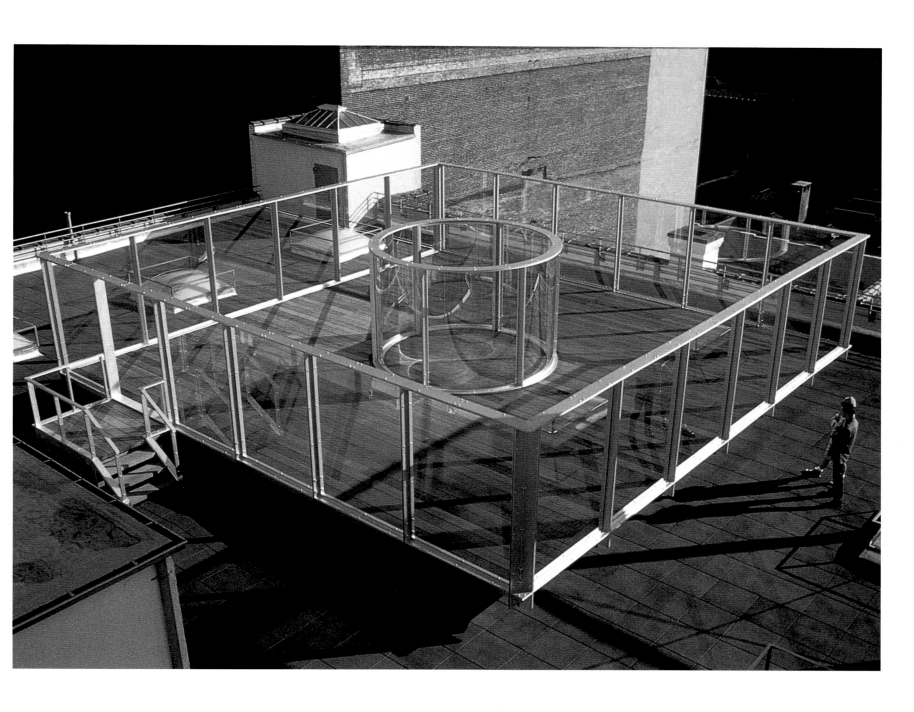

Two-way Mirror Cylinder inside Cube and Video Salon. Rooftop Park for Dia Center for the Arts
1981–91
Transparent glass, steel, wood, rubber
244 × 1098 × 1098 cm
Collection, Dia Center for the Arts, New York

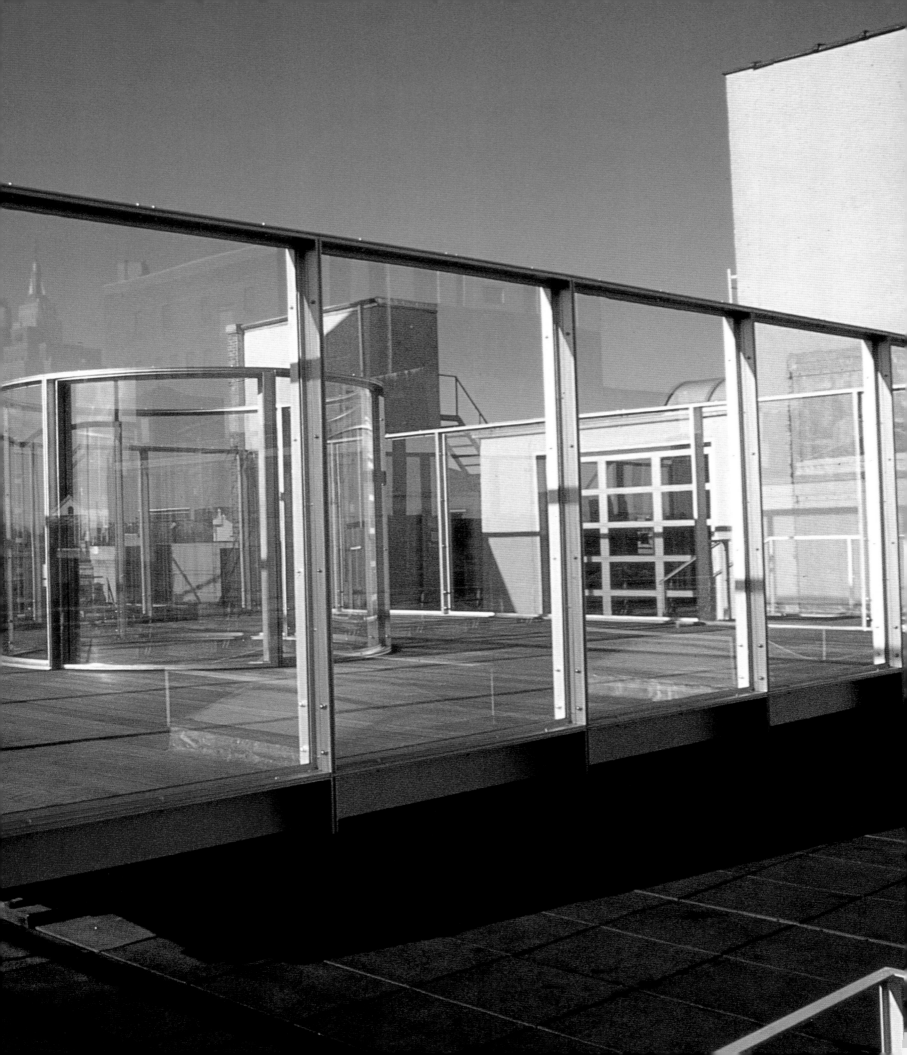

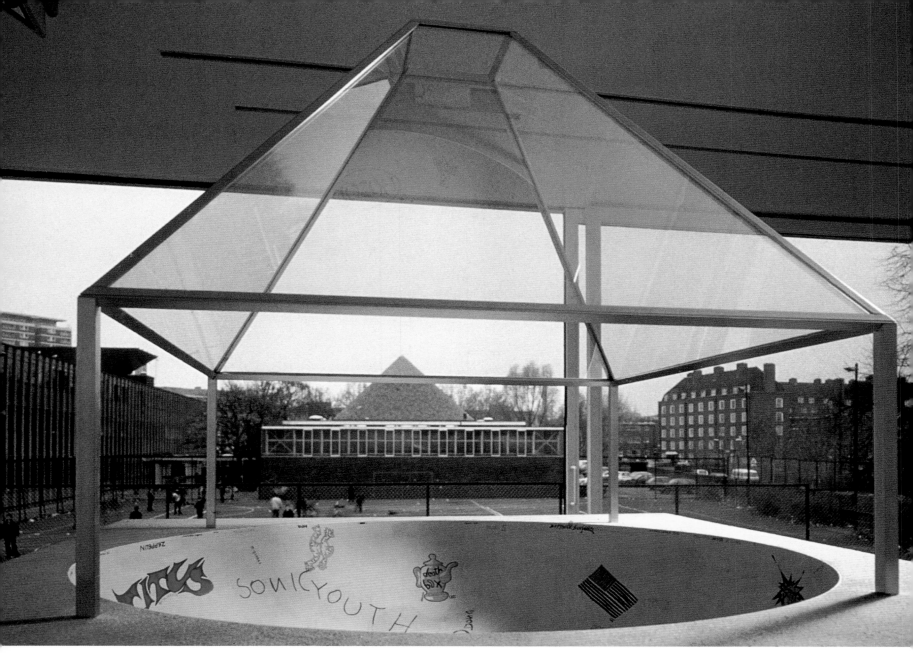

Skateboard Pavilion (Model)
1989
Two-way mirrors, aluminium,
wood
94 × 127 × 127 cm
Installation, Lisson Gallery,
London
Collection, E.A. Generali
Foundation, Vienna

fish – even, say, a shark. A sloping wooden ramp gives access to the swimming pool and diving board. Under the ramp, at the level of the glass walls of the pool, the artist imagined a café where visitors could observe the movements both of the swimmers and the fish. There is also a kind of 'fish-eye view' of the café space from inside the pool. The two-way mirror would send back distorted images of the fish, the swimmers and the people sitting at the tables. Graham has observed that in

Australia, parts of the garden set aside for the swimming pool often contain a separate pool for fish. In a single tract of water he brought together the aquarium and the swimming pool, an exercise-space and water attraction parks. The model recalls the early menageries at Versailles, where animals were integrated into the geometry of the garden, their visual, 'decorative' value enhancing the landscaping of the park. Nature's untamed wonders were also subject to Louis XIV's rule. The

urban zoo came into being in the nineteenth-century. A natural haven in the midst of the city, it provided a means for the study of animal behaviour while displaying the trophies of colonial conquest. Graham inverted this equation by mirroring it: the solitary fish and the human beings swim in the same stretch of water.

Another area for play and cultural enjoyment has been condensed into *Children's Day Care CD-ROM, Cartoon and Computer Screen Library Project* (2000). This installation was centred on different activities linked to the computer. Recreational spaces, which are as much play-oriented as they are educational, integrate different computer technologies and forms of virtual imagery. The spaces were subdivided within a curved enclosure made of two-way glass. Depending on the computers in their space, children choose between Internet programs, animated cartoons and CD-ROMs selected by the artist; institutions can build in their own choices. In 1992, Graham told the critic Brian Hatton: *'I have been asked recently if I would make work using virtual reality technology. I think that my work has been situated in that area of the cinematic, hallucinatory, kaleidoscopic, which virtual reality will now fill – a cinema/amusement park sensibility – so maybe virtual reality will lend itself to the next development in my work.'*[71]

VIII.

Graham's art is aesthetic as well as functional. There is also a third element: that of shared public space. His work is essentially parodic and critical, always offering a double reading. It creates an interaction between the conventional notions of entertainment and architecture; architecture and art; art and mass media. His ambivalent links are simultaneously dissections. The aim is to examine how illusion, artifice and allegory are constructed, and what modes of suggestion, legibility and blindness are at the basis of change and alteration. By shifting the outside to the inside; combining the focus and dissolution of images; and crossing the virtual with the real, the architecture of the pavilions explores the gaze, with its evasions, lures and reversals. Operating by means of reduction and equivalence, Graham's work produces a view within a view, a screen within a screen, time within time. The constant doublings in his work, from his interventions for magazines to the models and the pavilions, highlight and articulate different modes of semblance. *'In all my work – whether in the fields of video, film and performance or in the sculptural/architectural pavilions – geometric forms are inhabited and activated by the presence of the viewer, and a sense of uneasiness and psychologcal alienation is produced by a constant play between feelings of inclusion and exclusion.'*[72] Is there a place that exists neither inside nor outside? Graham's paradigm touches on dialectical operations of coming together and alienation, intersection and separation. His fantasies, his models of transformation – by focusing on access to social connection, its bonds and opacities – also aim to outline the sites of an unprecedented Utopia.

below, left, **Swimming Pool** (Model)
1992
Two-way mirror plastic, aluminium frame
61 × 86.5 × 122 cm

below, middle, **Swimming Pool/Fish Pond** (Model)
1997
Two-way mirror glass, wood
32 × 106.5 × 106.5 cm

below, right, **Children's Day Care CD-ROM, Cartoon and Computer Screen Library Project** (Model)
2000
Wood, glass, two-way mirror glass, punched aluminium
30.5 × 91.5 × 106.5 cm

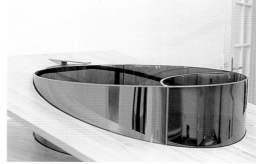
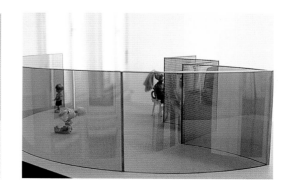

Robert Mangold Pavilion
1990–91
Two-way mirror glass, aluminium
250 × 400 × 400 cm

Translated from French by Liz Heron

I wish to thank Caroline Van Damme for illuminating discussions about Dan Graham's work and ideas.

1 'Dan Graham Interviewed by Ludger Gerdes', in Dan Graham, *Two-way Mirror Power: Selected Writings by Dan Graham on His Art*, ed. Alexander Alberro, introduction by Jeff Wall, MIT Press, Cambridge, Massachusetts, in association with the Marian Goodman Gallery, New York, 1999, p. 69.

2 The artist quoted in 'Interview with Mike Metz', in Dan Graham, *Two-way Mirror Power: Selected Writings by Dan Graham on His Art*, op. cit., p. 185.

3 *Homes for America*, Arts Magazine, New York, December 1966 –January 1967.

4 Letter from Dan Graham to the author, quoted in the seminal essay by Benjamin H.D. Buchloh, 'Moments of History in the Work of Dan Graham', *Articles*, Stedelijk Van Abbemuseum, Eindhoven, 1978, p. 73.

5 The artist quoted in Eric de Bruyn, 'Conversation avec Dan Graham', in Dan Graham, *Rock/Music, Textes*, Les Presses du Réel, Dijon, 1999, p. 148.

6 Donald Judd, 'Specific Objects', *Arts Yearbook*, No. 8, New York, 1965.

7 The artist quoted in 'Interview with Mike Metz', op. cit., p. 185. *Projection on a Gallery Window* was made at Franklin Furnace, New York, in 1979. It re-shaped the links between the closed space of the gallery and social space by projecting slides showing the surrounding exhibits onto the gallery facade.

8 The artist quoted in 'Dan Graham Interviewed by Ludger Gerdes', op. cit., p. 69.

9 Dan Graham, 'Ma Position', *Ma position: Écrits sur mes œuvres*, Le Nouveau Musée, Villeurbanne/Presses du Réel, Press, 1992

10 Bertolt Brecht, 'Alienation Effects in Chinese Acting', *Brecht on Theatre*, trans. and ed. John Willett, Hill and Wang, New York, 1964, pp. 92–94, quoted in Dan Graham, 'Art in Relation to Architecture/Architecture in Relation to Art', *Artforum*, Vol. 17, No. 6, New York, February, 1979, pp. 22–29.

11 *Dan Graham: Buildings and Signs,* The Renaissance Society at the University of Chicago, 1981.

12 'My Works for Magazine Pages: "A History of Conceptual Art"', *Rock My Religion: Writings and Art Projects 1965–1990*, ed. Brian Wallis, MIT Press, Cambridge, Massachusetts, 1993, pp. xviii–xx. See in this volume, pp. 138–41.

13 All the works for magazines, around twenty, were collected in *For Publication*, Otis Art Institute, Los Angeles, 1975. The description which follows is derived from this edition and from Dan Graham's essay 'My Works for Magazine Pages: "A History of Conceptual Art"', op. cit.

14 *Detumescence* (1966), published several times in newspapers including the *National Tatler*, which advertised for a 'specialist medical editor' to provide a scientific description of the sexual phenomenon of detumescence.

15 Most of the works for magazines employed the structure of a grid in ordering the data in the diagrams. Thus *Side Effects/Common Drugs* (1966) sets out the visual schema of pharmaceutical products and their side effects (see this volume, p. 36). *Time/Distance Extended* (1969) is a graphic work which represents the space/time continuum with abscissas and ordinates; the principle of extension is expressed graphically by means of a progressive checkerboard.

16 Cf. *INCOME (Outflow) PIECE* (1969), presented in the 'Language III' exhibition at the Dwan Gallery in New York in 1969. Taking a similar approach, the editorial *Proposal for Aspen Magazine* (1967–68) is an earlier reflection on the relationship between publication in an art magazine and validation as art; cf. *For Publication*, op. cit.

17 Ibid.

18 Dan Graham, 'Ma Positions', op. cit.

19 Ibid. This work recalls artistic initiatives like those of Piero Manzoni and Marcel Broodthaers, among others, who have interrogated the registers of authenticity, validation, speculation and guarantee.

20 Just as *Scheme* interrogated the optical matrix of the uninterrupted indefinitely extended and of interruption, *Schema (March 31)* (1966) is a graphic work which, through a decreasing alignment of figures, signposts the field of vision in terms of distance, from the furthest

imaginable (the limits of the known world) to the most microscopic (the wall of the retina).

21 'My Works for Magazine Pages: "A History of Conceptual Art"', op. cit.

22 The artist quoted in 'Interview with Eric de Bruyn', *Dan Graham*, ed. Gloria Moure, Fundació Antoni Tàpies, Barcelona, 1998, pp. 195–205.

23 Ibid., de Bruyn's footnote 1, p. 204

24 Ibid. p. 118. A reference can also be found in Dan Graham, *Films, Éditions Centre d'art Contemporain, Geneva/Écart Publications, Geneva,* 1977, pp. 3–5.

25 'Subject Matter', *End Moments*, New York, 1969; reprinted in *Rock My Religion: Writings and Art Projects 1965–1990*, op. cit., pp. 38–51. See in this volume pp. 112–15.

26 The artist quoted in an unpublished interview with Benjamin H.D. Buchloh, pp. 12–13.

27 'Film and Performance/Six Films, 1969–1974' (1976), *Films*, op. cit.; reprinted in *Two-way Mirror Power: Selected Writings by Dan Graham on His Art*, op. cit., pp. 84–93.

28 'Video-Architecture-Television', *Art Présent*, No. 9, Paris, 1981, pp. 14–19. See in this volume pp. 120–33.

29 Ibid.

30 Ibid.

31 'Performance: End of the '60s' (1989), *Two-way Mirror Power: Selected Writings by Dan Graham on His Art*, op. cit. pp. 142–44. For one of the first introductions to Dan Graham's work as a whole, right up to the early pavilions, see Anne Rorimer, 'Dan Graham: An Introduction', *Buildings and Signs,* op. cit., pp. 5–19.

32 Cf. all Graham's essays on rock music like 'Punk: Political Pop'; 'New Wave Rock and the Feminine'; 'Live Kinks', see in this volume pp. 108–11; 'Rock My Religion', see in this volume 134–37; and 'Dean Martin/Entertainment as Theater'.

33 Dan Graham, *Interviews*, Herausgeber Hans-Dieter Huber, Cantz Verlag, Stuttgart 1997, pp. 6–7. The sarcastic testing out of sexual roles is to be found in a performance which already makes use of video, *Two Consciousness Projection(s)*, 1972, and in the last

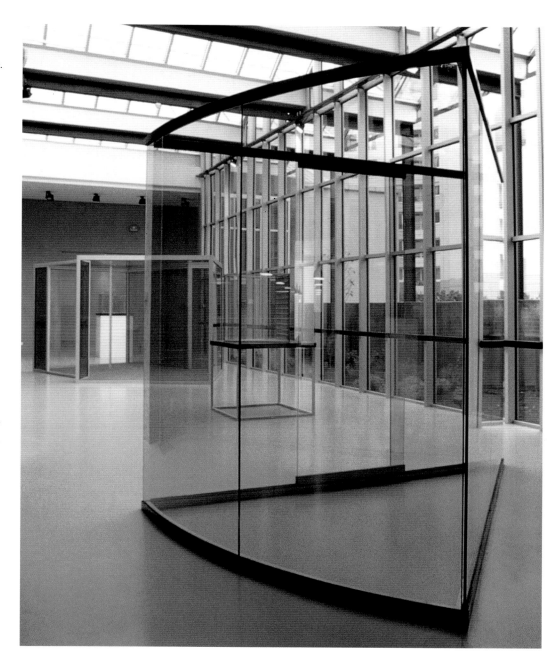

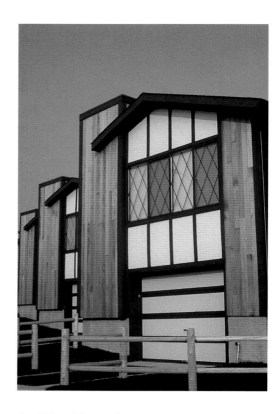

above, **Tudor-style Tract Housing**
1978
C-print
Dimensions variable

opposite, **Warehouse in Neocolonial Style, Westfield, NJ**
1978
C-print
Dimensions variable

performance of *Identification Projection*, 1972.

34 Ibid.

35 Thus *Intention Intentionality Sequence* (1972) plays on the split between the interior time of concentration and the descriptive time of the contact with the audience through the monologue of the performer who is giving an account of both. Likewise *Performer/Audience/Sequence* (1974) plays on progressive mimicry with a repeated description which contrasts the immediate present with the 'just past'. Cf. Thierry de Duve's essay, 'Dan Graham et la critique de l' autonomie artistique', *Dan Graham: Pavilions*, Kunsthalle, Bern, 1983, pp. 45–73.

36 'Dean Martin/Entertainment as Theater', first published in *Fusion*, Boston, 1969; reprinted in *Rock My Religion: Writings and Art Projects 1965–1990*, op. cit., pp. 56–65.

37 The artist quoted in 'Interview with Hans-Dieter Huber', *Interviews*, op. cit.

38 Ibid., p. 14

39 Ibid., p. 14.

40 The artist quoted in 'Interview with Eric De Bruyn', op. cit., p. 150.

41 The performance *TV Camera/Monitor Performance* had already used feedback video, in 1970. Dan Graham returned to the constraints of film in *Roll*, but in front of an audience which took the place of the static camera. A video camera and a monitor were added. Since the performer's focus was towards the video monitor, the result was a feedback of an image within an image. Cf. *Dan Graham: Video/Architecture/Television: Writings on Video and Video Works 1970–1978*, ed. Benjamin H.D. Buchloh, Press of Nova Scotia College of Art and Design, Halifax/New York University Press, 1979, p. 2. The description of *Present Continuous Past(s)* features on pp. 7–8.

42 A splitting analyzed by Jacques Lacan in seminar XI, *Four Fundamental Concepts of Psychoanalysis*, ed. Jacques-Alain Miller, trans. Alan Sheridan, introduction by David Macey, Vintage, London, 1998. Cf. the specific analysis of this aspect in Birgit Pelzer, 'Vision in Process', *October*, No. 10, Cambridge, Massachusetts, Fall, 1979, pp. 105–19.

43 'Performance: End of the '60s' (1989), *Two-way Mirror Power: Selected Writings by Dan Graham on His Art*, op. cit., pp. 142–44.

44 Dan Graham, 'Video-Architecture-Television', op. cit., pp. 11–24. Cf. also the succinct inventory of Dan Graham's works up until 1992 laid out by Rainer Metzger at the end of his study *Kunst in der Postmoderne – Dan Graham*, Verlag Walther Konig, Cologne, 1996, pp. 221–52.

45 Dan Graham, 'Ma Position', op. cit.

46 'Video-Architecture-Television', op. cit., pp. 41–48

47 'Video Piece for Shop Windows in a Shopping Arcade' (1976), *Dan Graham: Video/Architecture/Television: Writings on Video and Video Works 1970–1978*, op. cit., p. 53; reprinted in *Two-way Mirror Power: Selected Writings by Dan Gaham on His Art*, op. cit., pp. 48–49.

48 In the context of the exhibition titled 'Arte Ambiente', organized by Germano Celant. The text 'Public Space/Two Audiences' was written in 1978 and published in *Aspects*, No. 5, New York, Winter, 1978; republished in *Two-way Mirror Power: Selected Writings by Dan Graham on His Art*, op. cit., pp. 155–59.

49 'Public Space/Two Audiences', op. cit.

50 The artist quoted in 'Interview with Hans-Dieter Huber', op. cit., p. 24.

51 The artist quoted in 'Interview with Benjamin H.D. Buchloh', op. cit., p. 17.

52 The artist quoted in 'Interview with Hans-Dieter Huber', op. cit., p. 27. Graham's work *Edge of the City* (1981) answers Venturi's 'City Edges' by inverting them. Venturi showed images of urban society in a location on the city periphery. Graham used the city centre and the Philadelphia railway station, projecting images of the suburbs, where the trains were bound, onto giant screens.

53 Ibid. pp. 27–29.

54 This work also recalls the architectural model of 1978, *Video Projection outside Home*, intended for a suburb. This set up the projection of a selected television programme, to be watched by the family outside on a big screen in the street. It recalls, moreover, another *mise-en-abîme* of the voyeur watched – the 1976 project for

a local television station, *Production/Reception (Piece for Two Cable TV Channels)*, which is a doubling of mirrors and lookalikes between television series and the ordinary American family, craftily intertwining notions of seeing without being seen, of what is or isn't fiction. 'Video-Architecture-Television', op. cit., p.55

55 Dan Graham, 'Ma position', op. cit.

56 'Cinema' (1981), Anne Rorimer, op. cit., pp. 47–50; reprinted in *Two-way Mirror Power: Selected Writings by Dan Graham on His Art*, op. cit. pp. 94–95.

57 In response to an invitation from the Munich gallery-owner Rudiger Schottle to take part in his project on the ideal garden, 'Theatergarten Bestiarum'. Cf. 'Garden as Theater as Museum', Chris Dercon, ed., *Theatergarden Bestiarum: The Garden as Theater as Museum*, MIT Press, Cambridge, Massachusetts, 1990, pp. 86–105, reprinted in Dan Graham, *Rock My Religion: Writings and Art Projects 1965–1990*, op. cit., 286–307; and 'Pavilions, Stagesets and Exhibitions Designs, 1983–1988', *Dan Graham: Pavilions*, Kunstverin München, 1988, in which Dan Graham links film, theatre and the garden to the museum, so as to analyze the significance of interconnected issues of control, education and entertainment which are characteristic of a consumer and leisure society.

58 In the essay 'Theater, Cinema, Power', *Parachute*, No. 3, Montreal, Summer, 1993, pp. 11–19; reprinted in *Rock My Religion: Writings and Art Projects 1965–1990*, op. cit., 170–189, Dan Graham specifically analyzes Renaissance theatre and its single perspective, court theatre, with the Prince as its intended audience, and finally occult theatre, the theatre of memory which Renaissance thinker Giulio Camillo called the 'Teatro del Mondo', de Giulio Camillo. The question is taken up yet again in Graham's essays 'The Birth of Hollywood' and 'The President Ronald Reagan', in 'The End of Liberalism', *Rock My Religion: Writings and Art Projects 1965–1990*, op. cit.

59 Set up on the land of Argonne National Laboratory, the pavilion returns to the principle of *Square Room/Diagonally Divided* (1978) which itself echoes the principle of *Public Space/Two Audiences* (1976).

60 'Pavillion Proposals Using Chinese Moon Gates' and other passages in *Pavilions*, op. cit.

61 The artist quoted in 'Interview with Benjamin H.D. Buchloh', op. cit. p. 18

62 For Graham's dicussion of *Two Adjacent Pavilions* (1978–82) see 'Two-way Mirror Power' (1996) published in *Two-way Mirror Power: Selected Wrirings by Dan Graham on His Art*, op. cit., pp. 174–75; see in this volume 142–43.

63 Jeff Wall, *Dan Graham's Kammerspiel*, Art Metropole, Toronto, 1992

64 *Pergola/Conservatory* (1987), in 'Pavilions, Stagesets and Exhibition Designs, 1983–1988', *Dan Graham: Pavillions*, op. cit.

65 *Café Bravo*, Berlin, 1998, where the visitor could sample New York snacks while reading local newspapers.

66 For the pavilions cf. the catalogue *Dan Graham*, Fundació Antoni Tàpies, Barcelona 1998, and Alexander Alberro, *Dan Graham: Models to Projects, 1978–1995*, Marian Goodman Gallery, New York, 1996.

67 *Robert Mangold Pavillion* (1990–91)

68 'Corporate Arcadias' (with Robin Hurst), *Rock My Religion: Writings and Art Projects 1965–1990*, op. cit, pp. 266–83

69 *Children's Pavilion*, Galerie Roger Pailhas, Marseille, 1989.

70 *Dan Graham. Pavilions*, op. cit.

71 The artist quoted in 'Interview with Brian Hatton', op. cit., p.153

72 'Heart Pavilion' (1991), in Dan Graham, *Two-way Mirror Power: Selected Writings by Dan Graham on His Art*, op. cit., pp. 172–73.

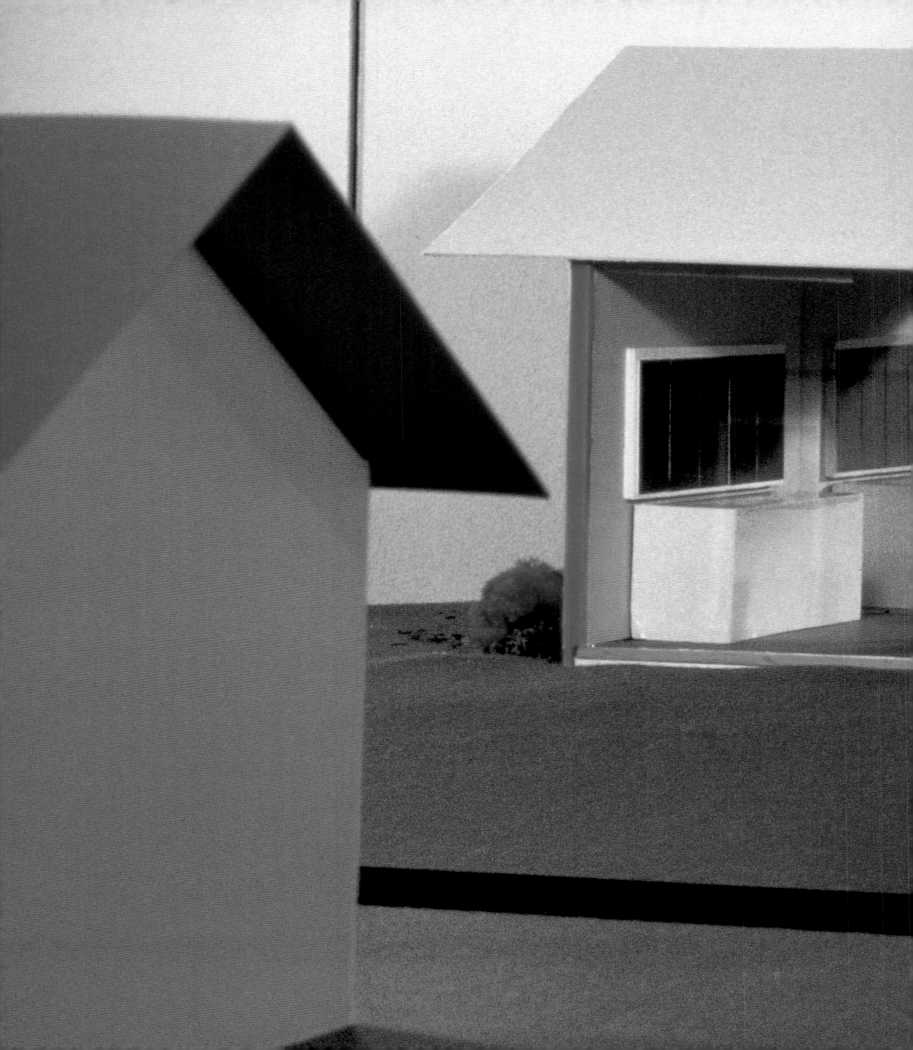

Contents

'I can't draw. I make models.' – Dan Graham[1]

'I hate models. I only make drawings.' – Peter Smithson[2]

'The entire facade of a typical suburban house has been removed and replaced by a full sheet of transparent glass. Midway back and parallel to the front glass facade, a mirror divides the house in two areas. The front section is revealed to the public, while the rear, private section is not disclosed. As the mirror faces the glass facade and the street, it reflects not only the house's interior but also the street and the environment outside the house. The reflected images of the facades of the two houses opposite the cut-away "fill-in" the missing facade.'[3]

Alterations, whether to a building or a dress, always involve, at a certain point in the process, the exposure of how a piece is constructed. When something is removed (a wall, a sleeve), elements are revealed that were previously hidden from view. Removing the facade of a suburban house reveals its structure – not just the physical but the social structure: how the suburban family is held together; and the optical structure, the lines of sight that sustain relationships. The facade is now a window. The picture window has extended itself to cover the entire wall.

The picture window is an integral element of the post-war American house. It turns the building into a showcase of domesticity. It is not, as is commonly assumed, that the house exposes its interiority. There is no interior. What the huge window reveals is not a private space but a public representation of conventional domesticity, an image of 'socially accepted normalcy', to use Dan Graham's words. The picture window is like a shop window selling the middle-class American dream, or like a billboard in which the passer-by's eyes will not stop for too long, will not scrutinize the scene, but will glance quickly and then move on, as if not wanting to know too much, or detect something out of the ordinary. A furtive look. It is not that the spectator is trying to be polite. It is her own identity that is at stake.

It is the passer-by who is really exposed in the suburbs, subjected to all the hidden eyes behind every window, every Venetian blind, every curtain. Inquisitive, implacable eyes. No restraint here. Every pedestrian is suspect. An intruder.

Alteration to a Suburban House (1978) makes visible the optical structure of suburban life. Passers-by are exposed, swallowed up by the house, incorporated into the interior as

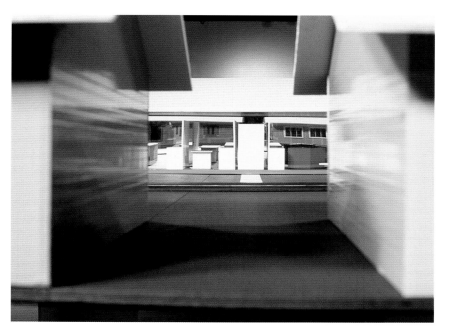
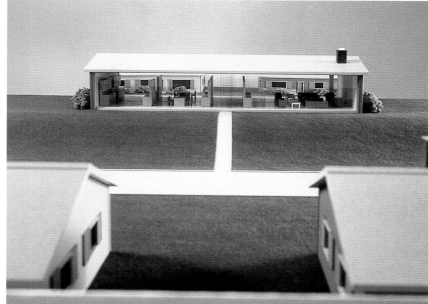

Alteration to a Suburban House
(Model)
1978
Wood, paint, synthetic materials
15 × 109 × 122 cm

part of the decoration, as a kind of wallpaper. The mirror, which slashes the house in half lengthwise, doubles the space that it exposes to the street. A virtual living room extends itself into the space occupied by the most private areas of the house, the bedrooms and bathrooms, which are hidden behind the mirror. The mirror both cuts the house in half and, at the same time, restores it to completion. In what corresponds to the private space, we find not only a double of the living room, but also of the lawn outside the house, the street, the facing houses, their lawns, the sky, the clouds and the passers-by. The most private space has been replaced by the most public.

Visitors and passers-by would see themselves inside the house, moving around in the virtual living room with the landscape of the suburb, the street, sidewalk, lawn and neighbouring houses behind them. They see themselves in an interior but also in an exterior which has now been made part of the interior. On the other side of the glass wall, inhabitants of the *Alteration* would see themselves outside, in the street reflected in the mirror. Their domestic set-up would be displayed in the mirror as an open-air room surrounded by clouds, lawns and the facades of houses. Passers-by and inhabitants would share the same convoluted space in the mirror.

The people 'outside' are doubly exposed. They are not only exposed to the view of those inside, but see themselves exposed to others, being seen by others. An erotically charged gaze is embedded within an apparently puritanical environment. Furtive wife swapping was in fact part of the lifestyle in the mass-constructed, post-war suburban community of Levittown, New York. The residents claim that the identical houses led to affairs, when late at

night and perhaps drunk, people ended up in the wrong house.[4]

If tract housing is the new city, as Graham says, it is unlike the turn-of-the-century city, which for Walter Benjamin's *flâneur* was a place in which one could hide while contemplating the spectacle. In the suburbs, the situation has been reversed. The pedestrian is now exposed, scrutinized by eyes behind every window, eyes that you don't see, and that, as Sartre pointed out, do not need to be there to be felt:

'I can feel myself under the gaze of someone whose eye I do not even see, not even discern. All that is necessary is for something to signify to me that there may be others there. The window if it gets a bit dark and if I have reasons for thinking that there is someone behind it, is straightway a gaze. From the moment this gaze exists, I am already something other, in that I feel myself becoming an object for the gaze of others. But in this position, which is a reciprocal one, others also know that I am an object who knows himself to be seen.'[5]

In Graham's *Alteration*, through the device of the mirror, this experience is doubled. I can see myself inside the living room of the house I am walking past. I have become as much a part of the living room as the furniture. I am the object of my own surveillance. I look in and see myself looking out.

The effect recalls that of Ludwig Mies van der Rohe's Barcelona Pavilion of 1928–29, where visitors saw themselves reflected in the dark glass, with the clouds, the sky and the trees appearing behind them. They saw themselves within an interior as they stood outside it. As architectural theorist José Quetglas has asked, 'could it be that the pavilion has no

interior, or that its interior is an exterior?'[6]

Very few people seem to have noticed this effect when it was built for the International Exhibition in Barcelona. What has come to be understood in the architectural world as the most influential building of the twentieth century was apparently seen by 'nobody' at the time. Virtual architecture. Despite its prominent location in the lay-out of the exhibition, journalists sent by professional architecture magazines passed it over entirely, unable to detect its significance. Naive visitors and local journalists provided the only testimony to its existence. One commented on the 'mysterious' effect, 'because a person standing in front of one of these glass walls sees himself reflected as if by a mirror,

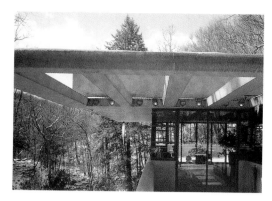

but if he moves behind them, he then sees the exterior perfectly. Not all the visitors notice this curious particularity, whose cause remains ignored.'[7]

It was only in the 1950s, in the aftermath of the 1947 Mies exhibition at The Museum of Modern Art in New York curated by Philip Johnson, that the pavilion burst into every architectural publication.[8] As glass architecture became dominant, the pavilion was hailed as the most beautiful building of the century, exemplifying the cult of transparency. A building that was known only through magazine images (it was dismantled at the close of the exhibition, its fragments misplaced) and was rebuilt as late as 1992, became the most significant monument of Modern architecture.

Glass architecture also made it to the 1950s suburbs through magazine images. The picture window, which had its origins in high art architecture, became a feature of suburban tract houses. But, as design critic Thomas Hine has noted, the largest windows in the houses of Frank Lloyd Wright, Mies van der Rohe or Richard Neutra framed the most spectacular views of the landscape, while picture windows in developers' houses would 'look out on whatever happened to be outside'. Because the public knew these 'custom-designed' houses only through publications, which tended to show the windows but not what they framed, developers didn't feel the need to provide this experience.[9]

Since each tract house looks out on the identical house across the street, the picture window becomes another screen of identification, a form of a mirror. People in the suburbs took clues for their behaviour and consumer habits not just from advertisements or television, but from their neighbours as well.

Alteration is the culmination of a continuous reflection on the post-war house in the work of Dan Graham going back to his *Homes for America*, published in *Arts Magazine* in December 1966–January 1967, and considered by some to be his first artwork. The convolution of vision in the suburbs first became evident in *'Picture Window' Piece* of 1974, where two sets of video cameras and monitors are placed one inside and the other outside the picture window of a typical suburban house; one camera sees in, while the other sees out. The interior, seen by visitors or passers-by, would be superimposed on an image of themselves within the outdoor surroundings. In reverse, the occupants of the house, when

looking out of the window, would see an image of themselves in their indoor environment superimposed on the view of the outside.[10] In *Video Projection Outside Home* (1978), made four years later, a large video screen was placed on the front lawn of the house, facing the street. It showed an image of the television programme being watched by the family inside the house. If television in the 1950s brought the public realm into the private, here the private – the choice of TV programme – is publicized. Graham argues that video, from the Latin 'I see', 'in architecture will function ... as window and as mirror simultaneously, but subvert the effects and functions of both.'[11]

But in *Alteration* of the same year (1978) Graham removes the video equipment. There is not even a TV in sight. Unlike such high art works as Philip Johnson's Glass House (1951) and Mies van der Rohe's Farnsworth House (1946–50), which expose the four sides of the structure to the landscape of the private estates in which they are placed, Graham's *Alteration* remains frontal to the viewer, like a film screen or a television set. The house itself is a television set. But which way is it facing? Who is watching what?

In the 1950s, the living room had to make space for TV and provide everybody with a view. And the house was itself operating as a television set, airing representations of family life to passers-by. Women's magazines, sitcoms and advertisements were doing the same in the mass media. Everything in post-war America centred around the house and domestic space. A nation of nuclear families in isolated houses was connected to the outside world through a variety of different screens: TV, illustrated magazines, car windshields, picture windows. What all these have in common is that they provide a view of the public. What the picture window exposes is no more private than a furniture showroom or a spread in a women's magazine.

In the age of TV, there is no privacy. In the early 1970s, when Graham started his work on the suburban house, the everyday domestic life of a real American family, the Louds of Santa Barbara, was presented on TV. In the course of the programme, the parents split, and it wasn't due to the stress of being on view. As Graham recalls it, the couple's marriage was already in crisis, due to the philandering of the husband. The wife thought that being exposed on television would solve their problems, as a form of therapy: exposing yourself to get a hold of yourself. The public reaction was initially negative, but soon the family members became stars. The wife appeared on *The Johnny Carson Show*, and the audience

identified with her. One son ended up working with Andy Warhol.[12]

With each passing year, this exposure of the private has become more extreme. It is no accident that the current television programme *Big Brother* was conceived in the Netherlands, where homes have traditionally been fully on display through sheer glass.

Nothing could seem further away from the high-art world of Mies. And yet his former students and associates, Edward Duckett and Joseph Fujikawa, said of Mies, 'He liked boxing, or at least he enjoyed watching it on television ... He had the largest television screen of anybody I knew. I think Herb Greenwald picked it out for him.'[13]

Greenwald was a rabbinical scholar turned real-estate developer whom Mies met in 1946.[14] Among other projects, the pair built the 860–880 Lake Shore Drive apartments in Chicago (1948–51): twin twenty-five-storey glass and steel structures on the shores of Lake Michigan containing 275 glass apartments. The project represented, according to a reporter of that time, the fulfillment of Mies' thirty-year dream of a 'skin and bone construction ... [Mies] wanted to give city apartment dwellers the feeling of living close to the out of doors, as people in suburbs do who have floor-to-ceiling picture windows in their houses. The lake front location seemed ideal for glass apartments.'[15] Lake Shore Drive brings the suburbs to the city, as if stacking suburban houses one on top of the other, like glass houses suspended in air. At night, the twin towers become multiplex theatres providing an audience for each other. The glass walls allow

Philip Johnson
Glass House
1951
New Canaan, Connecticut

Ludwig Mies van der Rohe
Farnsworth House
1946–50
Plano, Illinois

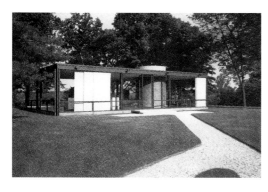

'breath-taking' views of the lake from every apartment and at the same time turn each apartment into a display. Each tower looks upon its identical twin as in a mirror image. Inhabitants seemed to feel perfectly at ease. As one of the first tenants put it: 'I feel quite tucked in, and not nearly as exposed as I thought I'd feel, now the furniture is in place.'[16]

Twinning is a common suburban condition explored by Graham in *Alteration* and in many other works. As he puts it, 'I often think in doubles'.[17] He traces the genesis of *Alteration* to *Public Space/Two Audiences* (1976), his contribution to the Venice Biennale 'Arte Ambiente' organized by Germano Celant, where a rectangular room was divided into two squares by an acoustic pane. One end wall was mirrored, while the other end wall was white. Graham has explained that the Venice Biennale and other international art events are like World Fairs, where each country is represented by a pavilion and art is the commodity. In

Ludwig Mies van der Rohe and Herb Greenwald
860–880 Lake Shore Drive
1948–51
Chicago

Venice he attempted to upset the system by turning the audience into the exhibit. Visitors to the pavilion could see themselves seeing themselves as the commodity.

Mies and Graham are linked by the idea of the pavilion. When commissioned to build the German pavilion in Barcelona, Mies asked the Ministry of Foreign Affairs what was to be exhibited. 'Nothing will be exhibited', he was told, 'the pavilion itself will be the exhibit.'[18] In the absence of a traditional programme, the pavilion became an exhibit about exhibition. All it exhibited was a new way of looking.

And if Mies' experiment turned into a house when he developed the Barcelona Pavilion according to a specific domestic use in his exhibition house for the Berlin Building Exhibition two years later, Graham too moved from pavilion to house. Dissatisfied with the fact that the pavilion was still a gallery space, that there was still a 'white wall', he moved his work to the suburbs, replacing the gallery with a suburban tract house whose facade has been replaced by a glass wall. A house split in two: the same format as *Public Space/Two Audiences* at the Venice Biennale. But the two audiences are no longer art -goers; they are the family inside the suburban house and the passers-by in the street.

Alteration to a Suburban House
(Model)
1978
Wood, paint, synthetic materials
15 × 109 × 122 cm

Graham's work parallels the evolution of modern architecture. If the architecture of the earlier twentieth century was inseparable from illustrated journals, photography and cinema, post-war architecture is the architecture of video and television. All of Graham's work is media-architecture – from the very first works for magazines, like *Homes for America*, to the house designs like *Alteration*, to the pavilions that currently dominate his work. It is not simply that he deals with architectural subjects – the tract house, the picture window, the corporate office building, etc. – or that he uses the media traditionally deployed by the architect, but that he understands the building itself as a medium. From journals to models with mirrors and glass facades, to videos in installations, to pavilions without video, we end up with spaces defined only by reflections: mirrors, glass, windows. The seemingly static pavilions themselves fully communicate the active space of the electronic media without the need of cameras or screens.

1 Dan Graham in conversation with the author, February, 2000.

2 Peter Smithson in conversation with the author, June, 2000.

3 'Alteration to a Suburban House, 1978', *Dan Graham: Public/Private*, Goldie Paley Gallery, Philadelphia, 1993, p. 36

4 John O'Hagan, *Wonderland*, documentary film about Levittown (the prototypic suburban community built on Long Island, New York, in 1947), including interviews with many original residents, 1997.

5 Jacques Lacan, *The Seminar of Jacques Lacan: Book I, Freud's Papers on Technique 1953–1954*, ed. Jacques-Alain Miller, trans. John Forrester, Norton, New York and London, 1988, p. 215. Lacan is referring to Jean-Paul Sartre's *Being and Nothingness* (1943).

6 José Quetglas, 'Fear of Glass: The Barcelona Pavilion', *Revisions*, No. 2, guest edited by Beatriz Colomina, Princeton Architectural Press, New York, 1988, p. 128.

7 Barcelona reviewer, quoted in José Quetglas, op. cit., p. 130.

8 Juan Pablo Bonta, *Architecture and Its Interpretation: A Study of Expressive Systems in Architecture*, Rizzoli International, New York, 1979, pp. 131–74.

9 Thomas Hine, *Populuxe: From Tailfins and TV Dinners to Barbie Dolls and Fallout Shelters*, MJF Books, New York, 1999, p. 49.

10 *'Picture-Window' Piece* recalls the small framed mirror that Freud hung against the window of his studio in Bergasse 19, Vienna, near his work table. The mirror (the psyche), in the same plane as the window, reflects an image of the occupant in the interior, superimposed on a view of the city outside. Beatriz Colomina, *Privacy and Publicity: Modern Architecture as Mass Media*, MIT Press, Cambridge, Massachusetts, 1994, pp. 80, 255–57.

11 Dan Graham, *Video/Architecture/Television: Writings on Video and Video Works 1970–1978*, ed. Benjamin H.D. Buchloh, The Press of the Nova Scotia College of Art and Design; New York University Press, 1979, p. 64.

12 Dan Graham in conversation with the author, February, 2000.

13 William S. Shell, *Impressions of Mies: An Interview on Mies van der Rohe, His Early Chicago Years 1938–1958, with Former Students and Associates Edward A. Duckett and Joseph Y. Fujikawa*, pamphlet, University of Tennessee, Knoxville, 1988, p. 30.

14 Franz Schulze, *Mies van der Rohe: A Critical Biography*, University of Chicago Press, 1985, p. 239.

15 Grace Miller, 'People Who Live in Glass Apartments Throw Verbal Stones at Scoffers: Chicago Tenants Praise Lake Shore Drive Cooperatives', clipping from unidentified newspaper, undated, Mies Archive, The Museum of Modern Art, New York.

16 Ibid.

17 Dan Graham in conversation with the author, February, 2000.

18 Julius Posener, 'Los primeros años: De Schinkel a De Stijl', *Mies van der Rohe, A&V: Monografías de Arquitectura y Vivienda 6*, S.G.V., Madrid, 1986, p. 33.

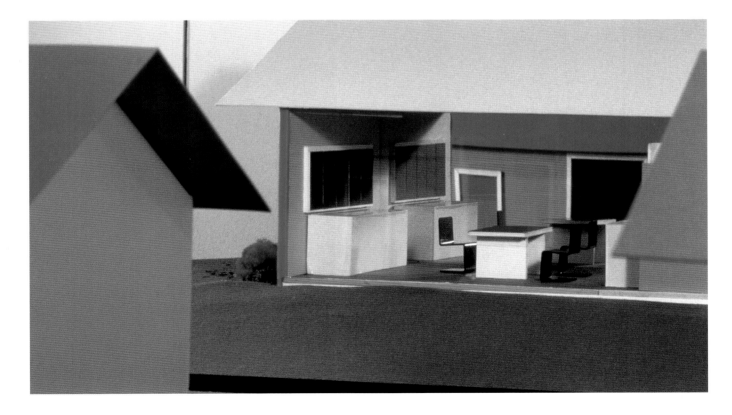

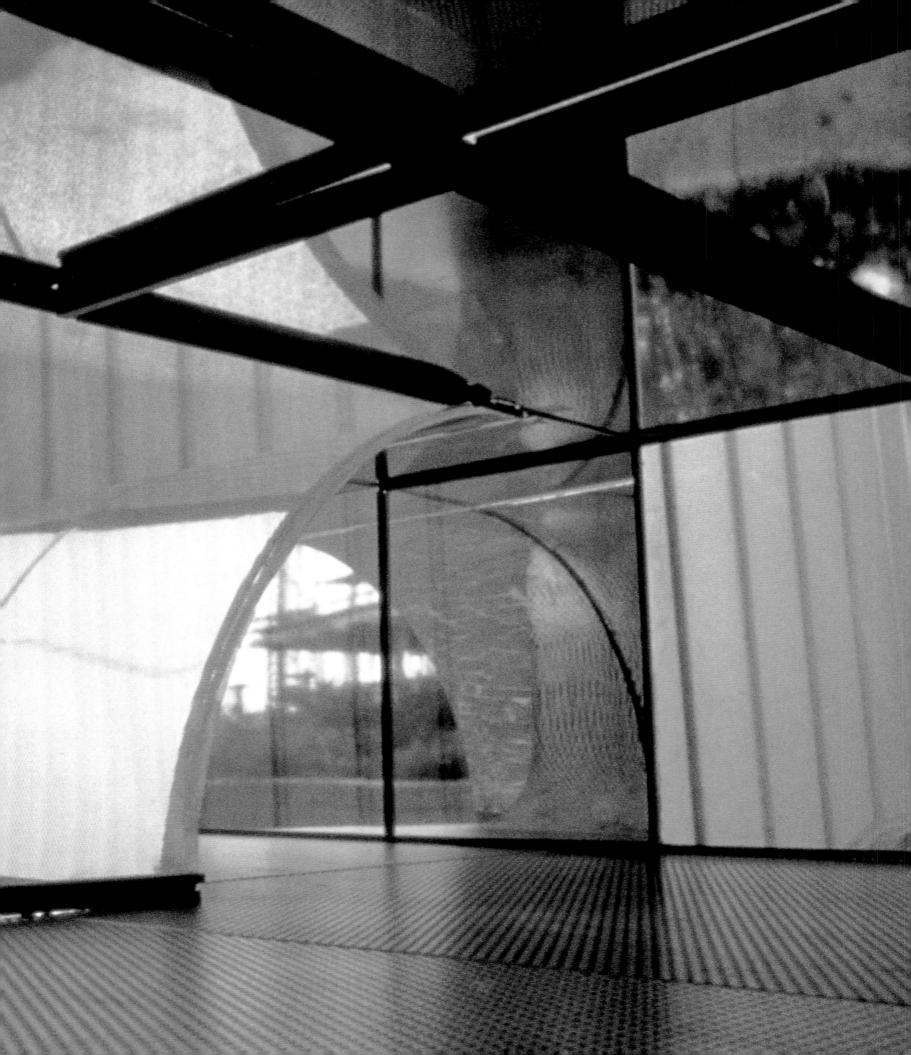

Contents

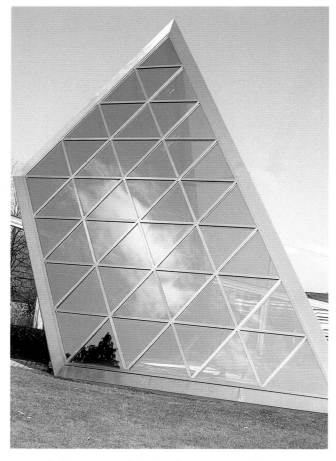

The best way to ask for beer is to sing out Ubik. Made from select hops, choice water, slow-aged for perfect flavour, Ubik is the nation's number-one choice in beer. Made only in Cleveland.

Upright in her transparent casket, encased in an effluvium of icy mist, Ella Runciter lay with her eyes shut, her hands lifted permanently toward her impassive face. It had been three years since he had seen Ella, and of course she had not changed. She never would, now, at least not in the outward physical way. But with each resuscitation into active half-life, into a return of cerebral activity, however short, Ella died somewhat. The remaining time left to her pulse-phased out and ebbed.

Knowledge of this underwrote his failure to rev her up more often. He rationalized this way: that it doomed her, that to activate her constituted a sin against her. As to her own stated wishes, before her death and in early half-life encounters – this had become handily nebulous in his mind. Anyway, he would know better, being four times as old as she. What had she wished? To continue to function with him as co-owner of Runciter Associates; something vague on that order. Well, he had granted this wish. Now, for example. And six or seven times in the past. He did consult her at each crisis of the organization. He was doing so at this moment.

Damn this earphone arrangement, he grumbled as he fitted the plastic disk against the side of his head. And this microphone; all impediments to *natural* communication. He felt impatient and uncomfortable as he shifted about on the inadequate chair which Vogelsang or whatever his name was had provided him; he watched her rev back into sentience and wished she would hurry. And then in panic he thought, maybe she isn't going to make it; maybe she's worn out and they didn't tell me. Or they didn't know. Maybe, he thought, I ought to get that Vogelsang creature in here to explain. Maybe something terrible is wrong.

Ella, pretty and light-skinned; her eyes, in the days when they had been open, had been bright and luminous blue. That would not again occur; he could talk to her and hear her answer; he could communicate with her ... but he would never again see her with her eyes opened; nor would her mouth move. She would not smile at his arrival. When he departed she would not cry. Is this worth it? he asked himself. Is this better than the old way, the direct road from full-life to the grave? I still do have her with me, in a sense, he decided. The alternative is nothing.

Gate of Hope
1992
Two-way mirror glass, steel
1,020 × 810 × 550 cm
Installation, 'International Garden
Year', Stuttgart

In the earphone words, slow and uncertain, formed: circular thoughts of no importance, fragments of the mysterious dream which she now dwelt in. How did it feel, he wondered, to be in half-life? He could never fathom it from what Ella told him; the basis of it, the experience of it, couldn't really be transmitted. Gravity, she had told him, once; it begins not to affect you and you float, more and more. When half-life is over, she had said, I think you float out of the System, out into the stars. But she did not know either; she only wondered and conjectured. She did not, however, seem afraid. Or unhappy. He felt glad of that.

'Hi, Ella', he said clumsily into the microphone.
'Oh', her answer came, in his ear; she seemed startled. And yet of course her face remained stable. Nothing showed; he looked away. 'Hello, Glen', she said, with a sort of childish wonder, surprised, taken aback, to find him here. 'What – ' She hesitated. 'How much time has passed?'

'Couple years', he said.

'Tell me what's going on.'

'Aw, Christ', he said, 'everything's going to pieces, the whole organization. That's why I'm here; you wanted to be brought into major policy-planning decisions, and God knows we need that now, a new policy, or anyhow a revamping of our scout structure.'

'I was dreaming', Ella said. 'I saw a smoky red light, a horrible light. And yet I kept moving toward it. I couldn't stop.'

'Yeah', Runciter said, nodding. 'The *Bardo Thödol*, the *Tibetan Book of the Dead*, tells about that. You remember reading that; the doctors made you read it when you were – ' He hesitated. 'Dying', he said then.

'The smoky red light is bad, isn't it?' Ella said.

'Yeah, you want to avoid it.' He cleared his throat. 'Listen, Ella, we've got problems. You feel up to hearing about it? I mean, I don't want to overtax you or anything; just say if you're too tired or if there's something else you want to hear about or discuss.'

'It's so weird. I think I've been dreaming all this time, since you last talked to me. Is it really two years? Do you know, Glen, what I think? I think that other people who are around me – we seem to be progressively growing together. A lot of my dreams aren't about me at all. Sometimes I'm a man and sometimes a little boy; sometimes I'm an old fat woman with varicose veins … and I'm in places I've never seen, doing things that make no sense.'

'Well, like they say, you're heading for a new womb to be born out of. And that smoky red light – that's a bad womb; you don't want to go that way. That's a humiliating, low sort of womb. You're probably anticipating your next life, or whatever it is.' He felt foolish, talking like this; normally he had no theological convictions. But the half-life experience was real and it had made theologians out of all of them. 'Hey', he said, changing the subject. 'Let me tell you what's happened, what made me come here and bother you. S. Dole Melipone has dropped out of sight.'

A moment of silence, and then Ella laughed. 'Who or what is an S. Dole Melipone? There can't be any such thing.' The laugh, the unique and familiar warmth of it, made his spine tremble; he remembered that about her, even after so many years. He had not heard Ella's laugh in over a decade.

'Maybe you've forgotten', he said.

Ella said, 'I haven't forgotten; I wouldn't forget an S. Dole Melipone. Is it like a hobbit?'

'It's Raymond Hollis' top telepath. We've had at least one inertial sticking close to him ever since G.G. Ashwood first scouted him, a year and a half ago. We *never* lose Melipone; we can't afford to. Melipone can when necessary generate twice the psi field of any other Hollis employee. And Melipone is only one of a whole string of Hollis people who've disappeared – anyhow, disappeared as far as we're concerned. As far as all prudence organizations in the Society can make out. So I thought, Hell, I'll go ask Ella what's up and what we should do. Like you specified in your will – remember?'

'I remember.' But she sounded remote. 'Step up your ads on TV. Warn people. Tell them ... ' Her voice trailed off into silence then.

'This bores you', Runciter said gloomily.

'No. I – ' She hesitated and he felt her once more drift away. 'Are they all telepaths?' she asked after an interval.

'Telepaths and precogs mostly. They're nowhere on Earth; I know that. We've got a dozen inactive inertials with nothing to do because the psi's they've been nullifying aren't around, and what worries me even more, a lot more, is that requests for anti-psi's have dropped – which you would expect, given fact that so many psi's are missing. But I know they're on one single project; I mean, I believe. Anyhow I'm sure of it; somebody's hired the bunch of them, but only Hollis knows who it is or where it is. Or what it's all about.' He lapsed into brooding silence then. How would Ella be able to help him figure it out? he asked himself. Stuck here in this casket, frozen out of the world – she knew only what he told her. Yet, he had always relied on her sagacity, that particular female form of it, a wisdom not based on knowledge or experience but on something innate. He had not, during the period she had lived, been able to fathom it; he certainly could not do so now that she lay in chilled immobility. Other women he had known since her death – there had been several – had a little of it, trace amounts perhaps. Intimations of a greater potentiality which, in them, never emerged as it had in Ella.

'Tell me', Ella said, 'what this Melipone person is like.'

'A screwball.'

'Working for money? Or out of conviction? I always feel wary about that, when they have that psi mystique, that sense of purpose and cosmic identity. Like that awful Sarapis had; remember him?'

'Sarapis isn't around any more. Hollis allegedly bumped him off because he connived to set up his own outfit in competition with Hollis. One of his precogs tipped Hollis off.' He added, 'Melipone is much tougher on us than Sarapis was. When he's hot it takes three inertials to balance his field, and there's no profit in that; we collect – or *did* collect – the same fee we get with one inertial. Because the Society has a rate schedule now which we're bound by.' He liked the Society less each year; it had become a chronic obsession with him, its uselessness, its cost. Its vainglory. 'As near as we can tell, Melipone is a money-psi. Does that make you feel better? Is that less bad?' He waited, but heard no response from her. 'Ella', he said. Silence. Nervously he said, 'Hey, hello there, Ella; can you hear me? Is something wrong?' Oh, God, he thought. She's gone.

A pause, and then thoughts materialized in his right ear. 'My name is Jory.' Not Ella's thoughts; a different *élan*, more vital and yet clumsier. Without her deft subtlety.

'Get off the line', Runciter said in panic. 'I was talking to my wife Ella; where'd you come from?'

'I am Jory', the thoughts came, 'and no one talks to me. I'd like to visit with you awhile, mister, if that's okay with you. What's your name?'

Stammering, Runciter said, 'I want my wife, Mrs Ella Runciter; I paid to talk to her, and that's who I want to talk to, not you.'

'I know Mrs Runciter', the thoughts clanged in his ear, much stronger now. 'She talks to me, but isn't the same as somebody like you talking to me, somebody in the world. Mrs Runciter is here where we are; it doesn't count because she doesn't know any more than we do. What year is it, mister? Did they send that big ship to Proxima? I'm very interested in that; maybe you can tell me. And if you want, I can tell Mrs Runciter later on. Okay?'

Runciter popped the plug from his ear, hurriedly set down the earphone and the rest of the gadgetry; he left the stale, dust-saturated office and roamed about among the chilling caskets, row after row, all of them neatly arranged by number. Moratorium employees swam up before him and then vanished as

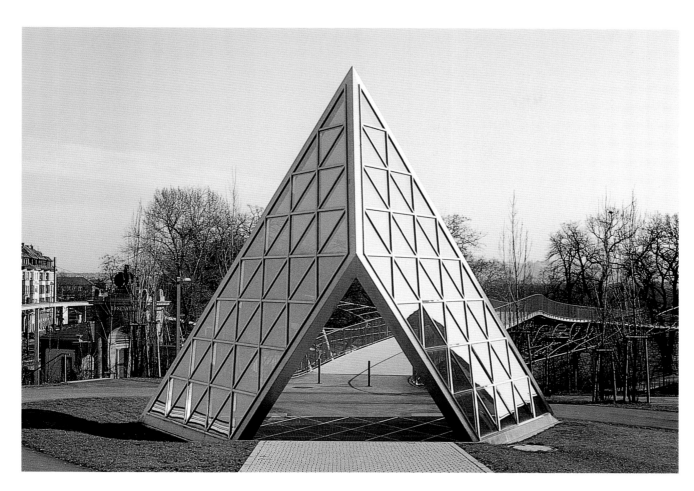

Gate of Hope
1992
Two-way mirror glass, steel
1,020 × 810 × 550 cm
Installation, 'International
Garden Year', Stuttgart

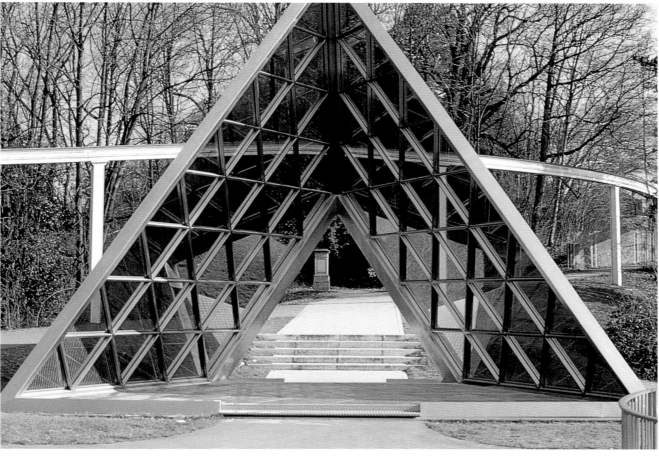

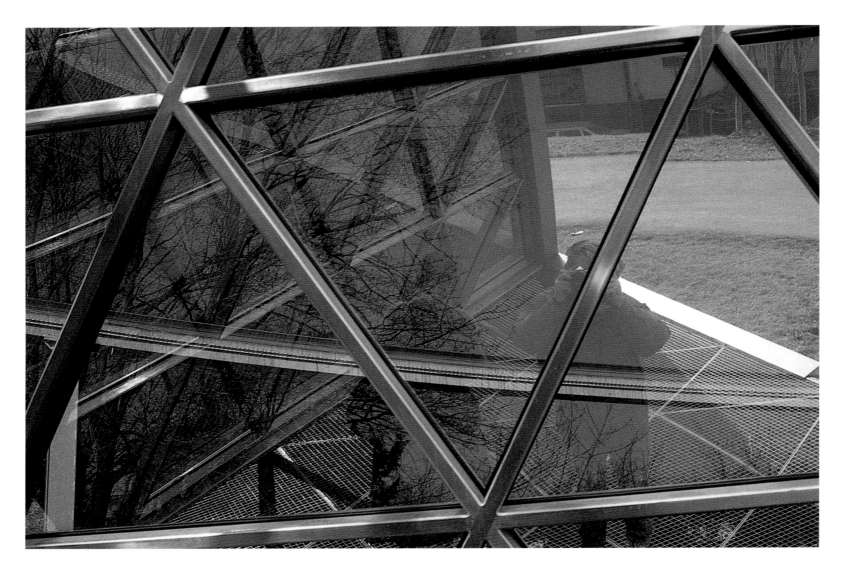

he churned on, searching for the owner.

'Is something the matter, Mr Runciter?' the von Vogelsang person said, observing him as he floundered about. 'Can I assist you?'

'I've got some *thing* coming in over the wire', Runciter panted, halting. 'Instead of Ella. Damn you guys and your shoddy business practices; this shouldn't happen, and what does it mean?' He followed after the moratorium owner, who had already started in the direction of office 2–A. 'If I ran my business this way – '

'Did the individual identify himself?'

'Yeah, he called himself Jory.'

Frowning with obvious worry, von Vogelsang said, 'That would be Jory Miller. I believe he's located next to your wife. In the bin.'

'But I can see it's Ella!'

'After prolonged proximity', von Vogelsang explained, 'there is occasionally a mutual osmosis, a suffusion between the mentalities of half-lifers. Jory Miller's cephalic activity is particularly good; your wife's is not. That makes for an unfortunately one-way passage of protophasons.'

'Can you correct it?' Runciter asked hoarsely; he found himself still spent, still panting and shaking. 'Get that thing out of my wife's mind and get her back – that's your job!'

Von Vogelsang said, in a stilted voice, 'If this condition persists your money will be returned to you.'

'Who cares about the money? Snirt the money.' They had reached office 2–A now; Runciter unsteadily reseated himself, his heart labouring so that he could hardly speak. 'If you don't get this Jory person off the line', he half gasped, half snarled, 'I'll sue you; I'll close down this place!'

Facing the casket, von Vogelsang pressed the audio outlet into his ear and spoke briskly into the microphone. 'Phase out, Jory; that's a good boy.' Glancing at Runciter he said, 'Jory passed at fifteen; that's why he has so much vitality. Actually, this has happened before; Jory has shown up several times where he shouldn't be.' Once more into the microphone he said, 'This is very unfair of you, Jory; Mr Runciter has come a long way to talk to his wife. Don't dim her signal, Jory; that's not nice.' A pause as he listened to the earphone. 'I know her signal is weak.' Again he listened, solemn and froglike, then removed the earphone and rose to his feet.

'What'd he say?' Runciter demanded. 'Will he get out of there and let me talk to Ella?'

Von Vogelsang said, 'There's nothing Jory can do. Think of two AM radio transmitters, one close by but limited to only 500 watts of operating power. Then another, far off, but on the same or nearly the same frequency, and utilizing 5,000 watts. When night comes – '

'And night', Runciter said, '*has* come.' At least for Ella. And maybe himself as well, if Hollis' missing teeps, parakineticists, precogs, resurrectors and animators couldn't be found. He had not only lost Ella; he had also lost her advice, Jory having supplanted her before she could give it.

'When we return her to the bin', von Vogelsang was blabbing, 'we won't install her near Jory again. In fact, if you're agreeable as to paying the somewhat larger monthly fee, we can place her in a high-grade isolated chamber with walls coated and reinforced with Teflon-26 so as to inhibit any hetero-psychic infusion – from Jory or anybody else.'

'Isn't it too late?' Runciter said, surfacing momentarily from the depression into which this happening had dropped him.

'She may return. Once Jory phases out. Plus anyone else who may have gotten into her because of her weakened state. She's accessible to almost anyone.' Von Vogelsang chewed his lip, palpably pondering. 'She may not like being isolated, Mr Runciter. We keep the containers – the caskets, as they're called by the lay public – close together for a reason. Wandering through one another's mind gives those in half-life the only ... '

'Put her in solitary right now', Runciter broke in. 'Better she be isolated than not exist at all.'

'She exists', von Vogelsang corrected. 'She merely can't contact you. There's a difference.'

Runciter said, 'A metaphysical difference which means nothing to me.'

'I will put her in isolation', von Vogelsang said, 'but I think you're right; it's too late. Jory has permeated her permanently, to some extent at least. I'm sorry.'

Runciter said harshly, 'So am I.'

Dear Dr. Turk,

These are the labels. The latest homeo...

(3) Trazodone 150mg.
D 30

(3) Celey 20 mg. D 10

(3) Parnate 10 mg. D 10

(3) Zyprexa 10mg. D 15

Dan Graham

Contents

The two structures discussed are from 1966 and 1967. They share the initial premise of the placement of the frame lattices of a cube form in the defined context of an interior spatial enclosure. In this they are somewhat like Josef Albers' logic in his linear 'inside/out' illusion drawings (and, to an extent, his colour squares) of what first appeared as Euclidean two-dimensional geometry, and Frank Stella's earlier sets of paintings (themselves influenced by Jasper Johns), which had as their 'content' the representation or replication of the literal structural support of the stretcher frame.

There were two related structures similar in appearance exhibited at Park Place Gallery, New York, in 1966. These consisted of cubic lattices of interlocking, identical open-framed cubic cells: one 58 inches (147 cm), the other 60 inches (152 cm) in overall dimensions. Each structure was placed on a surrounding, finite, two-dimensional taped grid on the floor. The grid in its articulated form, like the present lattice-work, was simultaneously a two-dimensional and a three-dimensional representation both of the entire space of the interior closure (the gallery room) and also of itself as idea beginning from a line.

First the artist defines meaning/
then the work takes place

As the structure is self-supporting in place as fact, so is the logic. It defines itself volumetrically and conceptually by extension, as it defines the larger limits of the enclosing context; it takes its own measure; the work is a measure of its place – of itself as placed.

The structure is defined in terms of measurement: a scale of outer and inner distances (*literally outside* the overall spatial enclosure as opposed to the 'illusory' space of the past: a space presumed to be 'in the head'). Conceptually, there is a parallel scale of distances defined: the distance in the room contained/containing the art object and the distance between the viewing subject and the viewed object being transformable to the concept of (an) art 'distance' between *object, concept* and *viewer's place,* and *place in the artist's mind* (in the past). (One becomes somehow aware that the notion of the grid is, to begin with, hypostulated/hypostatized – arbitrary – in the nature of first definitions.)

The informing relationship – by definition – is human (in some sense related to the older architectural notion of 'scale'): the fact of the bars literally barring the human viewer access to the interior of each of the structures has a defining 'distancing' effect,

and when (necessarily) viewed from their outside by the human participant, the bars' 'focus' read as intervals in the hypostulated/hypostatized orthogonal perspective of a spatial context larger than itself: appearing to 'project' transparently 'through' the transfixed viewer-reader.

'Steps' Court Building, New York City
1966
Black and white photograph
34 × 28 cm

The static view

The work is self-defining.

 For the viewer stationed in place there is a single frame of reference: each two-dimensional frame extends self-referentially only as far as its three-dimensional representation.

There is no single frame of reference/
the work conjugates itself

As soon as the viewer moves, time begins and the exterior 'space' is abolished in terms of extension; the entire 'interior' ensemble of permutations and relationships of two-dimensional and three-dimensional representations become nearly simultaneously available as 'perspectives' without spatial density or location. As the viewer moves from point to point about the art object, the physical continuity of the walk is translated into illusive, self-representing depth: the visual complication of representations 'develops' a discrete, non-progressive space and time.

There is no distinction between subject and object

object is		*subject is*
	and	
the viewer		*the viewer*
the art		*the art*

Object and subject are not dialectical oppositions, but one self-contained identity: reversible interior and exterior termini. All frames of reference read simultaneously: object/subject. The viewer as object/subject views subjectively/objectively a subjective/objective literal exterior spatial 'illusion'/'reality' […]

 The premise of LeWitt's Park Place piece(s) was next extended to a more complex articulation involving a serially extended reading process in a set of structures for four

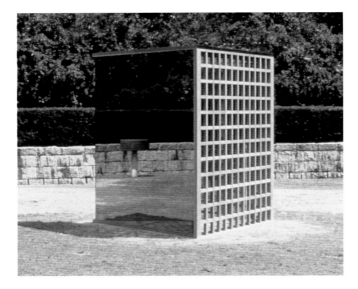

Triangular Pavilion with Shoji Screen
1990
Two-way mirror, wood, steel
250 × 250 × 250 cm
Installation, Yamaguchi
Prefectural Museum of Art, Japan

discrete interiors, although exhibited as small-scale models first. (One set was built and exhibited full-scale as a show in Los Angeles at Dwan Gallery in 1967; full-scale variations derived from pieces in the overall system were exhibited at various times in various places.) The logical first premise of this series is the grammatically represented relation of the enclosure of one thing within another thing, arranged on a grid so that the ensemble of parts are placed equivalently within the interior space of the gallery.

The four sets exhaust the dialectics of mass-space placements of a cube within a cube: outside open/inside open; outside closed/inside open; outside open/inside closed; outside closed/inside closed. There are three variables in terms of height: low, medium and high. The entire series is based upon two measurements: 28 inches (71 cm) and 81 inches (206 cm). Each set is based also upon a nine-square grid, which enables squaring a square within a square without adjacent edges. Mathematically, it is possible to translate the formal units into each other within the logic of the finite series created by the premise.

The control of such a complex of interdependent relationships by rigid *a priori* means was employed to eliminate both 'composition' and manual intrusion on the part of the artist just as the square-within-the-square subject matter repeats the conceptual necessity mirroring the work's placement in a gallery environment.

Total serialization of relations produces an autonomous, self-contained structure: the method is one of 'unseeing'; nothing adds up to the whole 'picture'; all expressive or 'interesting' effects – incident – are eliminated. Also the elimination of the usual linear reading of sculpture by the viewer produces no 'growth' (projected movement) regulating the parts in a progressive, sequential order. Instead, autonomy is given to a set of discrete levels. Each group is thus autonomous to its own level and still part of an equally discrete larger level until the 'highest' level of related levels is reached, a level which is also complete and self-contained. This may be read or arrived at in whatever information/time order the viewer *himself* brings to it. Serial procedures produce non-hierarchical and non-centralized orders, so they impose no principle of dominance or subordination, no hierarchy of levels: the whole is neither greater nor lesser in importance to the reading than its division into sub-sets. The logic is absolutely efficient. Each spatial relationship can be represented by discrete numerical values so that the series of works is built from the simple multiplication or addition of the sum of the smallest unit common to all the interlocking dimensions. This has the virtue of neutralizing horizontal or vertical biases (common to a traditional sculptural reading – i.e., 'meaning') to a common proportion, which regulates every spatial element – inside to outside, height

**Empty Shoji Screen/Two-way
Mirror Pergola**
1996
Two-way mirror, glass, wood, steel
120 × 100 × 40 cm
Installation, Galleria Massimo
Minini, Brescia

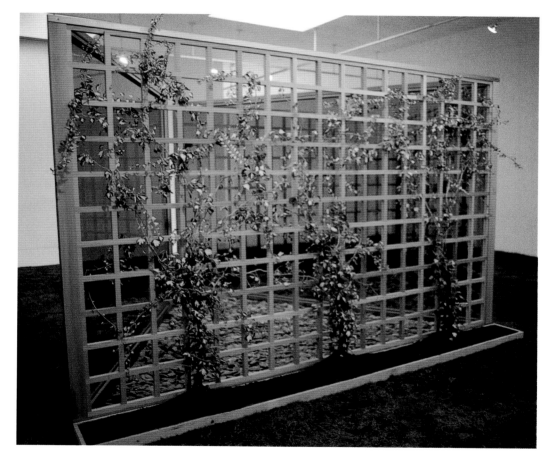

to width progressions, etc.

In LeWitt's structures it is the *interval*, manifested paradoxically in those parts of the artist's system to 'objectify' as space-occupying articulated presence – which gives the work substance. This is opposed to the usual artistic preoccupation with '*space*'; for LeWitt, 'space' may be read literally as air.

Originally published as 'Two Structures/Sol LeWitt', *End Moments*, New York (self-published), 1969; reprinted as 'Thoughts on Two Structures', *Sol LeWitt*, Haags Gemeentemuseum, The Hague, 1970; reprinted as 'Two Structures/Sol LeWitt', *Dan Graham: Articles*, Van Abbemuseum, Eindhoven, 1978. Revised 2001.

Photographs of Motion 1967/69

right and opposite, **Helix/Spiral**
1973
2 35mm films, 3 min., black and
white, silent, to be projected
simultaneously

The subject of motion through historical time has been pictured paradoxically: Zeno's early Greek word picture goes: 'If at each instant the flying arrow is at rest, when does it move?' (Zeno's object was to prove that continuous motion in time did not, logically, exist.) Forward to Joseph Pennell's observation on the early photographic object around the time of its first appearance in the mid nineteenth century: 'If you photograph an object in motion, all feeling of motion is lost.'

In the same way an abstraction of 'subject'/'object' framed and measured by verbal logic produces an equivalent illusion: a paradox. A look at the historical framework of motion picture photography permits multiple reference points, suggesting an illusory connection between the mechanism of its appearance and what we refer to as objective 'reality'.

The earliest devices made movement to reproduce movement, done either by moving the pictures themselves, or by moving their projected image optically, or by projecting them upon a mobile medium. The Laterna Magica used glass slides introduced from the sides. From this developed the technique of putting a sequence of several pictures on the same slide and showing them in succession in a continuous motion (the impression produced like that of seeing the world go by through the window of a moving car, with the single inversion that the movement represented by objectively *real* motion is illusory – i.e., the subjective experience of seeing the world slide by the window). For the next step it was necessary to invert the process: to fixate the *real* mobile to be reproduced as an illusion by means of the immobile. A series of still photos provided the means …

A time exposure of someone stationed before a camera as he changes expression yields a blurred picture due to the successive phases of the expression being overlaid (in time). The recording of periodic events represents a borderline case: the photograph of an oscillating pendulum will produce sharp images of the two extreme positions on each side. The 'image' of periodic movement in time is made evident by the fact that it gives an impression of complete rest.

In 1865 Étienne-Jules Marey was investigating the problem of accurately recording the motion of a horse trotting or galloping so that the period during which each of the horse's feet touched the ground could be established. His solution was to insert a

Étienne-Jules Marey
Horse Running
c. 1886
Black and white photograph

Eadweard Muybridge
Occident Trotting, Palo Alto, California
1878
Black and white photograph

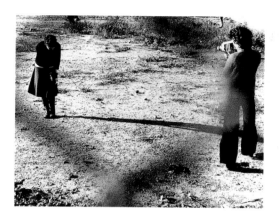 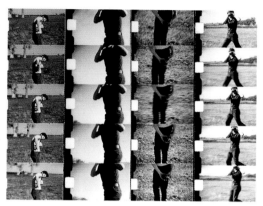

rubber ball in the hollow of each hoof of his subject, from which issued a long rubber hose. This led to an inked pen, which – whenever the animal placed its foot to the ground and increased the pressure of the rubber ball – drew a line on a piece of paper which was stretched around a continuously rotating drum. A registering instrument carried in the horserider's hand had four tubes, which led to four corresponding pens arranged one above the other. The length of time, in addition to the overlap of successive strokes on the registration paper, showed the time elapsed and the reciprocal relation between the lowering and rising of each of the horse's four feet. Later Eadweard Muybridge was commissioned by ex-Governor Leland Stanford of California to prove Marey's conclusions wrong. The Governor had wagered $10,000 in support of his belief that at some point all four legs were off the ground. Progress on the test was made when a new 'lightning process' in printing greatly reduced the shutter time exposure required, and with the introduction of drop shutters activated by strings and rubber bands (later by electricity) broken by the racing horse.

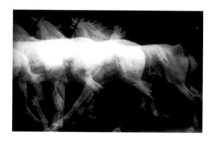

Soon the successful photographs (Stanford had been right) were extended by Muybridge to all types of animal locomotion (human locomotion included) and shown to the public by means of another Muybridge 'invention' – a modified stereopticon re-named the 'zoogyscope'. (The original stereopticon had been invented by Peter Mark Roget when he observed two principles: firstly, that a standing man walking on the other side of a slatted fence appeared through the slits to be in movement. Secondly, that the parallel disparity between the images of each of the observer's eyes as they viewed the flickering images from slightly different perspectives could be re-created using a revolving glass cylinder. When seen through slits of a real cylinder, the figures appeared animated; this was the *modus operandi* of the device Roget perfected.)

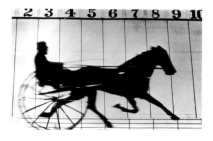

Muybridge mounted transparencies of his photographic series on a circular glass plate. A second glass plate and another plate of metal were then mounted parallel to the circular glass, but turned on a concentric axis in the other direction. The metal plate was slit at intervals, so that when the two glass plates rotated it acted like a shutter. An arc lamp projected the resulting image on a screen.

Later, in addition to using twenty-four fixed cameras, Muybridge used two batteries of twelve so that along with the front view, rear views and 60-degree angle

right, above, **László Moholy-Nagy**
Light-Space Modulator
1923–30
Steel, plastic, wood
h. 151 cm

right, below, **Marcel Duchamp**
Nude Descending a Staircase No. 2
1912
Oil on canvas
147.5 × 89 cm

opposite, **Fernand Léger**
Ballet méchanique
1923–24
Film frames

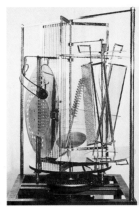

shots were taken simultaneously (using an electric circuit connected to a tuning fork which left graphic records on a sheet of paper). Exact time calculations could be made in relation to a grid marked upon the background to relate time to motion to a perspective system.

The photographs were published, the three angles in the series as a run per page. In looking at a Muybridge series: there is no fixed point of view when a group of cameras photograph the moving object in succession, a set of phases being recorded. But, since several cameras can't be set up in the same place, the stationary point keeps changing. The relationship between the camera and moving object may be kept constant by using a different camera for each phase along the path. The releasing mechanism is dependent upon the movement of the object. The resulting photos are arranged in two-dimensional rows on the pages so as to have multiple, static points of reference.

There is no single, fixed point of view. The changes are positional and only involve the motion of the *reader's* eye. This is unlike Renaissance perspective where there is a linear vanishing point 'inside' the frame. Photography eliminates this illusion: there is no central or climatic point.

Each image is always in the present. No moment is created: things – moments – are sufficient unto themselves. In Mallarmé's words: 'Nothing shall take place except place.' We see and measure things only in terms of related distance or ordinal placement. What separates one moment (shot) from another is the simple alteration in the positioning of things. Each shot – moment – can be read without relation to the preceding or following one, as they aren't linked. Things appear not to come from other things. Things don't happen: they merely re-place themselves relative to the framing edge and to each other.

The conventions of black and white still photography: a two-dimensional object that appears at once solid and transparent functioning simultaneously in two entirely different planes of reference (the two-dimensional and the three-dimensional). As one identical object, it fulfils two different functions in two contexts: first, as an image per frame which is always in the present. The image is fixed and limited to a contrast of light to be read all over horizontally – unlike Renaissance perspective in painting, where the artist (not in the picture) was trying to re-present impressions by fixing (composing) for all time his exact 'linear' perspective of things at a given moment. Secondly, as pictorial depth equated with the time it takes the eye to enter that depth …

Jules Marey, hearing of Muybridge's work, concluded that a battery of twenty-four separate cameras was too dumbly discrete, making it difficult to relate an action. Marey had by this time been influenced in his work by a French astronomer, Pierre Jules César

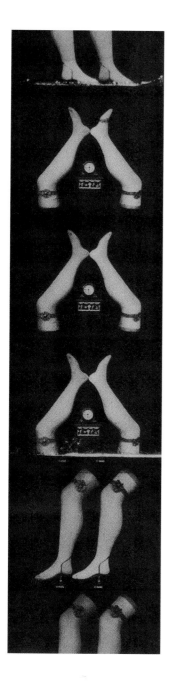

Janssen, who in 1874 used photography to record the positions of Venus during its transit across the face of the sun, having invented a 'photographic revolver' in which forty-eight instantaneous shots in juxtaposition were taken around the margin edges of the negative (a circular plate) as it rotated. The plate was timed to move forward at intervals, but remain stationary during the exposure. Marey's improvements on this method began in 1882 with the invention of a device with stationary plates and a moveable disk shutter to record in equal time-intervals pictures of successive phases of motion of objects on a black background. When an object to be photographed changes location in relation to the plate while it is moving, the phases that follow each other in time can be presented next to each other on a two-dimensional plane. The same year, Marey devised a set-up with moveable plates, which closely followed Janssen's 'gun', but was equipped with a sight and clock movement for picking up birds in flight. A few years later a 'chrono photograph' with stationary plates was installed in a moveable darkroom. It consisted of a rotating disk 41 feet (12.5 m) in diameter with a slot opening so that the disk turned ten times a second, each exposure 1/1000 of a second. Here the continuum is broken up into separate, sharp images – the recording interrupted periodically and the resulting exposure short enough to yield sharp pictures.

After 1890, Marey utilized a new serial device in which a strip of negative paper was used. When moved by a string, the negative paper wound itself continuously from spool to spool and remained stationary for a moment during exposure. The photographs produced this way, however, were not suitable for projection because of the unequal distances between pictures. At the time there was no transparent film suitable for projection. All that remained was the invention of the celluloid filmstrip, a camera and a projector (recording and projecting devices) to provide the packaged continuity of images: that was 'invented' by the American packaging genius, Thomas A. Edison.

Ironically, it wasn't the new medium of cinema (which evolved from Edison's invention) that first 'moved' artists; it was the preceding steps along its path. Marey's work is recalled by the Futurists and most notably, by Marcel Duchamp's paintings, culminating in *Nude Descending a Staircase,* whose overlapping time-space was directly modelled after Marey's superimposed series. Léger, Moholy-Nagy and others utilized the motion picture (as did Duchamp at a later date), but only as an available tool and not in terms of its structural underpinnings. It wasn't until recently, with the 'Minimalist' reduction of the medium to its structural support, in itself considered as an 'object', that photography could find its own subject matter.

'Photographs of Motion', *End Moments,* New York (self-published), 1969. Revised 2001.

Live Kinks 1969

Wild in the Streets, The Sixties
1987
Mini rock opera for stage and live
television adapted from the 1968
film, *Wild in the Streets*
Collage by Marie-Paule MacDonald

… The Kinks' composition, *The Last of the Steam-Engine Trains*, into which Ray Davies, 'flakey', shakily settled, was long-winded the first time around. 'You'll get what it's about', Ray told the audience, his craggy moonface a total (full) smile as broad as the sun or a kind of a caricature (the face of his 'brother and competitor', Dave, reflecting from the other side of the universe more of a grimace than a smile as he joined in for the chorus gliding forward as the two sung to their respective mike stands). 'OK!, I'm OK … '

Here the two brothers, in stop-and-go breathing, together, are gasping for air as they attack the song, setting the mechanism in motion; it still rolls. The climax comes in one last perversely lengthened 'rave-up': a series of discontinuous punctuations of sound which gradually succeed more and more-or-less in cancelling each other out when crossed by the extreme feedback; the effect, in the end, a flat, electronic, static, monotone devoid of interest (or rhythm) at one moment; and then a complexly patterned cross-rhythmic space and/or jarringly present simply as surface noise (texture).

In the beginning of their careers, the group's music gravitated between a sea-sickening (lurching) nauseous roll and a mineral-hard mechanical pulverization. Each discrete, mechanical phrase of lyric strata was a punctuated hollow of sound surrounded by surface vacancy. Wherever emotion was indicated instead there was only inexorable and tired anticipation:

So tired
Tired of waiting
Tired of waiting for yo–ou

Ray Davies was one step beyond Little Richard's incredible phrasing – his ability to breathlessly extend a point to a line and leave us gasping; where the mechanical problem of aspiration (breathing) and articulation (getting it out) help to determine the form. Examples are *You Really Got Me Goin'* and *All of the Day and All of the Night* (the first of Ray's *Steam-Engine Trains*). Here the mechanism of the song is set into motion with the words reduced to redundant figments of non-progressive, isolated, flat staccato, declarative eruptions indicating no movement – arrested emotion. Where everything is as if rushed, stop-and-go, breathing then, monotonous and brittle – susceptible to breakdown and decomposition at any point. Then came *Who'll Be the Next in Line*, its asthmatic, stop-and-go breathlessness and exaggerated use of echo chamber producing a shallow, overlapping 'hollow' surface (vacancy) whose nominal 'line' of meaning ('who'll be the next in line, who'll be the next in line … for you') is

caught, stopped and monosyllabicaly 'washed out' in the process. Everything glides along a single train; there is no movement during the built-up, pseudo-climax of the *Last of the Steam-Engine Trains*. They say: 'I live in a museum, but I'm OK.' Superficial, speeded-up, gasping for some air and condensed to agoraphobia.

The agoraphobic emotion glides (on the tonal expression in *See My Friends*) into the perfect vacuum in a depthless vortex of lost feeling: nostalgic, sweet, blandly climaxless, circular, inexorable, unmodulated, overmodulated, unrushed, depthless and even.

By their *Kinda Kinks* album, a collection mostly of subdued country-type songs with a regretful air, the lines go too long without air (there is now real difficulty in even breathing). Easily winded, flat, even, deflated, nearly singsong, supportless, as in:

> *Got my feet on the ground*
> *And I'm standing on my own*
> *I don't need no one*

Words (and images) are overlaid by double-tracked recording, not quite synchronized, over-dubbed with echo-chamber effects, drawn too loosely, drawn clichés of rock, played out, vacant situations cut short at the beginning as in *Something Better Beginning*, where the evenness of vocal modulation in the declaration is placed in doubt, suspended, become almost hysterical in the drawn-out words.

Ray is dressed in a spectrum-coloured banded polo shirt. The second set of their performance begins and Ray has forgotten he had performed in the first set (about an hour and a half earlier) *The Last of the Steam-Engine Trains*, his autobiographical confession: 'I like the song. A lot of people like the sound, but I like the song.' This time, in the middle of it, he interposes a chant or a poem (the words were too soft), a moving elegy or perhaps a mellifluous death-moan for what (and where) he has been and has vanished. His mouth is completely open, like a smile, not quite a parody, an expression that also may be read as a genuine smile (is a cat really intending to be sardonic when he appears to us that way?).

By the end of the song, the Kinks were orchard-coloured bodies attired in bright reds, pale to flamingo pinks, light 'butterfly' yellows, yellowish and off-shade green casting orange shadows, giving an awkward kind of prettiness – the sugary, simpering narcissism of *fin-de-siècle* dandies.

The Kinks
1966

After *Dandy*, Ray bowed to previous requests for *Fancy,* which, played with melismatic ease, goes nowhere on its surface:

Fancy if you believe in
What I believe in
Then we'll be the same

My love is like a ruby
That no one can see
Only my fancy
Always

No one can penetrate me
They only see what's inside their
Own fancy
Al-ways

Observing the 'poetic' expression on Ray's face, we see an image dissolve into two and a multitude of self-reflective images which, when they merge (as in *Two Sisters* – another ethereal surface tragicomedy), cancel themselves out. *Two Sisters* cancels itself out: the mirror-image is fixed and there are no resolutions – or, the 'end' to which the image unwinds is actually (due to authorial overview or contrivance) the dead centre of the played-out length of the song – so for the rest of the song the narrative simply unwinds backwards.

Victoria (Ray in another guise?) – a mellow and loamy yearning for innocence – his Wiffenpoof Song. 'She' evokes the magic and witchery (See *Wicked Annabella* on the *Village Green* album) of the English country in the guise of a scarecrow effigy (overstuffed and so also hollow), puffed-out, slightly tipsy and lost pride (pricked, insulted but defensible).

And through it Ray's voice carries it all: from the raunchy 'Little Richard-influenced'

beginning, to the flat, recitative, tragic-comic *Well-Respected Man*, to the weary, wry resignation of *Where Have All the Good Times Gone,* to the pleasant flatulence in *Sunny Afternoon* to Sinatra-like mellifluous acceptance. 'I have seen life and it has passed me by but I am no longer weary, just rather pleasantly ambient.'

> *Well, lived my life and never stopped to worry 'bout a thing*
> *Well, once we had an easy ride and always felt the same*
> *Time was on my side and I had everything to gain*
> *Let it be like yesterday*
> *Please let me have happy days.*
> *– Where Have All the Good Times Gone*

'Mr Pleasant' lives in the suburbs where there isn't anything to dislike. All is pleasant, bland and empty (a trifle smug): lazy modern split-levels, *House in the Country*, plastic with leather texture, the formica on wood, the cute 'modern' patterns on jets and refrigerators. A housing development in Florida, which, for instance, features eight musical possible 'styles':

 A The Sonata

 B The Concerto

 C The Ballet

 D The Overture

 E The Prelude

 F The Serenade

 G The Nocturne

 H The Rhapsody

Brian Wilson (*Surfin' USA*), Paul McCartney (*Yesterday*), Bob Dylan (*Too Much of Nothing*) all share the same astrological sun sign: Gemini. But Davies was born 21 June – cusp with Cancer – so he is made more 'moony' (poetic) and involved with things of the house.

'Live Kinks', *Fusion*, Boston, 1969; reprinted in *Performance*, John Gibson, New York, 1969. Revised 2001.

Donald Judd
Untitled (Eight modular unit,
v-channel piece)
1966–68
Stainless steel
120 × 313 × 318 cm

I. Judd

Objects will be *there* before being *something*; and they will be there afterwards, hard,
unalterable, eternally present, mocking their own 'meaning' …
– Alain Robbe-Grillet, 'For a New Novel'

Time takes place between parentheses … to keep man from participating in its
fabrication.
– Roland Barthes on Robbe-Grillet

With one of Don Judd's objects, the observing subject is separated from the 'object'. As
neither spectator nor artist projects meaning onto these objects, what is encountered
has the appearance of an open, phenomenal world; things are as they (simply) appear to
be. Surface reflections from these objects define plane projections from the wall; there
is no interior core of meaning. 'Art' is no mediator of experience transcribed by the artist
and sent out for later viewing – what is there being only the buoyant visual presence. All
points of view before a Judd – attempted part-to-part, 'whole' perspectives on the work
– are present only as literal distance – air ('space') – from the physical object, and not as
a place of interior reference; they exist as architectural separations between external
parts. These objects exist within an architecturally defining shell, although standing in
altered relation to this enclosure: Judd's forms simply appear as nonutilitarian,
adventitious additions. There is no general, artistically imposed, internal ordering of the
parts of the composition of the elements, for Judd rejects the notion of 'order' and
'structure', as 'both words imply that something is formed'. Material, area, volume,
space or colour is ordered or structural. This separation of means and structure, the
world and order, is one of the main aspects of the older art. 'In older art, order [was
assumed] within … everything.' Order in Judd's work is more specific, contextual to
placement. The work's placement in terms of a 'structure' is only 'local order, just an
arrangement'.

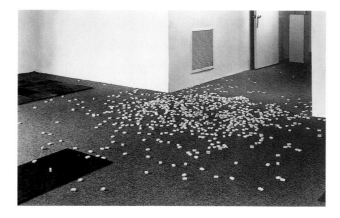

II. Andre
Things in their elements, not in their relations.
– Carl Andre

[…] Things take place in a visual field. Place means defining a field (as Carl Andre actually did outdoors at Windham College in 1968, basing his unit of measured size and weight to the base product of the area – bales of hay): the verb form being 'to take place' or 'taking place' – things take place. The field is perceptual as it is specific (the literal area). It is a rule that things on the perceptual field tend to be in contact with the ground (instead of in the air) and distributed over the ground with an even scatter. This is the premise for a group of works with small particles, among them *Spill (Scatter Piece)*, 1966. Its constituents were 'composed' gesturally by gravity as if they were dropped by the artist from a height. Perception of an Andre is reduced to ground field (perceptual field): the longitudinal surface is the field, literally the ground that is the bottom of our visual field by which we judge distance, shape, light, contour of all elements. Figure is identical with ground and perspective in his material blocks defining the ground to be covered. Andre let his bases precipitate (as material illustration of a rule) the artist's action in placing the forces in motion (being only a specific instance of a general precept). Random distribution by the force of gravity introduces order as an illustration of a general *a priori* (known) law. The artist precipitates the information and the observer (in a later time/space, but in the same place in the particular sense Andre uses this definition) senses the precipient (reads it) much the same as Andre's 'reading has put it'. Theoretically, the particles aren't prostrate, but recoverable, part and parcel of an ongoing environmental process and available for possible recombination with other elements in different orders. First, the portable material is transported to the place, arranged for viewing. No one is 'transported' into an imaginary world or view. Instead, the material constituents of the vision are literally transported from view when the exhibition is terminated and put to perhaps a nonrelated use as part of a different whole in a different, not necessarily related future (like Flavin's fluorescent units). Andre's time is mechanistic in the Newtonian sense, events being reducible to matter varying in space with time (i.e., in motion, and can be analyzed in terms of motion). Andre's place is the base dimension of space as spread out along a horizontal and vertical geometrical axis and location in relation to the viewer's points in space. All viewer relationships to matter presented are a function of the co-existence of time and place. Andre's art – as is also the case with Judd and LeWitt – treats the viewing subject as object – ground; just as the artist, in placing the material grounds for viewing, *is in/places the object in* a prop position to their functioning. The artist and viewer are read out of the picture […]

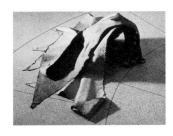

Bruce Nauman
Untitled
1965–66
Latex rubber, cloth
h. 35.5 cm

Bruce Nauman
Slow Angle Walk (Beckett Walk)
1968
Video, 60 min., black and white,
sound

III. Nauman I

[...] Latex rubber (in later works it is backed with cloth) is dropped on the floor or placed in corners to evidence its handling by the artist (and gravity acting upon material pressed upon its architectural support). This work is read because of its surface topological deformation (present in the material's *expansion, contraction* and *skew*) – the impression (cast) of the material forces in process (their velocity and direction) as revealed in the material in its present state. In place of the rigid notion of Euclidean geometry (as in 'Minimal' sculpture), these 1965–66 works of Bruce Nauman transform the medium (rubber) as it (the medium) acts as a medium conveying its material information. It acts as a record of its material changes of interaction and of its own material nature in yielding to natural forces (its own, the environment's and the artist's physical presence and procedures in placing it), while it (also) is inseparable from the material environment continuum in which it is present (to us, the viewers). Its present state yields a reading of its material reality: at once elusive past record and present material/perceptual presence. Further, the continuous transformation of image in such 'rubber-sheet' geometry correlates with the spectator's act of apprehension of the material object via eye and body movements as the spectator's visual (itself in the process of alteration, although usually at a much slower rate of change) itself shifts in a topology of expansion, contraction or skew.

In another group of works, Nauman turned to himself as the body of work: himself, his (its) own literal informing subject matter. These performance works consist of calisthenics performed by the artist and available for direct kinaesthetic reading by those present. These events are to be read in the topological skin of the artist's body, extended and undergoing a continuous topological, geometrical extension. The body information is the medium; the body information is the message for the presence of ... *Nauman himself*. There is no longer the necessity of a material (other than the artist's body) for the mediation. This work is in the present in the presence of the spectator; this is in contrast with the rubber-sheet sculptures, whose presence is constituted (for the spectator) as the sum of past processes. Just as Nauman has inverted his relation to the sculptured material he works upon, he now becomes the 'object' and the 'subject' simultaneously: he is both artist and material, both perceiver (as he perceives himself in order to execute the piece) and perceived, and both exterior and interior surface [...]

right, **Richard Serra**
To Lift
1967
Vulcanized rubber
93 × 211 × 90 cm

below, **Richard Serra**
Tearing Lead from 1:00 to 1:47
1968
Lead
Approx. 300 × 300 cm

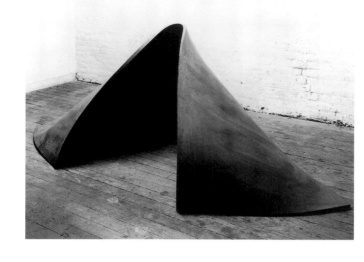

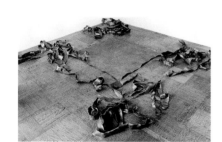

IV. Serra

Richard Serra's rubber sheets of 1967–68 state the relation of processes: material to artist to spectator's viewing time. Everything takes place (is located) in the informational order that is the spectator's time-process for reading the residue. For methodological clarity, Serra's works can be described by a simple verb action performed on the material by the artist, for example: *to fold, to tear, to throw*, etc. A specific activity performed upon a specific material is available to the viewer as residue of an information time (the stage of the process described in applying the verb action to the material). The viewer's time-field is as much part of the process (reading) as is the artist's former relation to the same material and the material's process in the former time […]

The viewer stays in his own time-space continuum in attempting to reveal the process (realizing he can't go back again to the prior point where the process began – as one is expected to, illusionistically, in a pictorial or representational art-object). An impression of *there* implies an impression of *here*. There remains only the physical trace of the time sequence as reflected in the deformation of the texture (or the surface) in relation to the present state of reading the matter: information read after a time-lag or a material shifting and relative to the time-space position of the viewer's own physical location. This information is always altered in the process through what has happened to the medium (material) subsequent to its handling by the artist and to the fact that the viewer's information sequence has not come from the same time-space continuum as the apprehended residue until the moment when the two coincide in apprehending the material presence of the sculpture. The residue still remains in its own self-enclosed frame of reference despite the shifting interaction as the viewer walks about the object, its transformations yielding a record of its past. So if there is a time, it is hidden in the object itself and it allows itself to reveal itself as the spectator tries to deal with the false possibility of reducing his *a priori* conceptualization of its sequences of past behaviour.

'Subject Matter', *End Moments*, New York (self-published), 1969; reprinted in *Rock My Religion: Writings and Art Projects 1965–1990*, ed. Brian Wallis, MIT Press, Cambridge, Massachusetts, 1993.

Roll
1970
2 Super-8 films (enlarged to 16
mm), 1 min., colour, silent, to be
projected simultaneously

One filming camera is an inert object, detached (although within the performer's visual field), while the other camera, attached to his eye, is both subject and object. The 'objective' camera is placed with its base on the ground. The performer positions his body and a second camera is placed to his eye, so that this camera's frontal view is directly parallel to the inert camera's view and at the line of its left framing edge. With both cameras filming, the performer with camera to his eye rolls slowly towards the right framing edge of the other camera's view, with the aim of continuously orienting his eye/camera's view to centre on the other camera's position (and image).

The performer's legs and frontal body trunk protrude at the bottom of the held camera's eye frame through which the performer must observe his shifting postural placement as feedback needed to achieve his orientation (and his image's). His camera observes (from within) the body's kinesthetic sensations. The performer, from within his eyeview inside the feedback loop, observes the body's shifts as it changes position in space in relation to the position of the aim (the fixed camera). The brain must correct the muscles to cause a skeletal alignment; this affects the camera's aim. It must be re-aligned by the hands to keep open the visual feedback between the two camera's images (upon which the perception of the piece depends).

The two films' images are projected for simultaneous viewing at eye-level on opposite, parallel walls. Observing the view from the first camera's body-feedback loop, the spectator sees a continuously rotating image. The body is subjectively experienced as weightless. The view from the second, 'objective' camera shows the body from outside as a weighted object orienting itself, but under the influence of gravity opposing a stationary, parallel force pressing down upon the body's muscular/skeletal frame.

'Roll' (1970), Dan Graham, *Films*, Éditions Centre d'Art Contemporain, Geneva; Écart Publication, Geneva, 1977. Reprinted in *Dan Graham*, ed. Gloria Moure, Fundació Antoni Tàpies, Barcelona, 1998, p. 85.

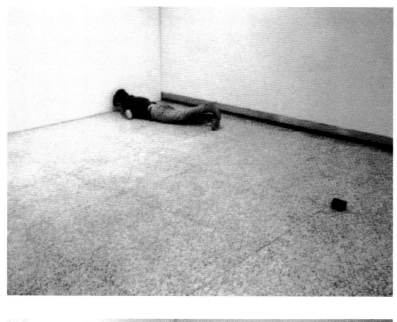

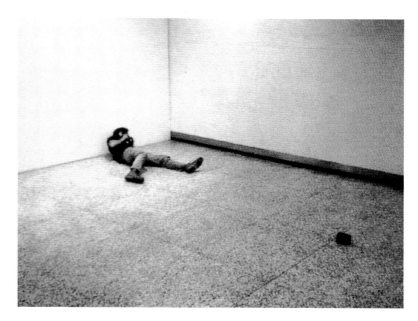

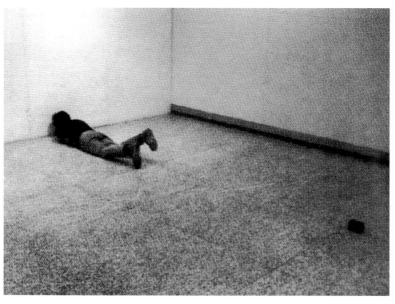

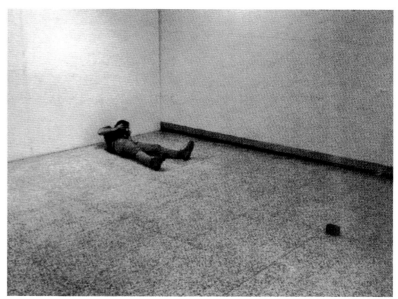

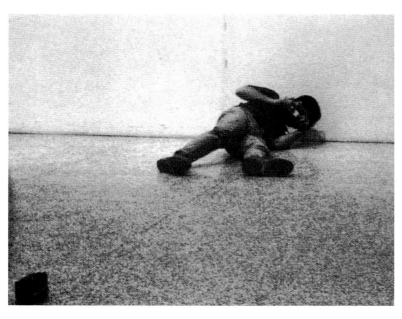

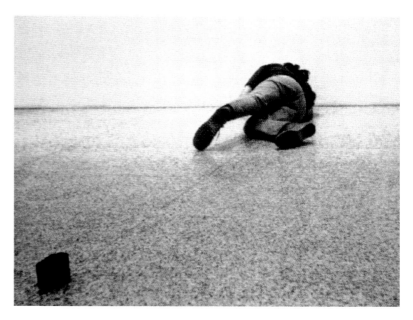

Body Press
1970–72
2 16mm films, approx. 20 min.,
colour, to be projected
simultaneously

Two filmmakers stand within a surrounding and completely mirrorized cylinder, body trunk stationary, hands holding and pressing a camera's back-end flush to, while slowly rotating it about, the surface cylinder of their individual bodies. One rotation circumscribes the body's contour, spiralling slightly upwards with the next turn. With successive rotations, the body surface areas are completely covered as a template by the back of the camera(s) until eye-level (view through cameraman's eyes) is reached; then reverse mapping downwards begins until the original starting point is reached. The rotations are at correlated speed; when each camera is rotated to each body's rear it is then facing and filming the other where they are exchanged so the cameras' 'identity' 'changes hands' and each performer is holding a new camera. The cameras are of different size and mass. In the process, the performers are to concentrate on the co-existent, simultaneous identity of both the camera describing them and their body.[1]

Optically, the two cameras film the image reflected on the mirror, which is the same surface as the box (and lens) of the camera's five visible sides, the body of the performer and (possibly) his eyes on the mirror.

The camera's angle of orientation/view of area of the mirror's reflective image is determined by the placement of the camera on the body contour at a given moment. (The camera might be pressed against the chest but such an upward angle shows head and eyes.) To the spectator, the camera's optical vantage is the skin. (An exception is when performer's eyes are also seen reflected or the cameras are seen filming the other.) The performer's musculature is 'seen' pressing in to the surface of the body (pulling inside out). At the same time, kinesthetically, the handling of the camera can be 'felt' by the spectator as surface tension – as the hidden side of the camera presses and slides against the skin it covers at a particular moment.

1 The camera may or may not be read as extension of the body's identity.

'Body Press' (1970–72), Dan Graham, *Films*, Éditions Centre d'Art Contemporain, Geneva; Écart Publication, Geneva, 1977. Reprinted in *Dan Graham*, ed. Gloria Moure, Fundació Antoni Tàpies, Barcelona, 1998, p. 88.

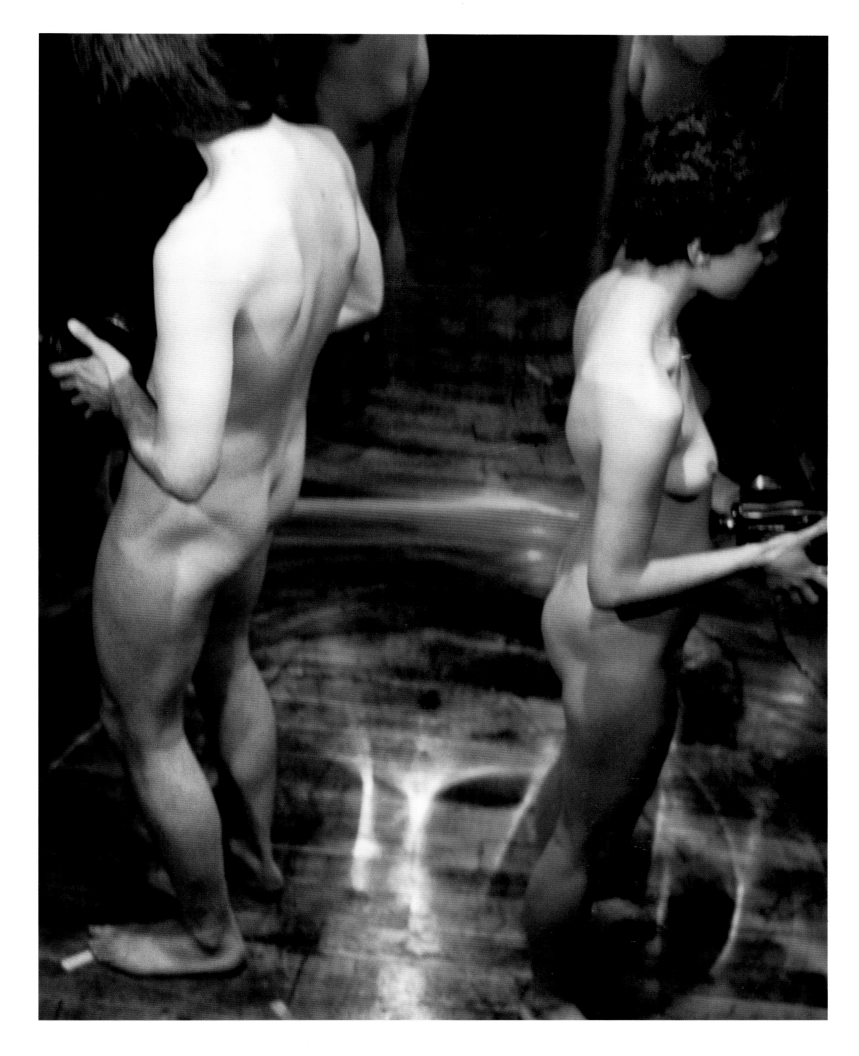

Essay on Video, Architecture and Television (extract) 1979

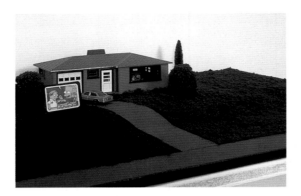

Video Projection outside Home
(Model)
1978/96
Painted wood, synthetic materials
22.5 × 77 × 51 cm

I. Film and Video: Video as Present-Time

Video is a present-time medium. Its image can be simultaneous with its perception by/of its audience (it can be the image of its audience perceiving). The space/time it presents is continuous, unbroken and congruent with that of the real time which is the shared time of its perceivers and their individual and collective real environments. This is unlike film, which is, necessarily, an edited re-presentation of the past of another reality/an other's reality for separate contemplation by unconnected individuals. Film is discontinuous, its language constructed, in fact, from syntactical and temporal disjunctions (for example, montage). Film is a reflection of a reality external to the spectator's body; the spectator's body is out of the frame. In a live-video situation, the spectator may be included within the frame at one moment, or be out of the frame at another moment. Film constructs a 'reality' separate and incongruent with the viewing situation; video feeds back indigenous data in the immediate, present-time environment or connects parallel time/space continua. Film is contemplative and 'distanced'; it detaches the viewer from present reality and makes him a spectator […]

II. The Architectural Code/The Video Code

An architectural code both reflects and directs the social order. In the not too distant future one can envisage that this code will be modified and in part supplanted by a new code, that of television. As cable television images displayed on wall-size monitors connect and mediate between rooms, families, social classes, 'public'/'private' domains, connecting architecturally (and socially) bounded regions, they take on an architectural (and social) function. Video in architecture will function semiotically speaking as window and as mirror simultaneously, but will subvert the effects and functions of both. Windows in architecture mediate separated spatial units and frame a conventional perspective of one unit's relation to the other; mirrors in architecture define, self-reflectively, spatial enclosure and ego enclosure.

Architecture defines certain cultural and psychological boundaries; video may intercede to replace or rearrange some of these boundaries. Cable television, being reciprocally two-way, can interpenetrate social orders not previously linked; its initial use may tend to deconstruct and redefine existing social hierarchies.

III. 'Public'/'Private' Codes

Public versus private can be dependent upon architectural conventions. By social convention, a window mediates between private (inside) and public (outside) space.

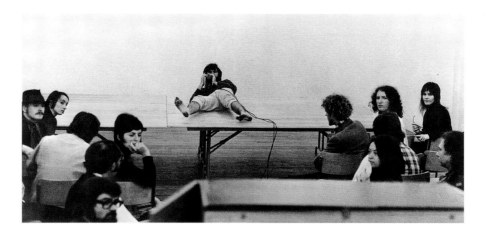

TV Camera/Monitor Performance
1970
Performance, Nova Scotia College
of Art and Design, Halifax
'A stage facing and at the level of
the tops of the heads of a seated
audience as wide, but
approximately ten rows deep, is
opposite and parallel to a rear TV
monitor placed just above the
heads of those in the last row.
'Lying feet facing the audience I
roll parallel to the left and right
edges of the stage while directing
a TV camera extended by a chord
to the monitor. My "orientation"
consists of a slowly and
continuously rolling while at all
times possible orientating the
camera's projected image to the
monitor to simultaneously feed
back the image to the monitor.
'The camera's projected monitor
image reverberates in the
handling of the camera (torsion);
the surface (in relation to gravity)
my body is rolling upon; my legs –
body extensions – as they shift
their muscular alignment to the
"goal" of directing my body and
camera forward; the machine
image-within-image feedback
self-reference; and the heads and
eyes of the audience enclosed
between the camera and monitor's
view. The machine to itself, I [set]
to my task and the audience to its.
Bodies in place are all closed
feedback systems or "learning"
loops, while the monitor shows
continuous rotation and a shift in
my angle of vantage during the
locomotion across the plane.
Individual spectators orientate
their views to a comparison of my
(and the camera's) opposite
monitor screen. Obversely, the
audience member can see himself
as my (and the camera's) view
sees him; he is moved to swivel
180 degrees back and forth to
reconcile his external view (of my
rotating axis) with the monitor
vantage. There is a time delay in
the physical necessity of shifting
attention as the audience and I
shift the tensions of our
respective muscular frameworks
of reference.'

The interior that is seen defines or is defined by the publicly accepted notion of privacy. An architectural division, the 'house,' separates the 'private' person from the 'public' person and sanctions certain kinds of behaviour for each. The *meaning* of privacy, beyond its mere distinguishability from publicness, is more complexly connected to other social rules. For example: a private home limits access to members of one family; a bathroom within that house is private as it allows usage by only one person at a time (whereas a toilet in a public space is public and allows multiple access, but is gender restricted); the individual bedroom of a child or adult member of the family may be considered to be private at certain times. Moral sanctions are attached to violation of these codes. There are areas that reflect transitional social change. The taping of private conversations for public law enforcement is one area of unresolved claims between private (including interpretation of the term 'private') rights and public rights to justice or knowledge. The widespread use of video surveillance cameras involves similar 'moral'/legal issues. The use of video would have social-psychological implications for the family structure; for instance, children being continuously observed through the use of a video camera by their parents 'lose' their 'right' to be different in private, that is, to have separate 'public' and 'private' identities.

IV. Conventions of the Glass Window

The glass window, like the Renaissance painting, creates a picture plane that places the world at a measured distance for the viewer on either side. The world, held at a distance, frames a conventional view which is defined by the specific size, shape and direction of orientation of the opening of the window frame. A view from one space into the other space, by what is allowed to be seen, defines one space's socially (pre-) conceived 'view' of the other. What someone on one side of the window can see of the other space, *and* what can be seen of them as part of their space by a viewer on the other side (and *vice versa*, for someone occupying that other side), is conventionalized by the social/architectural code. A view from the one side, as opposed to a view from the other side, may be symmetrical, appear symmetrical but not be, or be clearly asymmetrical. The 'picture-window' appears to be symmetrical in the length of time allowed a person on either side to stare, but actually is not. An employer's view of his employee's work space through one-way glass, as opposed to the employee's view of their employer's office, is asymmetrical, expressing inequalities of power.

Production/Reception (Piece for Two Cable TV Channels)

1976

'The piece utilizes two cable channels in a local environment in addition to a normal commercial broadcast. Two cable programmes are to be broadcast live and at the same time as a commercial programme, originating on a local station. Any locally produced commercial programme can be used, for instance a local evening news broadcast.

'Cable channel A broadcasts a live view from a single camera placed inside the control room of the studio producing the local commercial programme. A wide-angle lens is used, and the camera, aimed through the glass panel at the stage, shows the entire stage-set, surrounding cameras, cameramen, director, assistants and the technicians and technical operations necessary to produce the programme.

'Microphones placed in many locations within the stage-set, behind the stage and in the control booth are mixed together and accompany the visual image. They give a complete sense of all relationships occurring within the enclosed space of the commercial TV studio.

'Cable channel B broadcasts a live view from a single camera within a typical family house in the community. It shows viewers present observing the local commercial broadcast on their TV set (the view shows both the television image as well as the viewers present). The camera-view is fixed. Occupants of the household may or may not be present in the room watching the TV set at a given time. Sounds from *all* the rooms of the house, documenting all the activities taking place there for the duration of the broadcast, are mixed together and accompany the camera-view.

'Anyone in the local community who has cable television in addition to the commercial channels may, by switching from channel to channel, see channel A's view framing the local programme in the context of its process of production, of channel B's view showing the programme's reception within the frame of a typical family's household; or viewers can turn to the commercial channel and themselves receive the particular local programme in their house.'

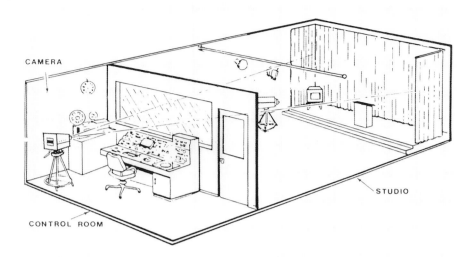

Position of camera in cable channel A broadcast.

V. The Mirror Image/The Video Image

A mirror's image optically responds to a human observer's movements, varying as a function of his position. As the observer approaches, the mirror opens up a wider and deeper view of the room-environment and magnifies the image of the perceiver. By contrast, a video image on a monitor does not shift in perspective with a viewer's shift in position. The mirror's image connects subjectively with the perceiver's time-space axis. Optically, mirrors are designed to be seen frontally.[1] A video monitor's projected image of a spectator observing it depends on that spectator's relation to the position of the camera, but not on his relation to the monitor. A view of the perceiver can be transmitted from the camera instantaneously or time-delayed over a distance to a monitor, which may be near or far from the perceiver's (viewing) position in space or time. Unlike the flat visuality of Renaissance painting, in the video image geometrical surfaces are lost to ambiguously modelled contours and to a translucent depth. Mirrors in enclosures exteriorize all objects within the interior space, so that they appear on the mirror as frontal surface planes. In rectilinear enclosures, mirrors create illusory perspective boxes. The symmetry of mirrors tends to conceal or cancel the passage of time, so that the overall architectural form appears to transcend time. The interior, inhabited by human movement, process and gradual change, is emptied of significance. As the image in the mirror is perceived as a static instant, place (time and space) becomes illusorily eternal. The world seen on video, in contrast, is in temporal flux and connected subjectively to (because it can be identified with) experienced duration […]

VI. Video Feedback

The video feedback of 'self'-image, by adding temporality to self-perception, connects 'self'-perception to physiological brain processes. This removes self-perception from the viewing of a detached, static image; video feedback contradicts the mirror model of the perceiving 'self'. Through the use of videotape feedback, the performer and the audience, the perceiver and his process of perception, are linked, or co-identified. Psychological premises of 'privacy' (as against publicness) which would derive from the mirror-model, depend on an assumed split between observed behaviour and supposedly unobservable, interior *intention*. However, if a perceiver views his behaviour on a 5- to 8-second delay[2] via videotape (so that his responses are part of and influence his perception), 'private' mental intention and external behaviour are experienced as one. The difference between intention and actual behaviour is fed back on the monitor and immediately influences the observer's future intentions and

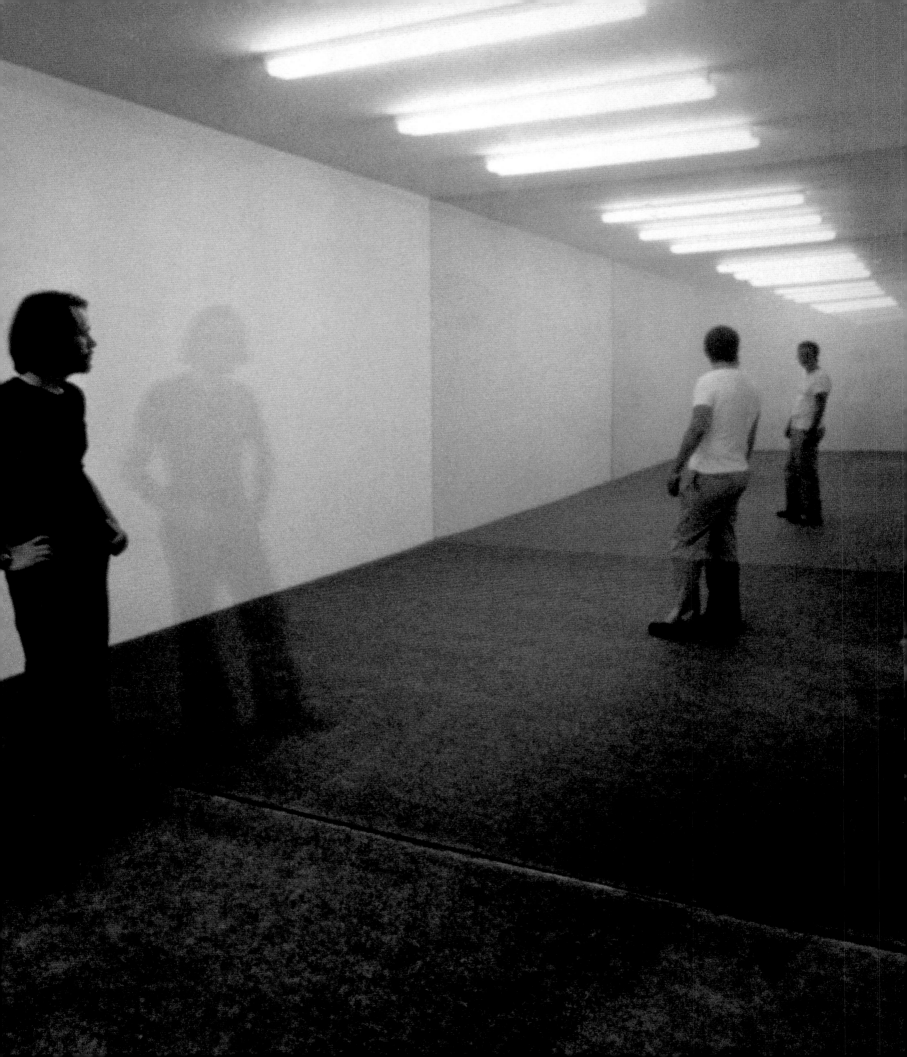

1975
Two-way mirror, 1 monitor,
1 camera, fluorescent lights
250 × 250 × 600 cm
Installation, ARC Musée d'Art
Moderne de la Ville de Paris, 1988
'Room A is approached from an
opposite direction than the
approach from Room B (so that it
is accidental which room a
spectator might enter first). Room
A is darkened. It contains a
camera on a tripod at eye-level,
placed against and facing the
surface of what is for it and the
spectator a transparent glass
window. The camera's lens
observes the other room, but is
itself unobserved through the
back mirror or by those people
facing it in Room B. A spectator in
Room A may see a person in Room
B looking directly at them in the
(direction of) the mirror/TV
monitor (whose image, of
themselves and not the person in
Room A, they are seeing). The TV-
monitor's view (the camera's
view) corresponds nearly, but not
identically, to that of the person
or persons looking in the direction
of Room B from Room A.
'Room B contains two opposite
mirrored walls. It is well lit. A TV
monitor is placed in front of the
mirror-wall dividing Room A and
B. Its image is reflected on the
opposite mirrored wall. The
monitor is at a height of 2 to 4
feet (60 to 120 cm) from the
ground. The monitor shows an
image of the spectator. If the
viewer in Room B is facing the
monitor (and front mirrored wall),
the monitor shows him a view of
himself different in scale and
mirror-reversed from that of the
mirror wall above the monitor. The
relative sizes of the mirror-image
and the monitor image continue
to change relative to the exact
distance a viewer in Room B is
from them. If the spectator faces
the other, rear mirror, he sees the
reflected view of the monitor
image (which now shows his
backside), and the mirror-view of
his front. The view on the monitor
will be smaller or larger in size
than the mirrror-view, depending
upon the distance the spectator is
from the mirror.'

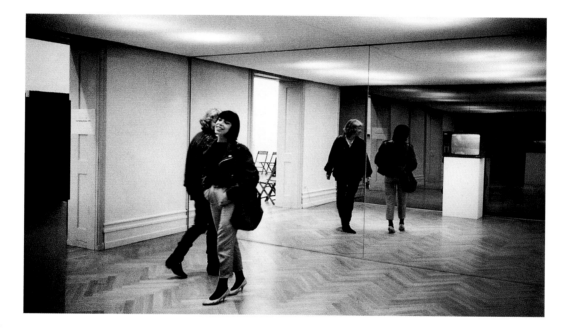

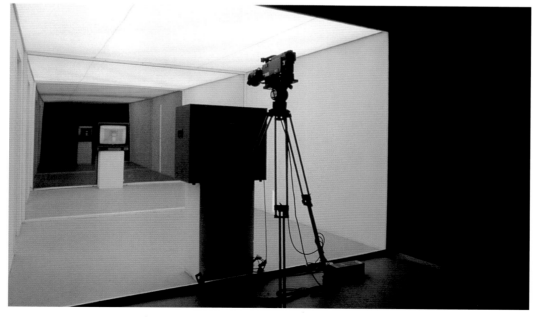

behaviour. By linking perception of exterior behaviour and its interior, mental perception, an observer's 'self', like a topological Möbius strip, can be apparently without 'inside' or 'outside'. Video feedback time is the immediate present, without relation to past and hypothetical future states – a continuous topological or feedback loop forwards or backwards between just-past or immediate future. Instead of self-perception being a series of fixed 'perspectives' for a detached ego, observing past actions with the intent of locating 'objective truth' about its essence, video feedback encloses the perceiver in what appears to be (only) what is subjectively present. While the mirror alienates the 'self', video encloses the 'self' within its perception of its own functioning, giving a person the feeling of a perceptible control over his responses through the feedback mechanism.

VII. The Glass Divider, Light and Social Division

Window glass alienates 'subject' from 'object'. From behind glass, the spectator's view is 'objective', while the observed's subject(ivity) is concealed.[3] The observer on the outside of the glass cannot be part of an interior group's 'intersubjective' framework. Being mirror-reflective,[4] glass reflects the mirror-image of an observer, as well as the particular inside or outside world behind him, into the image of the space into which he is looking.

Abstractly, this reflectiveness of glass allows it to be a sign signifying, at the same time, the nature of the opposition between the two spaces and their common mediation. The glass in the window through its reflectiveness unites, and, by its physical impenetrability, separates inside and outside. Due to its reflective qualities, illumination within or without the space divided by the glass produces either complex reflections, non-reflective transparency or opacity. Light signifies various distinct spatial or temporal locations. Artificial light is often placed in contrast to natural illumination (defining indoors and outdoors). The pattern of illumination phases with, and marks off, natural and cultural diurnal rhythms of human activities taking place on either side of the glass partition. Illumination is a controller of social behaviour. Both glass and light (separately or conjointly) enforce social divisions.

VIII. Glass Used in Shop Windows/Commodities in Shop Windows

The glass used for the showcase displaying products, isolates the consumer from the product at the same time as it superimposes the mirror-reflection of his own image onto the goods displayed. This alienation, paradoxically, helps arouse the desire to possess

New Design for Showing Videos
1995
Mirrored glass, clear tempered
glass, mahogany
213 × 884 × 427 cm

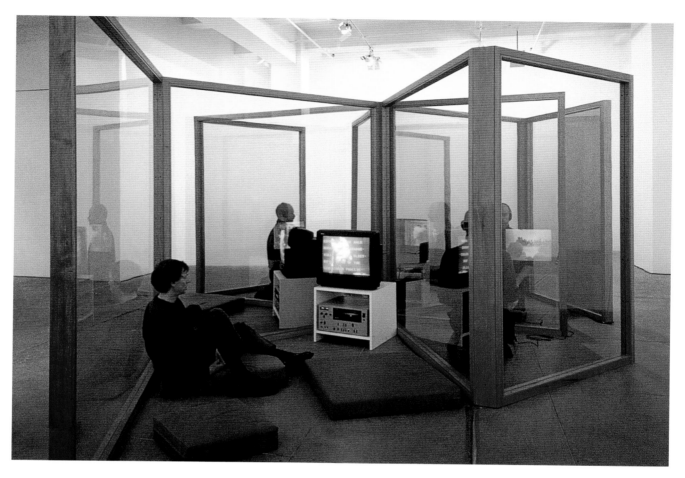

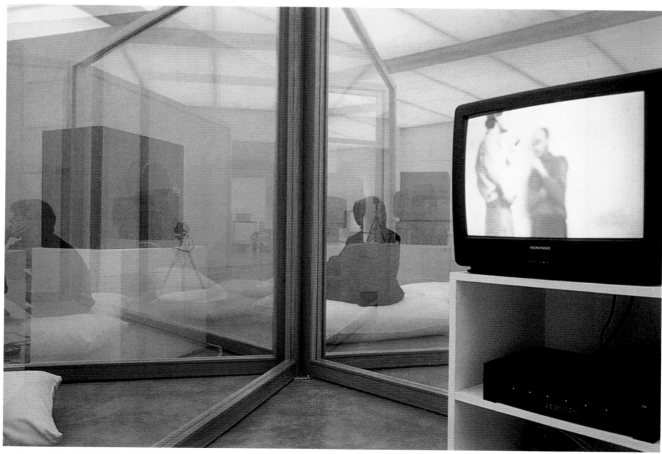

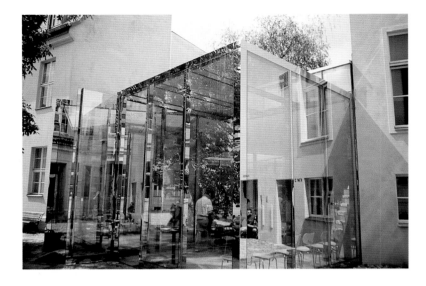

left and opposite, **Café Bravo**
1998
Two-way mirror glass, wood,
sainless steel
405 × 405 × 405 cm
Kunst-Werke, Berlin

Curved Showcase Window,
Chicago
1969
C-print
Dimensions variable

the commodity. The goods are often displayed as part of a human mannequin – an idealized image of the consumer. Glass isolates (draws attention to) the product's surface appeal, 'glamour', or superficial appearance alone (attributes of 'workmanship' that link craftsmen to a specific product being lost), while denying access to what is tangible or immediately useful. It idealizes the product. Historically, this change in the appearance of the product corresponds to the worker's alienation from the products he produces; to be utilized, the product must be bought on the market in exchange for wages at a market value, with the conditions of its production concealing the product's connection to another's real labour and allowing it to acquire exchange value over and above its use value […]

In the showcase display, the prospective customer's point of view, his sense of 'self', is equated not only with the object centred in his view, but with the System (which created the device). The showcase window as a framing or optical device replicates the form of the Renaissance painting's illusionary, three-dimensional 'space'. Like a painting's perspective, it frames a determined view (determines a view), creating a point of focus – meaning – organized around a central vanishing point. The customer's gaze is focused upon the centred object's external form; focus creates value. The spectator's 'self', unseen, projected into the space, is identified with the thing(s) represented. The spectator's gaze, his 'self-projection', organizes meaning around the centred object, meeting his centred look.

The material components of the showcase affect the viewer slightly differently from the painting. First, glass becomes a screen upon which a partial mirror-image of the observer himself (accentuated by the use of mirrors in the back in the case facing the front plane) is imposed. By means of strong overhead lighting, the faint reflection of the spectator, as well as that of the outside, real world, is superimposed on the glass in front of the visually highlighted objects seen within. The glass of the showcase is optically halfway between the invisibility (which hides the spectator's and the original painter's self-image) of the Renaissance painting and the reflectivity of the mirror (which shows the spectator himself looking, plus that part of the real space that is normally invisible behind him).[5] Often a rear mirror of smaller fragments of a mirror are positioned behind objects displayed in showcases, to fracture the ideal image of the spectator, partially glimpsed on the glass surface and rear mirror. By these means a viewer's initially desired ideal 'self'-image is focused and imposed upon – identified with – the inaccessible, but visually desired, commodity for sale; the object seems imaginarily complete, while the 'self' is detotalized, incomplete, lost, not graspable,

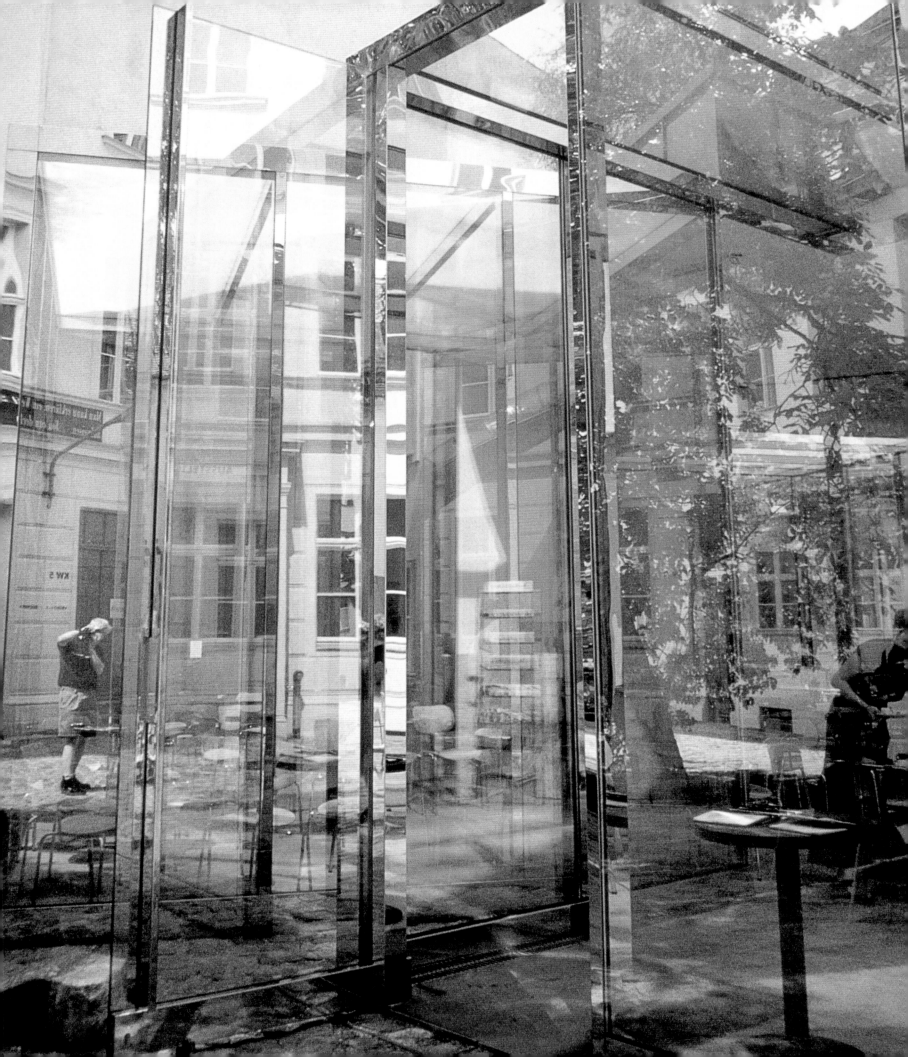

 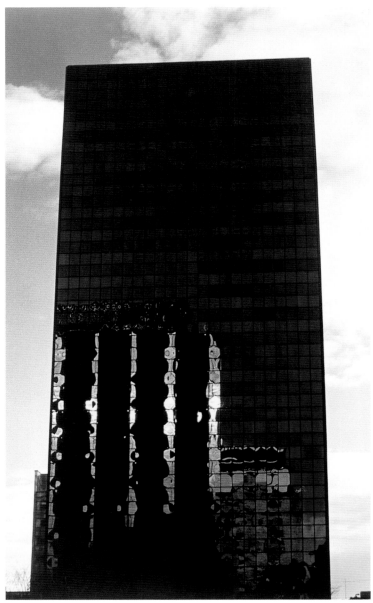

except through its visual projection upon the object. The shop window thus captures, focuses, and efficiently employs the latent desires of the casual passer-by, to confer a subjective, overdetermined meaning upon the goods it 'objectively' places on view.

IX. Glass Buildings: Corporate 'Showcases'
At the same time as glass reveals, it conceals. If one looks into a glass showcase, one can have the illusion that the container is neutral, without apparent interest in the content of what it displays; or, conversely, the appearance of what is contained can be seen as a function of the qualities of the container itself.[6] In the ideology of modern functionalist architecture, an architectural form appropriates and merges both of these readings. First, because symbolic form, ornamentation, is eliminated from the building (form and content being merged), there is no distinction between the form and its material structure; that is, the form represents nothing more or less than the material. Second, a form or structure is seen to represent only its contained function, the building's structural and functional efficiency being equated with its real utility for those who use it. Aesthetically, this idea is expressed in the formula: efficient form is beautiful and beautiful form is efficient. This has a 'moral' dimension; 'efficient' connotes a

melioristic, 'scientific' approach seemingly uncontaminated by 'ideology', which, pragmatically, has (capitalistic) use value. ('Efficiency' is how well a building contributes to the operations of the company housed within it. The look of a building, its cleanness and structural transparency, thus joins the myth of scientific progress to that of the social utility of efficient business practice.)[7]

These glass and steel buildings usually house corporations or government agencies. The building's transparent functionalism conceals its less apparent ideological function: justifying the use of technology or bureaucracy by large corporations or government agencies to impart their particular version of order on society. The spectator's view is diverted away from social context by focusing only on the surface material or structural qualities. Glass and steel are used as 'pure' materials, for the sake of their materiality. The use of glass gives another illusion: that what is seen is seen exactly as it is. Through the glass one sees the technical workings of the company and the technical engineering of the building's structure. The glass' literal transparency not only falsely objectifies reality, but is a paradoxical camouflage; for while the actual function of a corporation may be to concentrate its self-contained power and control by *secreting* information, its architectural facade gives the illusion of absolute openness.

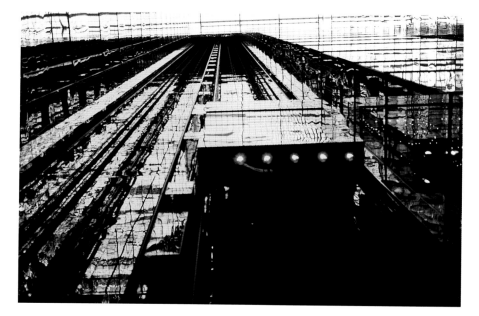

**Interior Atrium, Park Avenue
Atrium, New York, NY**
1988
C-print
Dimensions variable

Artist's Writings

The transparency is visual only; glass separates the visual from the verbal, insulating outsiders from the content of the decision-making processes and from the invisible yet real interrelationships linking company operations to society.

The glass building, in attempting to eliminate the disparity between its outside facade (which conventionally mediates its relation to the outside environment where it is sited) and its private, institutional function, pretends to eliminate the distinction between its outer form and its inner content. The self-contained, transparent glass building denies that it has an outside and that it participates as an element in the language of the surrounding buildings with other social functions that make up the surrounding environmental context. Where other buildings are usually decorated with conventional signs of their function for the public to see, the facade of the glass building is virtually eliminated. The aesthetic purity of the glass building, standing apart from the common environment, becomes transformed by its owner into a social alibi for the institution it houses. The building's transparent 'openness' to the environment (it incorporates the natural environment) on the one hand, and its claim to aesthetic hegemony over the surrounding environment (its formal self-containment) on the other, efficiently legitimate the corporate institution's claim to autonomy ('The World of General Motors'). A building with glass on four sides gives the illusion of self-containment. While it appears open to visual inspection, in fact, in looking through glass on all sides, one realizes the particular, focused-upon detail, the 'interior', is lost (one looks *through* and not *at*) to the architectural generality, to the apparent materialness of the outward form or to 'Nature' (light, sun, sky or the landscape glimpsed through the building on the other side).

1 The mirror inverts the position of the spectator seeing a Renaissance painting. There, the spectator faces the painting and looks forward into its projected space; in doing this, he reconstructs the exterior (and also the 'interior') view of the painter at the point in time and space when he made the painting.

2 Five to eight seconds is the limit of 'short-term' memory, or memory that is part of and influences a person's (present) perception.

3 Seen by a second observer on the other side of the glass, the first observer appears as an outsider.

4 There is a physical and a dialectical relation between mirrors and glass, each reflecting, accentuating qualities of the other.

5 Both the Renaissance painting and the mirror are two-dimensional rectilinear surfaces, conventionally hung to meet the standing spectator's eye-level view and flush with an interior wall, so that the wall functions both as an architectural (structural) support and as support for the painting or mirror. The mirror or painting's back surface and the area of the wall upon which it is hung are hidden from view; in

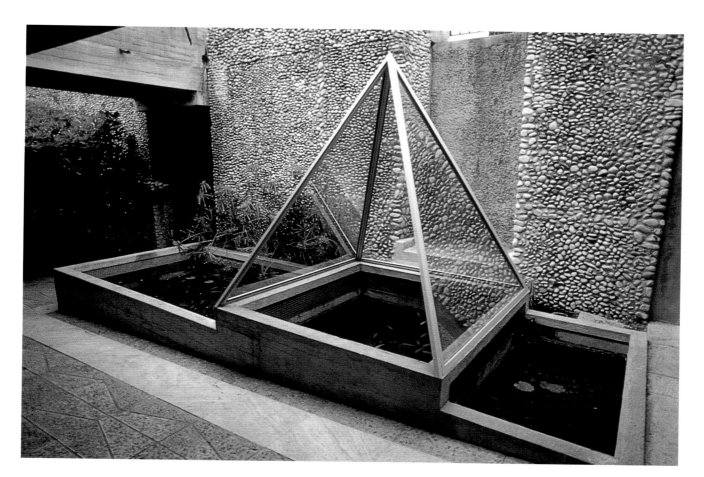

Pyramid Over Goldfish Pond
1989
Two-way mirror glass, stainless
steel, water
208 × 200 × 200 cm
Installation, Villa Arson, Nice

their place is either the reflection of the opposite side of the space of a depiction of an illusionary 'space'. Both mirror and painting use the frame to orient the spectator's view, necessitating that he turns frontally and faces the picture of mirror surface, focusing his attention toward the centre point (defined by the framed edges of the form).

6 But an optional focus – which aspect of the world is perceived when one looks – is culturally determined.

7 The technological-utilitarian glass office structure derives from the Bauhaus' vision of an architecture built from elemental, ideal formal and social images. The total, utopian vision in theory could serve as an alternative to the dominant, conservative, bourgeois order, wedding science and aesthetics to a socially just and more rational notion of progress (scientific progress aiding social progress). The vision begins with, and is grafted onto, the mid nineteenth-century notion of 'art for art's sake', which proposed an art that would negate the existing world order through the creation of an interior order of art. In this vision, 'Art'/'Architecture' attempts to create another (which is always 'its' own) language – in order to transcend that of the existent, real world. The total new order could be seen as a negation of all existing values, the avant-gardist notion being one that radically denies the 'old' in favour of the 'new' (social-aesthetic principle); this is seen in itself as healthy. The structuralist version of 'radical' art devaluation (e.g., Roland Barthes' *Writing Degree Zero*) is to purge the language of its (hidden) ideological contamination by reducing the text to purely elemental structure. The artist was seen as an 'underground' but heroic figure, standing apart from the social order – the existence of his art as a radical negation, denial, of this order. It is paradoxical, then, that the more wilful and heroic the imposition of the art form on an environment perceived as sterile or antagonistically unaesthetic, the more transcendent and utopian the artist's or architect's initial vision (which the building/artwork symbolically expresses), the much more distanced (and arrogant) the message that the building/artwork conveys to the general social body and more impotent is its intended ideological corrective effect.

'Essay on Video, Architecture and Television', *Dan Graham: Video/Architecture/Television: Writings on Video and Video Works 1970–78*, ed. Benjamin H. D. Buchloh, The Press of the Nova Scotia College of Art and Design, Halifax; New York University Press, 1979; reprinted in *Two-Way Mirror Power, Selected Writings by Dan Graham on His Art*, ed. Alexander Alberro, MIT Press, Cambridge, Massachusetts, 1999, p. 52–61.

Rock My Religion (extract) 1982–84

Ann Lee
c. 1774

Patti Smith
1978

Before the Shakers, the most important religious dissidents to arrive in America were the Puritans. The Puritans established a theocracy. They believed that a man stood a good chance of going to Hell, as all men were born evil. The only possible way to overcome this Original Sin was through hard work.

Ann Lee, an illiterate blacksmith's daughter from Manchester, England, founded the Shakers at the beginning of the Industrial Revolution. She had worked in the cotton mills at fourteen. Married to a man she disdained, Ann Lee bore four children, all of whom died in infancy. For English peasants, who were often forcibly removed from their land in the country, children were an asset. In the city, starving children were exploited by factory owners as cheap labour. The time was near when increased population would choke the earth.

Luddites smashed machines in the interest of the workers; apocalyptic visions of Christ's Second Coming swept through the oppressed proletariat. Ann Lee joined a sect which taught that Christ's Second Coming could be experienced through a trance produced by the rhythmic recitation of biblical phrases. This trembling also cured the body of ills.

As an adolescent, Patti Smith worked in a factory.

> *Sixteen and time to pay off. I get this job in a Piss Factory inspecting pipe. Forty hours, $36 a week, but it's a paycheck, Jack. It's so hot in here, hot like Sahara. I couldn't think for the heat. But these bitches are too lame to understand, too goddamn grateful to get this job to realized they're gettin' screwed up the ass.*
> – Patti Smith

In a trance, Ann Lee had a revelation. She saw the answer to the troubles of the urban working class. Heterosexual marriage had produced a multitude of starving children whose cheap labour was exploited by factory owners. The Bible showed heterosexual marriage to be the unnatural result of Adam's sin. Originally Adam had been created bisexual and self-contained. God punished Man and Woman by having them work at alienated labour and by the burden of childbearing. Ann Lee believed herself to be the female incarnation of God, Christ having been the male incarnation. She would create in America a utopian commune based on sexual abstinence, strict equality between Man and Woman, and an economy based on craft with common ownership of property.

To the woman He said:
'I will multiply your pains in childbearing
you shall give birth to your children in pain'.
To the man He said:
'With sweat on your brow
shall you eat your bread'.

Imprisoned as a witch, Ann Lee had visions that she was the Second Coming of Christ, incarnated in the form of a Woman. While other religions awaited the Apocalypse, Ann's belief was that it had arrived. In 1774, Ann Lee and a few followers left for America, a virginal 'Garden of Eden', to perfect the utopia which Ann, as the Second Christ, had the task of bringing into being.

The histories of the universe lie in the sleeping sex of a woman. Now back in [ancient] Egypt … they got these women and they put them in these tombs shaped like mummies; only they didn't mummify them, what they did was, they made this mixture out of opium and salad oil and henna and they put it all over them. First they'd knock them out with a sledgehammer and then they'd lay them in there and then wipe them all over with this opiate-henna oil – maybe throw in a little merc, anything they could get in there. And she'd be laid out; and she'd start feeling all this stuff gettin' in her pores and into her veins and you know how the filaments of a light bulb react when you turn it on – the next thing you know her fingers are writing Egyptian-style – very rigid, very hieroglyphic. She'd do this and the scribes would be standing around with their scrolls and anyway she'd start babbling. She'd start babbling and they'd write this stuff.
– Patti Smith

Patti Smith saw that the language of the Egyptian priestesses could be merged with the religious revivalist's 'talking in tongues' to produce a new rock language – BABYLOGUE – neither male nor female.

Rimbaud writes this letter and he says … in the future when women get away from their long servitude to men … they're going to have the new music, new sensations, new horrors, new spurts … Now … I've found this new toy …
– Patti Smith

Rock My Religion
1982–84
Video, 55 min., black and white
and colour, stereo
Collection, Centro Galego de Arte
Contemporánea, Santiago de
Compostela

The Shakers forbade ornament in their architecture, as it was considered sinful. All buildings were based on bilateral symmetry, dividing the women's areas from the men's areas. In the meeting house, used for worship, two groups of benches faced each other. The Elder was at the rear of the men's side. The Eldress sat at the rear of the women's benches. Separate staircases on each side were reserved for the Elder and Eldress to ascend to their quarters. The old sexually-based nuclear family was replaced with a family of co-equal Brothers and Sisters, who slept and worked in different houses. They met on two occasions during the week. A group of men and women sat 5 feet (153 cm) apart and discussed theological matters.

After a sober work week, the Shakers met on Sundays to worship. In the Circle Dance, lines of men and women formed four concentric, moving circles. The dance liberated the group from individual sin and helped them to achieve a collective purity. The group rhythmically chanted from the Bible and marched in circles. Stomping their feet, they shouted, 'Stomp the Devil!' Sisters and Brothers began whirling in place. The group cried, 'Shake! Shake! Shake! Christ is with you!' There is a noise like 'Whoosh', which means the Devil is present. People clapped. They leaped up and down. Some removed their outer clothes. A fit of shaking, ecstatic seizures passed over the group. 'Reeling, turning, twisting', some rocked on their feet. Still others were doubled over, feet and hands linked, as they rolled on the floor. They rolled over and over, like wheels, or they turned like rolling logs. Some got down on four legs [sic] like dogs, growled, snapped their teeth and barked. Indian spirits entering the meeting, 'possessed' the bodies of the Shakers. Elder and Eldress would have to pull Squaws and Warriors apart. Carnal mortification freed the Shaker from pride. Ritualistically, the Devil was snared from his hiding place within the group and cast out.

[…] Secular Puritanism led to capitalism. But backwoods prophets warned that the United States was serving the Devil in its new commercialism. At the 'Great Religious Revival of 1801', preachers pitched tents on the edges of pioneer settlements. They spoke of the need for salvation, mortification … and of the need in America for a *spiritual* mission. In tent meetings, rural pioneers clapped their hands, rhythmically reciting biblical texts. Here for the first time, the piano and the guitar replaced the organ as conveyor of spiritual feeling. The saved would 'reel and rock' and, in their collective desire to be 'reborn', people would 'talk in tongues'.

There is an unresolved conflict between Puritan individualism and the yearning for communalism free of sexual and economic competition […]

'Rock My Religion', *Video by Artists 2*, Art Metropole, Toronto, 1986. Revised and reprinted in *Rock My Religion: Writings and Art Projects 1965–1990*, ed. Brian Wallis, MIT Press, Cambridge, Massachusetts, 1993.

My Works for Magazine Pages: 'A History of Conceptual Art' (extract) 1985

I became involved with the art system accidentally when friends of mine suggested that we open a gallery. In 1964, Richard Bellamy's Green Gallery was the most important avant-garde gallery and was just beginning to show people such as Judd, Morris and Flavin. Our gallery, John Daniels, gave Sol LeWitt a one-man show, as well as doing several group shows that included all the 'proto-Minimalist' artists whether they already showed at Green Gallery or not. We also had plans to have a one-man exhibition of Robert Smithson – then a young Pop artist. However, the gallery was forced to close due to bankruptcy at the end of the first season.

If we could have continued for another two years with the aid of more capital, perhaps we might have succeeded. Nevertheless, the experience of managing a gallery was particularly valuable for me in that it afforded the many conversations I had with Dan Flavin, Donald Judd, Jo Baer, Will Insley, Robert Smithson and others who, if they were not able to give works for thematic exhibitions, supported the gallery by recommending other artists and by dropping by to chat. In addition to a knowledge of current and historical art theory, some of these artists had an even greater interest, which I shared, in intellectual currents of that moment such as serial music, the French 'New Novel' (Robbe-Grillet, Butor, Pinget, etc.) and new scientific theories. It was possible to connect the philosophical implications of these ideas with the art that these 'proto-Minimal' artists and more established artists, such as Warhol, Johns, Stella, Lichtenstein and Oldenburg or dancers such as Yvonne Rainer or Simone Forti, were producing.

The autumn after the gallery failed I began experimenting with artworks myself, which could be read as a reaction against the gallery experience, but also as a response to contradictions I discerned in gallery artists. While American Pop art of the early 1960s referred to the surrounding media world of cultural information as framework, 'Minimal' art of the mid through late 1960s seemed to be referring to the gallery's interior cube as the ultimate contextual frame of reference or support for the work. This reference was only compositional; in place of a compositional reading interior to the work, the gallery would compose the art's formal structure in relation to the gallery's interior architectural structure. That the work was equated with the architectural container tended to literalize it; both the architectural container and the work contained within were meant to be seen as non-illusionistic, neutral and objectively factual – that is, as simply material. The gallery functioned literally as part of the art. One artist's work of this period (although not always his later work) examined how specific, functional architectural elements of the gallery interior prescribed meaning and determined

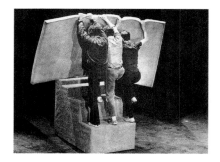

Dan Flavin
icon IV (the pure land) (to David
John Flavin 1933–1962)
1962–69
White formica with daylight
fluorescent light
123 × 113 × 28.5 cm

Yvonne Rainer, David Gordon and
Steve Paxton
'Stairs', from The Mind Is a Muscle
1968
Anderson Theatre, New York

specific readings for the art defined within its architectural frame: Dan Flavin's
fluorescent light installations […]

His arrangements of light fixtures in a gallery space depend for significance,
contextually, upon the function of the gallery and the socially determined architectural
use of electric lighting. Use of electric light is related to a specific time in history. Flavin
has observed that when the existing system of electric lighting has ceased to exist, his
art will no longer function. Being a series of standardized, replaceable units, which, in
Flavin's words, 'can be bought in any hardware store', his arrangements of fluorescent
tubes within the interior or adjacent exterior architectural frame of the gallery
exhibition space function only in situation installation, and upon completion of the
exhibition cease to function artistically.

Perhaps I misread the implications of these works by suggesting a conscious
intention to examine the relation of the value of art to the question of the gallery in
which it was exhibited. I also felt that the 'solution' Marcel Duchamp had found to this
problem of art's 'value' was unsatisfactory.

In his readymades, Duchamp brought objects that were not considered art when
placed outside the gallery, into the gallery to prove dialectically that it is in fact the
gallery that gives the object its value and meaning. Instead of reducing gallery objects
to the common level of the everyday object, this ironic gesture simply extended the
reach of the gallery's exhibition territory. In bringing the 'non-art' object into the gallery,
Duchamp wished to place in apparent contradiction the conventional function of the
gallery to designate certain objects as 'art' and to exclude others.

Essentially, Duchamp attempted to question the aristocratic function of art and the
art gallery as an institution. Because this question was only presented on a logical
abstract level, his critique was itself immediately integrated back into the institutional
system of gallery or museum art, becoming a kind of 'idea' art. A further problem with
Duchamp's analysis is the resolution of the contradiction between gallery art and art in
relation to its social value based on a historical concept; the condition of art is seen as
neither social nor subject to external social change. By contrast, Flavin's fluorescent
light pieces are not merely a priori philosophical idealizations, but have concrete
relations to specific details of the architectural arrangement of the gallery, details which
produce meaning.

In addition, Duchamp saw the problem of value and meaning in art as a simple
binary opposition, inside the gallery or outside in the world. He failed to link this
opposition of art and so-called 'non-art' to more ambiguous phenomena such as the

WANTED: PROFESSIONAL MEDICAL WRITER to write medical, sexological description of sexual detumescence in human male (physiological and psychological aspects) laxity and pleasure should be dealt with. Needed for reproduction as a poem by Dan Graham to be deseminated 25,000 readers in June issue of ASPEN. Respondent retains all rights and fees from use of. 84 Eldridge St., NYC 10002.

MIAMI BOUND? Swing in Miami with young couple. She: 29, stunning redhead; He: 32.6 ft. & loaded. Write: Boxholder, Box 7462, Miami, Florida 33155.

SKILLED NEGRO MALE. Skilled in French, Greek and Oriental sex arts. Would like correspondence with ladies of same mind. Race and age unimportant. Photo, phone, if possible. Not a must. (Frankness) H. Green, G.P.O. Box 2514, N.Y., N.Y. 10001.

FINEST QUALITY battery-operated personal vibrators 7"x1½" $5.00 each. Strap-on rubber health-mates 6"×1½", recommended by doctors $6.00 ~~ ' postage. No C.O.D.: V.T. Co~~~

PLAYGIRLS DIRECTOR' nymphs, amazons, sex-pots, names, addresses. $2.00. FA N.Y.C., N.Y. 10038.

CAN'T RECEIVE Personal ℕ special CONFIDENTIAL ℕ per month. Phone service contact: The Continental S 42nd St., N.Y.C. 10036. T

HANDSOME, YOUNG, w females 20-30 yrs. old. On loving. Contact me evening Completely confidential. C

WANTED. . . Stag movie Betty Page. Write: Taylor, B

PHOTOGR '' fuc¹

reproduction of the art object by the media, which was mediated upon by the critic Walter Benjamin in the 1930s and was even earlier an important aspect of Constructivist art.

Through the actual experience of running a gallery, I learned that if a work of art wasn't written about and reproduced in a magazine, it would have difficulty attaining the status of 'art'. It seemed that in order to be defined as having value – that is, as 'art' – a work had only to be exhibited in a gallery and then to be written about and reproduced as a photograph in an art magazine. Then this record of the no longer extant installation, along with more accretions of information after the fact, became the basis for its fame, and to a large extent, its economic value.

From one perspective, the art object can be analyzed as inseparably connected to the institution of the gallery or museum; but from another perspective it can be seen as having a certain independence, as it belongs also to the general cultural framework of which the magazine is a part. Magazines specialize in a way that replicates other social and economic divisions. Any magazine, no matter how generalized, caters to a certain market or a specific audience in a particular field. All art magazines are directed to people who are involved in the art world professionally in one way or another. Furthermore, the art magazine itself is supported by advertisements that, with one or two exceptions, come from art galleries that are presenting exhibitions. It follows that in some way the advertisers have to be taken care of in that their shows have to be reviewed and made a matter of record in the magazine. Thus these shows and works are guaranteed some kind of value and can be sold on the market as 'art'. The fact that sales do take place yields enough money for the gallery to purchase more advertisements in art magazines and to sustain the art system in general.

Art magazines ultimately depend upon art galleries for their economic support, just as the work shown in galleries depends on photographic reproduction for its value in the media. Magazines determine a place or are a frame of reference both outside and inside. Magazines specialize in a 'field' – for instance, the specialized 'world' of art and artists termed the 'art' world. *Sports Illustrated* caters to those who are interested in sports, the *American Legion* magazine caters to members of the American Legion. Art magazines cater to artists, dealers, collectors, connoisseurs and writers who have a professional interest in art. And the art magazine itself is supported by advertisements.

Originally published in *Dan Graham,* Art Gallery of Western Australia, Perth, 1985, pp. 8–13. An extract was included in *Rock My Religion: Writings and Art Projects 1965–1990,* ed. Brian Wallis, MIT Press, Cambridge, Massachusetts, 1993, pp. xviii–xx.

37	adjectives
0	adverbs
87.40%	area not occupied by type
12.60%	area occupied by type
2	columns
0	conjunctions
0 mms.	depression of type into surface of page
0	gerunds
0	infinitives
24	letters of alphabet
28	lines
11	mathematical symbols
36	nouns
49	numbers
7	participles
5⅜" × 8"	page
Dondell	paper sheet
uncoated offset	paper stock
.0039"	paper stock
6	prepositions
0	pronouns
10 point	size type
Aster	typeface
60	words
2	words capitalized
0	words italicized
58	words not capitalized
60	words not italicized

WHOEVER THOUGHT THAT SHIT COULD BE BEAUTIFUL

send $5.00 (postpaid) for this limited edition, 22X22 inch silk-screened print
(red, Yellow & Blue) to DADAPOSTERS/80 Fifth Ave, N.Y.C., 10011

Two-way Mirror Power 1996

right, **Two Anamorphic Surfaces**
2000
Two-way mirror, glass, stainless
steel
Dimensions unknown
Installation, Wanas, Sweden

opposite, **Two Adjacent Pavilions**
1978–82
Two-way mirror, glass, steel
2 units, 251 × 186 × 186 cm each
Installation, Documenta 7, Kassel,
Germany, 1982
Collection, Kröller Müller Museum,
Otterlo

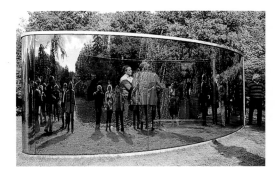 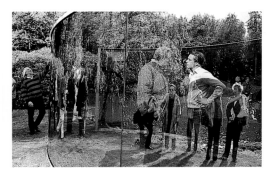

In Western culture the pavilion placed in a park setting began with the Renaissance
garden, where it was often used for Disney-like special effects. In the nineteenth
century it grew in size into the Crystal Palace of the 1851 World's Fair Exposition in
London. It now encompasses the quasi-utilitarian modern 'non-place' bus shelter and
telephone booth.

 Two Adjacent Pavilions, first shown as a model in 1978, was realized at Documenta
7 in 1982; it was my first outdoor two-way mirror pavilion. Each of the two square,
enterable forms allows four to six people to stand or to lie prone inside. Each structure
is the same size as the other. The four sides of each structure are made from two-way
mirror glass of the same percentage reflectivity. The difference is that one pavilion has a
transparent glass ceiling, while the other's ceiling is covered with a dark, non-light-
admitting material.

 The properties of the mirror-reflective glass used in the pavilions' sides cause one
side to be either more reflective or more transparent than the other side at any given
moment, depending on which side receives more light.

 Two-way mirror used in office buildings is always totally reflective on the exterior,
reflecting the sunlight, and totally transparent for workers inside. Surveillance power is
given to the corporate tower. In *Two Adjacent Pavilions* and other pavilions the inside
and outside views are both quasi-reflective and quasi-transparent, and they
superimpose intersubjective images of inside and outside viewers' bodies and gazes
with the landscape.

 One of the two pavilions, the one whose ceiling is opaque, remains more reflective
on the outside and transparent on the inside. The other pavilion is flooded with
changing interior light, depending on the sun and clouds, shifting between being more
reflective or more transparent.

 The work can be seen as a psychological model; metaphorically, each pavilion may
be seen as an 'ego' which gets its identity in a continuous semi-reflection of another
semi-reflective 'ego'.

 Typologically, the work belongs to the park/garden's pleasure pavilion, which has
been an antidote to the alienating qualities of the city as well as a utopian metaphor for
a more pleasurable city in the future. The pavilions are used for people at restful play – a
fun-house for children and a romantic retreat for adults. They are both emblematic of
the power of the corporate city and help to dissolve the city's alienation effects. They
also relate to the eighteenth-century notion of the Arcadian 'rustic hut'. This type begins
after the Enlightenment with the notion of the 'elemental rustic hut' first proposed by

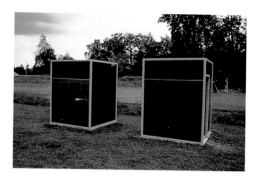

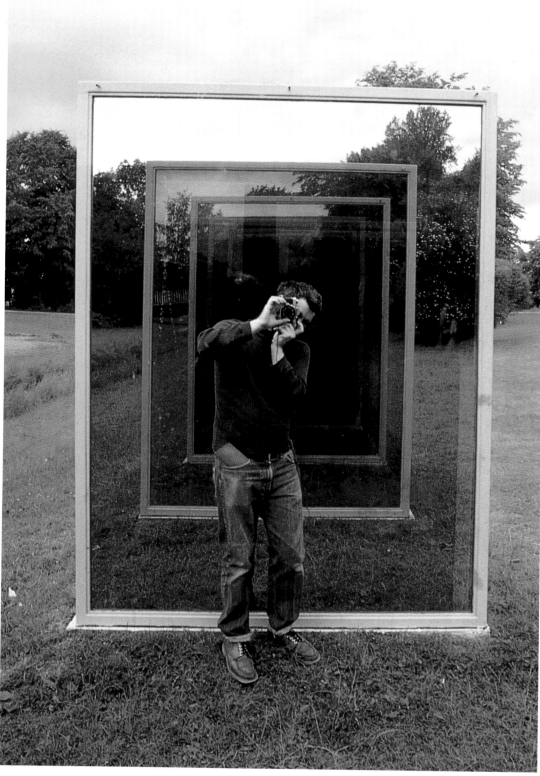

Marc-Antoine Laugier. Laugier was a mid eighteenth-century French urban planner and theorist. Like Jean-Jacques Rousseau, Laugier set up his model of the elemental 'rustic hut' in relation to uncontaminated Nature. The 'rustic hut' was supposed to be a reduction to man's and architecture's original nature, to its 'own self-sufficiency', when there was no oppression of man by man: Architecture and Man were closest to 'Nature'.

'Two-way Mirror Power', *Two-way Mirror Power: Selected Writings by Dan Graham on His Art*, ed. Alexander Alberro, MIT Press, Cambridge, Massachusetts, 1999, pp. 174–75.

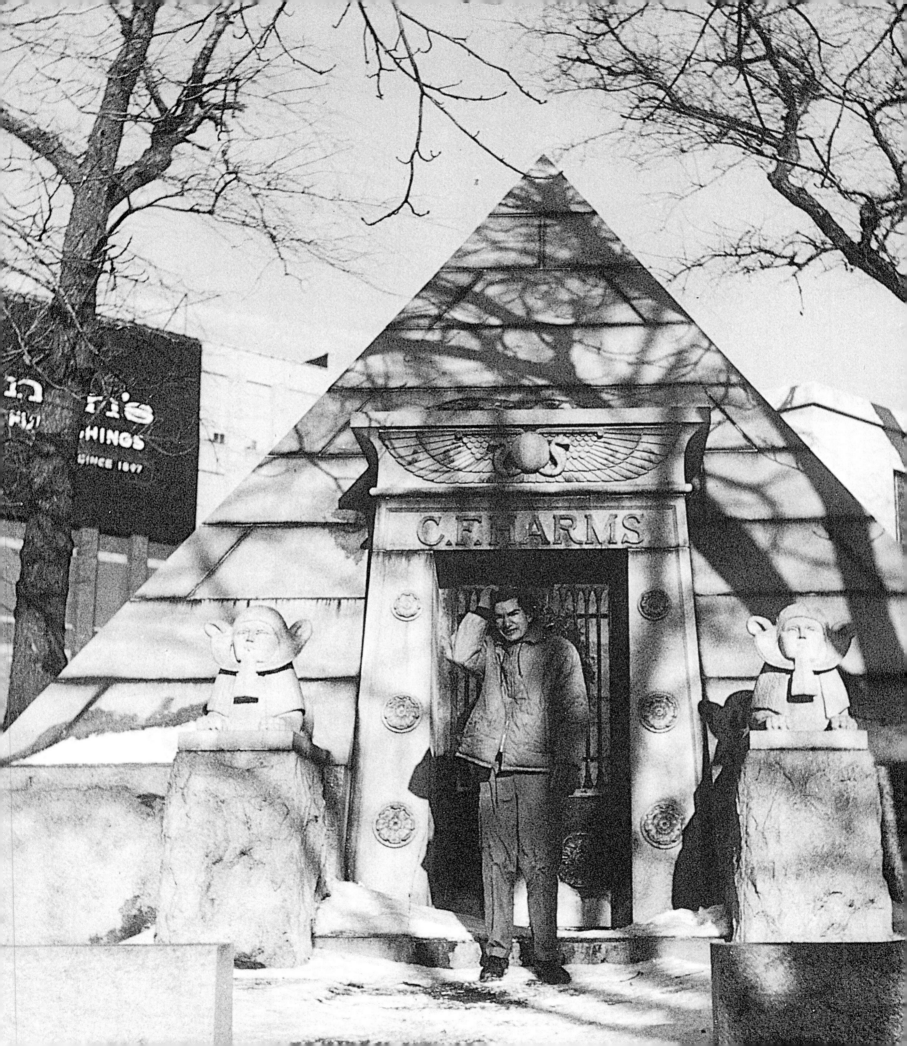

Contents

Selected exhibitions and projects
1966–71

1966
'Projected Art',
Contemporary Wing, Finch College Museum of Art,
New York (group)

'Working Drawings and Other Visible Things on Paper
Not Necessarily Meant to Be Viewed as Art',
Visual Arts Gallery, School of Visual Arts, New York
(group)

1967
'Language to Be Looked at – Words to Be Seen',
Dwan Gallery, New York (group)

'Normal Art',
Lannis Museum of Normal Art, New York (group)

'Language II',
Dwan Gallery, New York (solo)

1969
John Daniels Gallery, New York (solo)

Performance, *Lax/Relax*, **NYU Loeb Student Center**,
New York

'Konzeption-Conceptions',
Stadtisches Museum, Leverkusen (group)
Cat. *Konzeption-Conceptions*, Opladen, Westdeutscher
Verlag, Cologne, texts Konrad Fischer, Rolf Wedewer

'Language III',
Dwan Gallery, New York (group)

1970
Anna Leonowens Gallery, Nova Scotia College of Art,
Halifax (solo)

'Information',
The Museum of Modern Art, New York (group)
Cat. *Information*, The Museum of Modern Art, New
York, texts Kynaston McShine, et al.

1971
'Sonsbeek '71',
Arnhem, The Netherlands (group)
Cat. *Sonsbeek '71*, Deventer, The Netherlands, texts
Geert van Beijeren, Coosje Kapteyn

Selected articles and interviews
1966–71

1966

Bochner, Mel, 'Less Is Less', *Art & Artists*, London,
December
Smithson, Robert, 'Quasi-Infinities and the Waning of
Space', *Arts Magazine*, New York, November

1967

Bochner, Mel, 'The Serial Attitude', *Artforum*, New York,
December
Flavin, Dan, 'Some Other Comments', *Artforum*, New
York, December
LeWitt, Sol, 'Paragraphs on Conceptual Art', *Artforum*,
New York, Summer

1968
Smithson, Robert, 'A Museum of Language in the
Vicinity of Art', *Art International*, New York, March

Atkinson, Terry, 'Introduction', *Art-Language*, Vol. 1,
No. 1, Leamington, England

1970
Antin, David, 'Dan Graham', *Studio International*,
London, July

1971

VOLUME 1 NUMBER 1 MAY 1969

Art-Language
The Journal of conceptual art
Edited by Terry Atkinson, David Bainbridge,
Michael Baldwin, Harold Hurrell

Contents

Art-Language *is published three times a year*
Price 75p UK, $2.50 USA All rights reserved
Printed in Great Britain

Selected exhibitions and projects
1971–75

Performance, *Like*, **Nova Scotia College of Art and Design**, Halifax

7e Biennale de Paris,
Musée d'Art Moderne de la Ville de Paris (group)

'Prospect 71',
Stadtische Kunsthalle, Dusseldorf (group)
Cat. *Prospect*, Stadtische Kunsthalle, Dusseldorf, text Hans Strelow

1972
Lisson Gallery, London (solo)
Cat. *Dan Graham: Selected Works, 1965–72*, Lisson Publications, London; Gbr. König, Cologne, texts Dan Graham

Performances, *Two Consciousness Projection(s)* and *Intention Intentionality Sequence*, **Lisson Gallery**, London

Galleria Toselli, Milan (solo)

Documenta 5,
Kassel, Germany (group)
Cat. *Documenta 5*, Documenta GmbH, Kassel, texts Harald Szeemann, et al.

1973
Galerie Rudolf Zwirner, Cologne (solo)

Galleria Schema, Florence (solo)

Institute of the Arts, Valencia, California (solo)

1974
Galerie 17, Paris (solo)
Cat. *Dan Graham: Textes*, Galerie 17, Paris, text Dan Graham

Royal College of Art, London (solo)

Lisson Gallery, London (solo)

'Kunst bleipt Kunst: Projekt '74',
Kunstverein, Cologne (group)

'Art/Video/Confrontation',
Musée d'Art Moderne de la Ville de Paris (group)
Cat. *Art/Video/Confrontation*, Musée d'Art Moderne de la Ville de Paris, text Suzanne Pagé

1975
Lucio Amelio, Modern Art Agency, Naples (solo)

Selected articles and interviews
1971–75

Nemser, Cindy, 'Subject-Object: Body Art', *Arts Magazine*, New York, September
Pacquement, Albert, 'L'Art Conceptuel', *Connaissance des Arts*, Paris, October

1973

Lebeer, I., 'Le corps matériel perceptuel', *L'Art Vivant*, Paris, July

1974

Fuller, P., 'Dan Graham: Lisson Gallery', *Arts Review*, London, 18 October

Herzogenrath, Wulf; Grüterich, M., 'Video', *Magazine Kunst*, No. 4, Germany

1975

Selected exhibitions and projects
1975–78

John Gibson Gallery, New York (solo)
Cat. *Dan Graham: Some Photographic Projects*, John
Gibson Gallery, New York, text Dan Graham

Otis Art Institute Gallery, Los Angeles (solo)
Cat. *Dan Graham: For Publication*, Otis Art Institute,
Los Angeles, text Dan Graham

'Video Art',
Institute of Contemporary Art, University of
Pennsylvania, Philadelphia; **Contemporary Arts
Cincinnati**, Ohio; **Museum of Contemporary Art**,
Chicago; **Wadsworth Atheneum**, Hartford,
Connecticut (group)
Cat. *Video Art*, Institute of Contemporary Art,
University of Pennsylvania, Philadelphia, text David
Antin

1976
Sperone Westwater Fischer Gallery, New York (solo)

Institute of Contemporary Arts, London (solo)

Kunsthalle Basel, Basel (solo)
Cat. *Dan Graham*, Kunsthalle, Basel, texts Rudi Fuchs,
Dan Graham, Maria Netter, et al.

'Arte Ambiente',
XXXVII Venice Biennale (group)
Cat. *Arte Ambiente*, Edizioni La Biennale di Venezia,
texts Germano Celant

1977
Stedelijk Van Abbemuseum, Eindhoven (solo)

Performances, *Performer/Audience/Mirror*, **De Appel
Foundation**, Amsterdam; **Riverside Studios**, London;
P.S. 1 Museum, Long Island City, New York

'Two Rooms Reverse Video Delay',
Museum van Hedendaagse Kunst, Ghent (solo)

'Documenta 6',
Kassel, Germany (group)
Cat. *Documenta 6*, P. Dierichs, Kassel, texts Manfred
Schneckenburger, et al.

Perfomances, *Identification Projection*, Leeds
Polytechnic; De Appel Foundation, Amsterdam

Selected articles and interviews
1975–78

Plagens, P., 'Dan Graham and Mowry Baden', *Artforum*,
New York, December

Antin, David, 'Television: Video's Frightful Parent',
Artforum, New York, December
Kozloff, Max, 'Pygmalion Reversed', *Artforum*, New
York, November
Mayer, R., 'Dan Graham: Past/Present', *Art in America*,
New York, November–December

1976
Grove, N., 'Reviews', *Arts Magazine*, New York, April
Baracks, B., 'Dan Graham', *Artforum*, New York, May
Wooster, A., 'New York Reviews: Dan Graham', *ARTnews*,
New York, April

Fiels, S., 'The Venice Biennale', *Burlington Magazine*,
London, October

Cameron, E., 'Dan Graham: Appearing in Public',
Artforum, New York, November
Von Graevenitz, A., 'Dingen Gebeuren in het
Gezichtsveld Uit Gesprek met Dan Graham',
Museumjournaal, Amsterdam, April

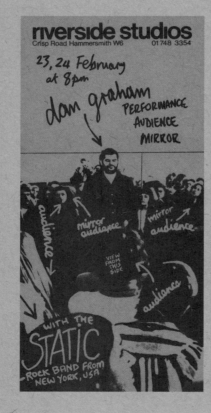

AMBIENTE/ARTE
DAL FUTURISMO
ALLA BODY ART
Germano Celant
Edizioni
La Biennale di Venezia

Selected exhibitions and projects
1977–82

Book, *Films*, Éditions Centre d'art Contemporain,
Geneva/Écart Publications, Geneva, text Dan Graham

1978
Museum of Modern Art, Oxford (solo)

Book, *Articles*, Stedelijk Van Abbemuseum, Eindhoven,
texts Benjamin H.D. Buchloh, Rudi Fuchs, Dan Graham,
Anton Herbert

1979
Franklin Furnace, New York (solo)

Galerie Rüdiger Schöttle, Munich (solo)

Book, *Dan Graham: Video/Architecture/Television.*
Writings on Video and Video Works, 1970–1978, ed.
Benjamin H.D. Buchloh, Press of Nova Scotia College of
Art and Design, Halifax/New York University Press,
texts Michael Asher, Dara Birnbaum, Dan Graham

1980
'Two Viewing Rooms',
The Museum of Modern Art, New York (solo)
Cat. *Dan Graham: Two Viewing Rooms*, The Museum of
Modern Art, New York, texts Dan Graham, Barbara J.
London

Museo de Arte Contemporánea, Lisbon (solo)

1981
'Buildings and Signs',
Lisson Gallery, London (solo)

Institute for Art and Urban Resources at P.S.1, Long
Island City, New York (solo)

'Dan Graham: Buildings and Signs',
The Renaissance Society at the University of Chicago
(solo)
Cat. *Dan Graham: Buildings and Signs*, The Renaissance
Society at the University of Chicago, texts Dan Graham,
Anne Rorimer

'Westkunst',
Museen der Stadt Köln, Cologne (group)
Cat. *Westkunst*, Du Mont, Cologne, texts Narcel
Baumgartner, Kasper König, et al.

1982
Gewad 23, Ghent (solo)

Book, *Dan Graham: Théâtre*, Anton Herbert, Ghent,
text Dan Graham

'Documenta 7',
Kassel, Germany (group)
Cat. *Documenta 7*, Dierichs, Kassel, texts Rudi Fuchs, et
al.

'60–80 Attitudes/Concepts/Images',
Stedelijk Museum, Amsterdam (group)

Selected articles and interviews
1977–82

1978
Domingo, W., 'Review', *Art Monthly*, London, October
Francis, Mark, 'Dan Graham', *Aspects*, London, Winter

1979

Beveridge, C., 'Dan Graham's Video-Architecture-
Television', *Fuse*, Toronto, May, 1980

Glusberg, J., 'La Situación del Arte Corporal', *Créer*,
Buenos Aires, March
Pelzer, Birgit, 'Vision in Process', *October*, Cambridge,
Massachusetts, Fall

1980
Wooster, A.S., 'Two Viewing Rooms', *Village Voice*, New
York, December

1982

Buchloh, Benjamin H.D., 'Documenta 7: A Dictionary of
Received Ideas', *October*, New York, Fall
Kuspit, Donald, 'Documenta 7', *Artforum*, New York,
October

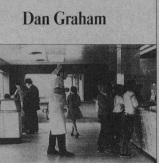

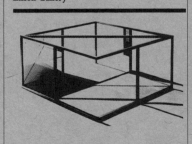

Selected exhibitions and projects
1982–86

'Architecture by Artists',
Institute of Contemporary Arts, London (group)

Sydney Biennial,
Sydney (group)

1983
'Pavilions',
Kunsthalle, Bern (solo)
Cat. *Dan Graham: Pavilions*, Kunsthalle, Bern, texts
Thierry de Duve, Dan Graham, Jean-Hubert Martin

1985
Art Gallery of Western Australia, Perth (solo)
Cat. *Dan Graham*, Art Gallery of Western Australia,
Perth, texts Gary Dufour, Dan Graham, Jeff Wall

'The Art of Memory/The Loss of History',
New Museum of Contemporary Art, New York (group)
Cat. *The Art of Memory/The Loss of History*, New
Museum of Contemporary Art, New York, texts David
Deitcher, William Olander, Abigail Solomon-Godeau,
Reese Williams

'Les Inmateriaux',
Musée National d'Art Moderne, Centre Georges
Pompidou, Paris (group)

1986
'Sculpture, Pavilions & Photographs',
Galerie Rüdiger Schöttle, Munich (solo)

'Three Pavilions/Sculptures',
Galerie Johnen & Schöttle, Cologne; **Galerie für
Architektur und Kunst**, Munich (solo)

Galleria Lia Rumma, Naples (solo)

Storefront for Art and Architecture, New York (solo)

Selected articles and interviews
1982–86

Hatton, Brian, 'Artist and Architects at the ICA,
London', *Architectural Review*, London, March, 1983

1983
Glintz, C., 'Dan Graham à Berne', *Art Press*, Paris, March
Wechslen, M., 'Dan Graham: Pavilions, Kunsthalle
Bern', *Artforum*, New York, October

Saliga, P., 'Dan Graham and Helmut Jahn Reshape
Argonne Environment', *New Art Examiner*, New York,
Summer
Schöttle, Rüdiger, 'Louis XIV tanzt, Purgatorium-
Inferno-Rette sich wer kann (das Leben). Konzept
einer Ausstellung', *Kunstforum International*, Vol. 66,
Cologne

1984
De Moffarts, E., 'Dan Graham: le présent ou l'indice du
temps', *Artistes*, Paris, March

1985

Lyotard, Jean-François, 'Les Inmatériaux', *Art + Text*,
Sydney, April

Buchloh, Benjamin H.D., 'From Gadget Video to Agity
Video: Some Notes on Four Recent Video Works', *Art
Journal*, New York, Fall
Fol, J., 'Dan Graham, L'artiste à distance', *Des Arts*, No.
2, Paris
Gale, Peggy, 'A Tableau Vivant', *Parachute*, Toronto,
June–August
Kirschner, J.R., 'Non-uments', *Artforum*, New York,
October
Kuspit, Donald, 'Dan Graham: Prometheus
Mediabound', *Artforum*, New York, May
Mot, J., 'Doch Doch', *Metropolis M*, Utrecht, January–
February
Wall, Jeff, 'Dan Graham's Kammerspiel, Part 1', *Real
Life Magazine*, Nos. 14–15, New York

1986
Dreher, Thomas, 'Dan Graham, Aussenwelt im Kubus',
Neue Kunst in Europa, Cologne, May–June

DAN GRAHAM
PAVILIONS

12. März – 17. April 1983
KUNSTHALLE BERN

Selected exhibitions and projects
1986–87

'Dan Graham and Sol LeWitt',
Lisson Gallery, London (group)

'Sonsbeek '86',
Arnhem, The Netherlands (group)
Cat. *Sonsbeek '86*, Reflex, Utrecht, texts Saskia Bos, et al.

'Chambres d'Amis',
Museum van Hedendaagse Kunst, Ghent (group)
Cat. *Chambres d'Amis*, Museum van Hedendaagse Kunst, Ghent, texts Jan Hoet

'Sol LeWitt, Dan Graham, Aldo Rossi',
Galerie Rüdiger Schöttle, Munich (group)

'Ludger Gerdes, Dan Graham',
Kaiser Wilhelm Museum, Krefeld (group)

1987
'Dan Graham: Pergola/Conservatory',
Marian Goodman Gallery, New York (solo)

ARC Musée d'Art Moderne de la Ville de Paris (solo)
Cat. *Dan Graham*, ARC Musée d'Art Moderne de la Ville de Paris, text Suzanne Pagé

Le Consortium, Dijon (solo)

Museo Nacional Centro de Arte Reina Sofía, Madrid (solo)
Cat. *Dan Graham*, Ministerio de Cultura, Madrid, texts Dan Graham, Suzanne Pagé

Fruitmarket Gallery, Edinburgh (solo)
Cat. *Dan Graham, Art as Design as Art*, Fruitmarket Gallery, Edinburgh, texts Mark Francis, Dan Graham

1987 Whitney Biennial,
Whitney Museum of American Art, New York (group)
Cat. *1987 Whitney Biennial*, Whitney Museum of American Art, New York, texts Richard Armstrong, et al.

Skulptur. Projekte in Münster,
Westfälischer Landesmuseum, Münster (group)
Cat. *Skulptur. Projekte in Münster*, Du Mont, Cologne, texts Kasper König, et al.

'L'Époque, la mode, la morale, la passion',
Musée Nationale d'Art Moderne, Centre Georges Pompidou, Paris (group)
Cat. *L'Époque, la mode, la morale, la passion*, Centre

Selected articles and interviews
1986–87

Wall, Jeff, 'Zinnebeeldige Procedures van Versterving, Dan Grahams Kammerspiel', *Museumjournaal*, No. 5, Amsterdam
Weschler, M; Tazzi, Pier Luigi; Pohlen, Annelie; Groot, Paul, 'Sculpture in Review: Critics and Curators, What Is Today's Sculpture? Three Views', *Artforum*, New York, September

1987
Bos, Saskia, 'Dan Graham, Marian Goodman Gallery, New York', *De Appel*, No. 2, Amsterdam
Fisher, Jean, 'Dan Graham, Marian Goodman Gallery, New York', *Artforum*, New York, December
Heartney, Eleanor, 'Marian Goodman Gallery, New York', *New Art Examiner*, New York, November
Thompson, W., 'Dan Graham at Marian Goodman Gallery, New York', *Artforum*, New York, December

Dan Graham with **Pergola/Conservatory**, Marian Goodman Gallery, New York

Heartney, Eleanor, 'Sighted in Münster', *Art in America*, New York, September
Hueck-Ehemer, B., 'Skulptur/Projekte/Münster/1987', *Das Kunstwerk*, Stuttgart, September

DAN GRAHAM
PERGOLA/CONSERVATORY

SEPTEMBER 9–OCTOBER 3, 1987

MARIAN GOODMAN GALLERY
24 WEST 57TH STREET NEW YORK NY 10019 (212) 977-7160

Selected exhibitions and projects
1987–89

Georges Pompidou, Paris, texts Catherine David, Christine Van Assche, et al.

'The Viewer as Voyeur',
Whitney Museum of American Art, New York (group)
Cat. *The Viewer as Voyeur*, Whitney Museum of American Art, New York, texts Andrea Inselmann, Grant Kester, James Peto, Charles A. Wright

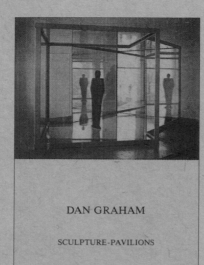

DAN GRAHAM

SCULPTURE-PAVILIONS

1988
Kunsthalle zu Kiel (solo)
Cat. *Dan Graham: Sculpture – Pavilions*, Kunsthalle zu Kiel, texts Ulrich Bischoff, Jeff Wall

'Pavillions',
Kunstverein, Munich (solo)
Cat. *Dan Graham: Pavillions*, Kunstverein München, Munich, texts Zdenek Felix, Dan Graham, Anne Rorimer

'Cultural Geometry',
Deste Foundation for Contemporary Art, Athens (group)

A Guide to the
Children's Pavilion

*a collaborative project
by Jeff Wall and Dan Graham*

Santa Barbara Contemporary Arts Forum

1989
'Theater Garden Bestiarium: The Garden as Theater as Museum',
Entrepôt-Galerie du Confort Moderne, Poitiers; **The Institute for Contemporary Art**, **P.S. 1 Museum**, Long Island City, New York; **Casino de la Exposición**, Seville (group)
Cat. *Theater Garden Bestiarium: The Garden as Theater as Museum*, MIT Press, Cambridge, Massachussets, 1990, texts Dan Graham, et al.

'Dan Graham, Jeff Wall: Children's Pavilion',
Galerie Roger Pailhas, Marseille; **Santa Barbara Contemporary Arts Forum**; **FRAC Rhône-Alpes, Villa Gillet**, Lyon; **Marian Goodman Gallery**, New York; **Galerie Chantal Boulanger**, Montreal (group)
Cat. *Dan Graham and Jeff Wall: Children's Pavilion*, Villa Grillet, FRAC Rhône-Alpes, Lyon, texts Dan Graham, Jeff Wall, F. Migayrou

Selected articles and interviews
1987–89

Freudenheim, S., 'Suburban Hamlets', *Artforum*, New York, May
Miller, John, 'In the Beginning There Was Formica', *Artscribe International*, London, March–April
Piquet, Philippe, 'Dan Graham, Sol LeWitt, Vladimir Skoda', *Flash Art*, Milan, May
Wall, Jeff, 'Het glazen huis, Dan Grahams Kammerspiel III', *Museumjournaal*, No. 1, Amsterdam
Wall, Jeff, 'Dan Grahams Kammerspiel IV', *Museumjournaal*, No. 2, Amsterdam
Wall, Jeff, 'Dan Grahams Kammerspiel V', *Museumjournaal*, No. 3, Amsterdam
Wood, Paul, 'Dan Graham', *Artscribe International*, London, November–December

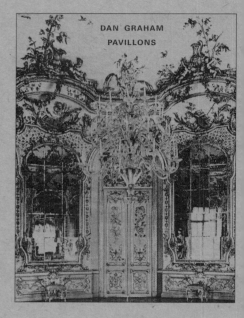

DAN GRAHAM
PAVILLONS

1988

Groot, Paul, 'Bolwerken zijn houdbaar, illusies niet: Over onder meer het pittoreske of de rehabilitatie van een verloren gewaand genre', *Museumjournaal*, No. 5-6, Amsterdam
Reeve, Charles, 'TV Eye: Dan Graham's Homes for America', *Parachute*, Toronto, Winter
Schwabsky, Barry, 'Non in Codice', *Flash Art*, Milan, January–February

1989
Migayrou, F., 'Bestiarium', *Galleries Magazine*, Paris, October–November

DAN GRAHAM AND JEFF WALL
THE CHILDREN'S PAVILION
IN COOPERATION WITH GALERIE ROGER PAILHAS

NORTH GALLERY

JANUARY 5 THROUGH JANUARY 27
RECEPTION FOR THE ARTISTS: 6-8 PM JANUARY 5

The Children's Pavilion
Interior view of maquette. Wood, cibachromes and lightboxes. 600 cm in diameter; 350 cm in depth.

MARIAN GOODMAN GALLERY
24 West 57th Street New York NY 10019 212-977-7160 FAX 212-581-5187

Albertazzi, L., 'Jeff Wall and Dan Graham', *Lápiz*, No. 59, Madrid
Christov-Bakargiev, Carolyn, 'Dan Graham and Jeff Wall', *Flash Art*, Milan, Summer
Faust, Gretchen, 'Marian Goodman Gallery, New York', *Arts Magazine*, New York, April, 1990
Johnson, Ken, 'Small World', *Art in America*, New York, April, 1990
Ledes, R.C., 'Dan Graham and Jeff Wall, Marian

Selected exhibitions and projects
1989–91

'L'Art Conceptuel en Perspective',
Musée Nationale d'Art Moderne, Centre Georges
Pompidou, Paris; **Caixa de Pensions**, Madrid; **Musée
d'Art Contemporain**, Montreal; **Deichtorhallen**,
Hamburg (group)

1990
Yamaguchi Prefectural Museum of Art, Japan (solo)
Cat. *Dan Graham*, Yamaguchi Prefectural Museum of
Art, Japan, text Dan Graham

1991
Margo Leavin Gallery, Los Angeles (solo)

'Pavilions, Sculptures',
Fondation pour l'Architecture, Brussels; **Galerie Roger
Pailhas**, Marseille; **Lisson Gallery**, London (solo)
Cat. *Dan Graham*, Galerie Roger Pailhas, Marseille,
texts Dan Graham, Brian Hatton

Galerie Micheline Szwajcer, Antwerp (solo)

'New Work - Roof Project',
Dia Center for the Arts, New York (solo)
Cat. and video, *Dan Graham, Two-Way Mirror Cylinder
inside Cube*, Dia Center for the Arts, New York, text Dan
Graham

Selected articles and interviews
1989–91

Goodman Gallery', *Artforum*, New York, March
Schottenkirk, Dena, 'Dan Graham and Jeff Wall',
Artforum, New York, March, 1990
Spector, Nancy, 'The Children's Pavilion: Jeff Wall's and
Dan Graham's Collaborative Project', *Canadian Art*,
Toronto, Summer, 1990
Woodard, Josef, 'An Artspace Not for Children Only',
ArtWeek, New York, October
van den Boogerd, Dominic, 'De Architectuur van het
kinderspel ... , Dan Graham & Jeff Wall: het Children's
Pavilion', *Archis*, Rotterdam, June, 1991

Dreher, Thomas, 'Bühnen-Stücke', *Das Kunstwerk*,
Germany, September
Dreher, Thomas, 'Dan Graham: Plastiche Modelle als
betretbare Geschichtsmetapherm', *Artefactum*,
Antwerp, September–October
Dreher, Thomas, 'Pavilions', *Das Kunstwerk*, Germany,
February
Long, T., 'Art and Moral Resistance to Simulation', *Art
Criticism*, May
de Duve, Thierry, 'Ex situ: l'harmonie du lieue de
l'espace et de l'echelle', *Cahiers du Musée National
d'Art Moderne*, Paris, Spring

1990

Buchloh, Benjamin H.D., 'Conceptual Art 1962–1969:
From the Aesthetic of Administration to the Critique of
Institutions', *October*, Cambridge, Massachusetts,
Winter
Chevrier, Jean-François, 'Entre les beaux-arts et les
médias', *Galleries Magazine*, Paris, June–July
Salvioni, Daniela, 'Dan Graham: I'll Call Myself a
Conceptual Artist, Though I Don't Like Conceptual Art',
Flash Art, Milan, May–June

1991
Kandell, Susan, 'Dan Graham: Margo Leavin Gallery',
Arts Magazine, New York, January, 1992

Ardenne, P; Barak, A., 'Dan Graham, Fondation pour
l'Architecture', *Art Press*, Paris, July–August
Fleck, Robert, 'Dan Graham at Roger Pailhaus', *Flash
Art*, Milan, October

Avkigos, Jan, 'Dan Graham: Dia Center for the Arts,
New York', *Artforum*, New York, December
Heartney, Eleanor, 'Dan Graham: Dia Center for the
Arts', *ARTnews*, New York, April, 1992
Francis, Mark, 'Dan Graham: Dia Center for the Arts',
Burlington Magazine, London, February, 1992
Decter, Joshua, 'Dan Graham: Dia Center for the Arts',
Arts Magazine, New York, December

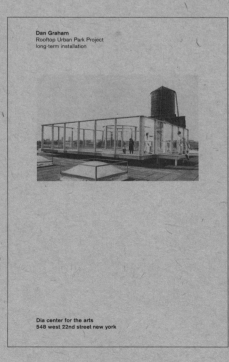

Dan Graham
Rooftop Urban Park Project
long-term installation

Dia center for the arts
548 west 22nd street new york

Selected exhibitions and projects
1991–92

Lisson Gallery, London (solo)

Castello di Rivara, Turin (solo)
Cat. *Dan Graham*, Castello di Rivara, Turin, texts
Benjamin H.D. Buchloh, Dan Graham, Anne Rorimer

Book, *Dan Graham: For Publication*, Marian Goodman
Gallery, New York, text Dan Graham

Book, *Dan Graham's Kammerspiel*, Art Metropole,
Toronto, text Jeff Wall

'Carnegie International',
Carnegie Museum of Art, Pittsburgh (group)
Cat. *Carnegie International*, Rizzoli International, New
York, texts Lynne Cooke, Mark Francis, et al.

1992
Receives award, Coutts Contemporary Art Foundation
Award, Zurich

Receives award, Skowhegan Medal for Mixed Media,
Skowhegan School of Painting and Sculpture, New York

'Dan Graham',
Wiener Secession, Vienna (solo)
Cat. *Dan Graham*, Wiener Secession, Vienna, texts
Adolf Krischanitz

'Walker Evans & Dan Graham',
Witte de With Center for Art, Rotterdam; **Musée
Cantini**, Marseille; **Westfälisches Landesmuseum**,
Münster; **Whitney Museum of American Art**, New York
(solo)
Cat. *Walker Evans & Dan Graham*, Witte de With,
Rotterdam, texts Benjamin H.D. Buchloh, Jean-
François Chevrier, Dan Graham, Allan Sekula

'Dan Graham, Travaux 1964–1992',
Le Nouveau Musée, Villeurbanne (solo)

Book, *Ma position: Écrits sur mes œuvres*, Le Nouveau
Musée, Villeurbanne/Les Presses du Réel, Paris , text
Dan Graham

'House and Garden',
Marian Goodman Gallery, New York (solo)

'Documenta IX',
Kassel, Germany (group)
Cat. *Documenta IX*, Documenta, Gmbh, texts Jan Hoet,
et al.

'Passages de l'Image',
Musée National d'Art Moderne, Paris; **San Francisco
Museum of Modern Art**; **Fundació Caixa de Pensions**,
Barcelona; **The Power Plant**, Toronto; **Wexner Center
for the Arts**, Columbus, Ohio (group)

Selected articles and interviews
1991–92

Dercon, Chris, 'Dan Graham, I Enjoy that Closeness
Where I Take Things that Are Very Close and Just
Slightly Overlap Them', *Forum International*, Antwerp,
September–October
Hatton, Brian, 'Dan Graham: Present Continuous',
Artscribe International, London, Winter
Zevi, Adachiara, 'Dan Graham: il minimo allo specchio',
L'Architettura. Cronache e storia, October

1992

Restorff, J., 'Walker Evans & Dan Graham', *Kunstforum
International*, No. 122, Cologne, 1993
Olivares, R., 'Walker Evans/Dan Graham', *Lápiz*,
Madrid, April, 1994

LE NOUVEAU MUSÉE
Institut d'Art Contemporain

DAN GRAHAM
TRAVAUX 1964–1992
VERNISSAGE LE 3 DÉCEMBRE 1992
À PARTIR DE 18 H 30

Selected exhibitions and projects
1992–94

Cat. *Passages de l'Image*, Fundació Caixa de Pensions, Barcelona, Paris, texts Jacques Aumont, Raymond Bellour, Pascal Bonitzer, Jean-François Chevrier, Serge Daney, Catherine David, Jean-Louis Schefer, Christine van Assche

1993
'Dan Graham: Public/Private',
Goldie Paley Gallery, Moore College of Art and Design, Philadelphia; **MIT List Visual Arts Center**, Massachusetts Institute of Technology, Cambridge, Massachusetts; **Art Gallery of Ontario**, Toronto; **Los Angeles Contemporary Exhibitions** (solo)
Cat. *Dan Graham: Public Private*, Goldie Paley Gallery, Moore College of Art and Design, Philadelphia, texts Mark Francis, Dan Graham, Christina Ritchie

'Museum for Matta-Clark, for Paris, 1984, Marie-Paule MacDonald and Dan Graham',
Austellungsraum Künstlerhaus, Stuttgart (solo)

'House and Garden',
Margo Levin Gallery, Los Angeles (solo)

Book, *Rock My Religion: Writings and Art Projects 1965–1990*, ed. Brian Wallis, MIT Press, Cambridge, Massachusetts, texts Dan Graham, Brian Wallis

Book, *Dan Graham: Rock My Religion, Écrits d'artistes*, Le Nouveau Musée, Villeurbanne; Les presses du réel, Paris, texts Dan Graham

'International Garden Exhibition',
Stuttgart (group)

'Dan Graham: Kunst und Architektur/Architektur und Kunst',
Le Nouveau Musée, Villeurbanne; **Stedelijk Van Abbemuseum**, Eindhoven; **Museum Villa Stuck**, Munich (solo)
Cat. *Dan Graham: Kunst und Architektur/Architektur und Kunst*, Le Nouveau Musée, Villeurbanne, texts Jo-Anne Birnie Dansker, Dan Graham, Birgit Pelzer, Adachiara Zevi

'Passagearbeten/Passageworks',
Rooseum Centre for Contemporary Art, Malmo (group)

'American Art of the Twentieth Century',
Martin-Gropius-Bau, Berlin; **Royal Academy of Arts**, London (group)

1994
'Dan Graham: New American Film and Video Series',
Whitney Museum of American Art, New York (solo)

Selected articles and interviews
1992–94

van den Boogerd, Dominic, 'Welkom in Suburbia, Dan Graham en de architectuur van de wegwerpwonig', *Metropolis M*, No. 6, Amsterdam

1993
Lageira, Jacinto, 'Retrospective Dan Graham', *Beaux-Arts*, January

Gintz, Claude, 'Beyond the Looking Glass', *Art in America*, New York, May
Metzger, Rainer, 'Dan Graham', *Flash Art*, Milan, October
Metzger, Rainer, 'Dan Graham', *Kunstforum International*, Cologne, July–September, 1994
Piguet, Phillippe, 'Dan Graham', *L'Oeil*, Lausanne, January–February
Thurn und Taxis, Lilli, 'Spiegelbilder', *Baumeister*, Germany, April, 1994

Küng, M., 'The Public Eye, Over het werk van Dan Graham/On the Work of Dan Graham', *Archis*, Germany, May

1994

Selected exhibitions and projects
1994–97

Book, with Marie-Paule MacDonald, *Wild in the Streets: The Sixties*, Imschoot, Ghent, texts Chris Dercon, Dan Graham

1995
Marian Goodman Gallery, New York (solo)

'Dan Graham: Video/Architecture/Performance',
E.A. Generali Foundation, Vienna (solo)

'Dan Graham and Mariko Mori',
American Fine Arts, New York (solo)

Book, *Dan Graham*, Éditions Dis Voir, Paris, texts Alain Charre, Marie-Paule McFonald, Marc Perelman

Book, *Dan Graham: Ausgewählte/Dan Graham. Collected Writings*, Ulrich Wilmes, Stuttgart, texts Dan Graham, Zdenek Felix, Kasper König

'ARS 95',
Museum of Contemporary Art, Finnish National Gallery, Helsinki (group)

'Reconsidering the Object of Art',
Los Angeles Museum of Contemporary Art (group)
Cat. *Reconsidering the Object of Art,* Los Angeles Museum of Contemporary Art, texts Ann Goldstein, Lucy R. Lippard, Stephan Melville, Anne Rorimer, Jeff Wall

1996
'Star of David',
Schloß Buchberg, Austria (solo)

Massimo Minini, Brescia (solo)

Invitation card, Massimo Minini, Brescia

'Dan Graham – The Suburban Center',
Museum für Gegenwartskunst, Basel (solo)

Book, *Dan Graham: Selected Writings and Interviews on Art Works, 1965–1995*, ed. Adachiara Zevi, I Libri di Zerynthia, Rome, texts Dan Graham

Book, *Dan Graham: Models to Projects, 1978–1995*, Marian Goodman Gallery, New York, text Alexander Alberro

1997
'Architecture 1/Architecture 2',
Camden Arts Centre, London; **Architectural Association**, London (solo)
Cat. *Dan Graham: Architecture*, Camden Arts Centre, London/Architectural Association, London, texts Dan Graham, Brian Hatton, Mark Pimlott, Adachiara Zevi

Selected articles and interviews
1994–97

Alberro, Alexander, 'The Pychedelic Fantasies of the Sixties', *frieze*, London, November–December, 1995

Glintz, Claude, 'Beyond the Looking Glass', *Art in America*, New York, May
Metz, Mike, 'Dan Graham', *Bomb*, New York, Winter

1995

Joselit, David, 'Object Lessons', *Art in America*, New York, February, 1996
Tumlir, J., 'Reconsidering the Object of Art', *ArtWeek*, New York, January

Doroshenko, Peter, 'Interview with Dan Graham', *Journal of Contemporary Art*, New York, Winter
London, Barbara, 'Time as Medium: Five Artists' Video Installations', *Leonardo*, No. 5, New York

1996

Dan Graham with **Pyramid**, 1997

Stemmrich, G., 'Dan Graham's Cinema und die Filmtheorie', *Texte zur Kunst*, Cologne, March

1997
Higgs, Matthew, 'Dan Graham', *Art Monthly*, London, June
Caruso, Adam, 'Enriched Encounters with the Everyday', *Architects' Journal*, London, 15 May

Selected exhibitions and projects
1997–2000

Permanent installation, *Café Bravo*, Kunst-Werke, Berlin

1997 Whitney Biennial,
Whitney Museum of American Art, New York (group)
Cat. *1997 Whitney Biennial*, H.N. Abrams New York, texts Louise Neri, Lisa Phillips, et al.

'Sculptur. Projekte in Münster',
Münster (group)
Cat. *Sculptur. Projekte in Münster*, Verlag Gerd Hatje, Stuttgart, texts Daniel Buren, Kasper König, et al.

'Città Natura',
Palazzo delle Esposizioni, Rome; **Mercati di Traiano**, Rome; **l'Orto Botanico**, Rome; **Museo Civico di Zoologia**, Rome; **Villa Mazzanti**, Rome; **Fratelli Palombi**, Rome (group)
Cat. *Città Natura*, Palazzo delle Esposizioni, Rome, text Carolyn Christov-Bakargiev

SCULPTURE. PROJECTS IN MÜNSTER 1997

1998
Centro Galego de Arte Contemporánea de Santiago de Compostela (solo)

Fundació Antoni Tàpies, Barcelona (solo)
Cat. *Dan Graham*, Fundació Antoni Tàpies, Barcelona, texts Alexander Alberro, Eric de Bruyn, Mark Francis, Dan Graham, Brian Hatton, Mike Metz, Gloria Moure, Apolonija Sustersic, Christine van Assche, Adachiara Zevi

'Dan Graham: Unrealized Projects',
Christian Meyer & Renate Kainer, Vienna (solo)

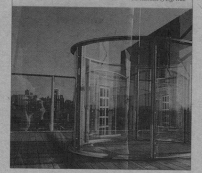

Two-Way Mirror Power
Selected Writings by Dan Graham
on His Art

Dan Graham
edited by Alexander Alberro
introduction by Jeff Wall

1999
Book, Alexander Alberro (ed.), Dan Graham, *Two-way Mirror Power: Selected Writings by Dan Graham on His Art*, texts Dan Graham, Jeff Wall

2000
'Children's Day Care, CD-Rom, Cartoon and Computer Screen Library',
Marian Goodman Gallery, New York (solo)

'Postmedia, Conceptual Photography in the Guggenheim Museum Collection',
Solomon R. Guggenheim Museum, New York (group)

2001
Museu de Arte Contemporânea de Serralves, Porto; **Musée d'Art Moderne de la Ville de Paris**; **Kröller Müller Museum**, Otterlo; **Kiasma**, Helsinki (solo)

Selected articles and interviews
1997–2000

Zohlen, Gerwin, 'Dan Graham: Café Bravo in Berlin, Germany', *Baumeister*, Berlin, April, 1999

Dan Graham

Volkart, Yvonne, 'Dan Graham's Suburban City and Andrea Zittel's Living Units', *Flash Art*, Milan, Summer
Lebredt, Gordon, 'Some Thoughts on Modeling: Dan Graham's *Present Continuous Past(s)*', *Parachute*, Toronto, April–June

1998

Bader, Joerg, 'The Artchitecture of Seeing', *Art Press*, Paris, January, 1999
Bosch, Gloria, 'Dan Graham', *Flash Art*, Milan, January–February

1999

2000
Gilmore, Jonathan, 'Dan Graham at Marian Goodman', *Art in America*, New York, December

Wagner, Anne M., 'Performance, Video, and the Rhetoric of Presence', *October*, Cambridge, Massachusetts, Winter

Bibliography

Alberro, Alexander, 'The Pychedelic Fantasies of the Sixties', *frieze*, London, November–December, 1995

Alberro, Alexander, *Dan Graham: Models to Projects, 1978–1995*, Marian Goodman Gallery, New York, 1996

Alberro, Alexander, *Dan Graham*, ed. Gloria Moure, Fundació Antoni Tàpies, Barcelona, 1998

Albertazzi, L., 'Jeff Wall and Dan Graham', *Lápiz*, No. 59, Madrid, 1989

Antin, David, 'Dan Graham', *Studio International*, London, July, 1970

Antin, David, 'Television: Video's Frightful Parent', *Artforum*, New York, December, 1975

Ardenne, P.: Barak, A., 'Dan Graham, Fondation pour l'Architecture', *Art Press*, Paris, July–August, 1991

Asher, Michael, *Dan Graham: Video-Architecture-Television. Writings on Video and Video Works, 1970–1978*, ed. Benjamin H.D. Buchloh, Press of Nova Scotia College of Art and Design, Halifax/New York University Press, 1979

Atkinson, Terry, 'Introduction', *Art-Language*, Vol. 1, No. 1, Leamington, England, 1969

Avkigos, Jan, 'Dan Graham: Dia Center for the Arts, New York', *Artforum*, New York, December, 1991

Bader, Joerg, 'The Artchitecture of Seeing', *Art Press*, Paris, January, 1999

Baracks, B., 'Dan Graham', *Artforum*, New York, May, 1976

Barak, A.; Ardenne, P., 'Dan Graham, Fondation pour l'Architecture', *Art Press*, Paris, July–August, 1991

Beveridge, C., 'Dan Graham's Video-Architecture-Television', *Fuse*, Toronto, May, 1980

Birnbaum, Dara, *Dan Graham: Video-Architecture-Television. Writings on Video and Video Works, 1970–1978*, ed. Benjamin H.D. Buchloh, Press of Nova Scotia College of Art and Design, Halifax/New York University Press, 1979

Birnie Dansker, Jo-Anne, *Dan Graham: Kunst und Architektur/ Architektur und Kunst*, Le Nouveau Musée, Villeurbanne, 1993

Bochner, Mel, 'Less Is Less', *Art & Artists*, London, December, 1966

Bochner, Mel, 'The Serial Attitude', *Artforum*, New York, December, 1967

Bonnet, Frédéric, 'Un panthéon des enfants Blois', *L'Architecture d'Aujourd Hui*, Paris, June, 2000

Bos, Saskia, 'Dan Graham, Marian Goodman Gallery, New York', *De Appel*, No. 2, Amsterdam, 1987

Bosch, Gloria, 'Dan Graham', *Flash Art*, Milan, January–February, 1998

Buchloh, Benjamin H.D., *Dan Graham: Articles*, Stedelijk Van Abbemuseum, Eindhoven, 1977

Buchloh, Benjamin H.D., 'Documenta 7: A Dictionary of Received Ideas', *October*, New York, Fall, 1982

Buchloh, Benjamin H.D., 'From Gadget Video to Agity Video: Some Notes on Four Recent Video Works', *Art Journal*, New York, Fall, 1985

Buchloh, Benjamin H.D., 'Conceptual Art 1962–1969: From the Aesthetic of Administration to the Critique of Institutions', *October*, Cambridge, Massachusetts, Winter, 1990

Buchloh, Benjamin H.D., *Dan Graham*, Castello di Rivara, Turin, 1991

Buchloh, Benjamin H.D., *Walker Evans & Dan Graham*, Witte de With, Rotterdam, 1992

Cameron, E., 'Dan Graham: Appearing in Public', *Artforum*, New York, November, 1976

Caruso, Adam, 'Enriched Encounters with the Everyday', *Architects' Journal*, London, 15 May, 1997

Chevrier, Jean-François, 'Entre les beaux-arts et les médias', *Galleries Magazine*, Paris, June–July, 1990

Chevrier, Jean-François, *Walker Evans & Dan Graham*, Witte de With, Rotterdam, 1992

Christov-Bakargiev, Carolyn, 'Dan Graham and Jeff Wall', *Flash Art*, Milan, Summer, 1989

de Bruyn, Eric, *Dan Graham*, ed. Gloria Moure, Fundació Antoni Tàpies, Barcelona, 1998

de Duve, Thierry, *Dan Graham: Pavilions*, Kunsthalle, Bern, 1983

de Duve, Thierry, 'Ex situ: l'harmonie du lieue de l'espace et de l'echelle', *Cahiers du Musée National d'Art Moderne*, Paris, Spring, 1989

De Moffarts, E., 'Dan Graham: le présent ou l'indice du temps', *Artistes*, Paris, March, 1984

Decter, Joshua, 'Dan Graham: Dia Center for the Arts', *Arts Magazine*, New York, December, 1991

Dercon, Chris, 'Dan Graham, I Enjoy that Closeness Where I Take Things that Are Very Close and Just Slightly Overlap Them', *Forum International*, Antwerp, September–October, 1991

Dercon, Chris, *Wild in the Streets: The Sixties*, Imschoot, Ghent, 1994

Domingo, W., 'Review', *Art Monthly*, London, October, 1978

Doroshenko, Peter, 'Interview with Dan Graham', *Journal of Contemporary Art*, New York, Winter, 1995

Dreher, Thomas, 'Dan Graham, Aussenwelt im Kubus', *Neue Kunst in Europa*, Cologne, May–June, 1986

Dreher, Thomas, 'Bühnen-Stücke', *Das Kunstwerk*, Germany, September, 1989

Dreher, Thomas, 'Pavilions', *Das Kunstwerk*, Germany, February, 1989

Dreher, Thomas, 'Dan Graham: Plastiche Modelle als betretbare Geschichtsmetapherm', *Artefactum*, Antwerp, September–October, 1989

Dufour, Gary, *Dan Graham*, Art Gallery of Western Australia, Perth, 1985

Fargier, Jean-Paul, 'Maman Cube', *Cinema Journal*, April, 1987

Faust, G., 'Marian Goodman Gallery, New York', *Arts Magazine*, New York, April, 1990

Fiels, S., 'The Venice Biennale', *Burlington Magazine*, London, October, 1976

Fisher, Jean, 'Dan Graham, Marian Goodman Gallery, New York', *Artforum*, New York, December, 1987

Flack, Robert, 'Dan Graham at Roger Pailhaus', *Flash Art*, Milan, October, 1991

Flavin, Dan, 'Some Other Comments', *Artforum*, New York, December, 1967

Fol, J., 'Dan Graham, L'artiste à distance', *Des Arts*, No. 2, Paris, 1985

Francis, Mark, 'Dan Graham', *Aspects*, London, Winter, 1978

Francis, Mark, *Dan Graham: Art as Design as Art*, Fruitmarket Gallery, Edinburgh, 1987

Francis, Mark, *Dan Graham*, ed. Gloria Moure, Fundació Antoni Tàpies, Barcelona, 1998

Francis, Mark, 'Dan Graham: Dia Center for the Arts', *Burlington Magazine*, London, February, 1992

Francis, Mark, *Dan Graham: Public Private*, Goldie Paley Gallery, Moore College of Art and Design, Philadelphia, 1993

Freudenheim, S., 'Suburban Hamlets', *Artforum*, New York, May, 1987

Fuchs, Rudi, *Dan Graham*, Kunsthalle, Basel, 1976

Fuchs, Rudi, *Dan Graham: Articles*, Stedelijk Van Abbemuseum, Eindhoven, 1977

Fuller, P., 'Dan Graham: Lisson Gallery', *Arts Review*, London, 18 October, 1974

Gale, Peggy, 'A Tableau Vivant', *Parachute*, Toronto, June–August, 1985

Gilmore, Jonathan, 'Dan Graham at Marian Goodman', *Art in America*, New York, December, 2000

Glintz, Claude, 'Dan Graham à Berne', *Art Press*, Paris, March, 1983

Gintz, Claude, 'Beyond the Looking Glass', *Art in America*, New York, May, 1993

Glintz, Claude, 'Beyond the Looking Glass', *Art in America*, New York, May, 1994

Glusberg, J., 'La Situación del Arte Corporal', *Créer*, Buenos Aires, March, 1979

Graham, Dan, *Dan Graham: Selected Works, 1965–72*, Lisson Publications, London; Gbr. König, Cologne, 1972

Graham, Dan, *Dan Graham: Textes*, Galerie 17, Paris, 1974

Graham, Dan, *Dan Graham: Some Photographic Projects*, John Gibson Gallery, New York, 1975

Graham, Dan, *For Publication*, Otis Art Institute, Los Angeles, 1975; reprinted Marian Goodman Gallery, New York, 1991

Graham, Dan, *Dan Graham*, Kunsthalle, Basel, 1976

Graham, Dan, *Films*, Éditions Centre d'art Contemporain, Geneva/Écart Publications, Geneva, 1977

Graham, Dan, *Dan Graham: Articles*, Stedelijk Van Abbemuseum, Eindhoven, 1977

Graham, Dan, *Dan Graham: Video-Architecture-Television. Writings on Video and Video Works, 1970–1978*, ed. Benjamin H.D. Buchloh, Press of Nova Scotia College of Art and Design, Halifax/New York University Press, 1979

Graham, Dan, *Dan Graham: Two Viewing Rooms*, The Museum of Modern Art, New York, 1980

Graham, Dan, *Dan Graham: Buildings and Signs*, The Renaissance Society at the University of Chicago, 1981

Graham, Dan, *Dan Graham: Théâtre*, Anton Herbert, Ghent, 1982

Graham, Dan, *Dan Graham: Pavilions*, Kunsthalle, Bern, 1983

Graham, Dan, *Dan Graham*, Art Gallery of Western Australia, Perth, 1985

Graham, Dan, *Dan Graham: Art as Design as Art*, Fruitmarket Gallery, Edinburgh, 1987

Graham, Dan, *Dan Graham*, Ministerio de Cultura, Madrid, 1987

Graham, Dan, *Dan Graham and Jeff Wall: Children's Pavilion*, Villa Grillet, FRAC Rhône-Alpes, Lyon, 1989

Graham, Dan, *Dan Graham*, Yamaguchi Prefectural Museum of Art, Japan, 1990

Graham, Dan, *Dan Graham*, Castello di Rivara, Turin, 1991

Graham, Dan, *Dan Graham*, Galerie Roger Pailhas, Marseille, 1991

Graham, Dan, *Ma position: Écrits sur mes œuvres*, Le Nouveau Musée/Institut les Presses du Réel, Villeurbanne, 1992

Graham, Dan, *Walker Evans & Dan Graham*, Witte de With, Rotterdam, 1992

Graham, Dan, *Rock My Religion: Writings and Art Projects 1965–1990*, ed. Brian Wallis, MIT Press, Cambridge, Massachusetts, 1993

Graham, Dan, *Dan Graham: Kunst und Architektur/Architektur und Kunst*, Le Nouveau Musée, Villeurbanne, 1993

Graham, Dan, *Dan Graham: Public Private*, Goldie Paley Gallery, Moore College of Art and Design, Philadelphia, 1993

Graham, Dan, *Dan Graham: Rock My Religion, Écrits d'artistes*, Le Nouveau Musée, Villeurbanne/Les presses du réel, Paris, 1993

Graham, Dan, *Wild in the Streets: The Sixties*, Imschoot, Ghent, 1994

Graham, Dan, *Dan Graham: Architecture*, Camden Arts Centre, London/The Architectural Association, London, 1997

Graham, Dan, *Dan Graham*, ed. Gloria Moure, Fundació Antoni Tàpies, Barcelona, 1998

Graham, Dan, *Two-way Mirror Power: Selected Writings by Dan Graham on His Art*, ed. Alexander Alberro, MIT Press, Cambridge Massachusetts, in association with Marian Goodman Gallery, New York, 1999

Groot, Paul, 'Bolwerken zijn houdbaar, illusies niet: Over onder meer het pittoreske of de rehabilitatie van een verloren gewaand genre', *Museumjournaal*, Nos. 5–6, Amsterdam, 1988

Grove, N., 'Reviews', *Arts Magazine*, New York, April, 1976

Hatton, Brian, 'Artist and Architects at the ICA, London', *Architectural Review*, London, March, 1983

Hatton, Brian, 'Dan Graham: Present Continuous', *Artscribe International*, London, Winter, 1991

Hatton, Brian, *Dan Graham*, Galerie Roger Pailhas, Marseille, 1991

Hatton, Brian, *Dan Graham: Architecture*, Camden Arts Centre, London/The Architectural Association, London, 1997

Hatton, Brian, *Dan Graham*, ed. Gloria Moure, Fundació Antoni Tàpies, Barcelona, 1998

Heartney, Eleanor, 'Marian Goodman Gallery, New York', *New Art Examiner*, New York, November, 1987

Heartney, Eleanor, 'Sighted in Münster', *Art in America*, New York, September, 1987

Heartney, Eleanor, 'Dan Graham: Dia Center for the Arts', *ARTnews*, New York, April, 1992

Herbert, Anton, *Dan Graham: Articles*, Stedelijk Van Abbemuseum, Eindhoven, 1977

Higgs, Matthew, 'Dan Graham', *Art Monthly*, London, June, 1997

Hueck-Ehemer, B., 'Skulptur/Projekte/Münster/ 1987', *Das Kunstwerk*, Stuttgart, September, 1987

Johnson, Ken, 'Small World', *Art in America*, New York, April, 1990

Joselit, David, 'Object Lessons', *Art in America*, New York, February, 1996

Kandell, Susan, 'Dan Graham: Margo Leavin Gallery', *Arts Magazine*, New York, January, 1992

Kirschner, J.R., 'Non-uments', *Artforum*, New York, October, 1985

Kozloff, Max, 'Pygmalion Reversed', *Artforum*, New York, November, 1975

Krischanitz, Adolf, *Dan Graham*, Wiener Secession, Vienna, 1992

Kuspit, Donald, 'Documenta 7', *Artforum*, New York, October, 1982

Kuspit, Donald, 'Dan Graham: Prometheus Mediabound', *Artforum*, New York, May, 1985

Küng, M., 'The Public Eye, Over het werk van Dan Graham/On the Work of Dan Graham', *Archis*, Rotterdam, May, 1993

Lageira, Jacinto, 'Retrospective Dan Graham', *Beaux-Arts*, January, 1993

LeWitt, Sol, 'Paragraphs on Conceptual Art', *Artforum*, New York, Summer, 1967

Lebeer, I., 'Le corps matériel perceptuel', *L'Art Vivant*, Paris, July, 1973

Lebredt, Gordon, 'Some Thoughts on Modeling: Dan Graham's *Present Continuous Past(s)*', *Parachute*, Toronto, April–June, 1997

Ledes, R.C., 'Dan Graham and Jeff Wall, Marian Goodman Gallery', *Artforum*, New York, March, 1989

London, Barbara, *Dan Graham: Two Viewing Rooms*, The Museum of Modern Art, New York, 1980

London, Barbara, 'Time as Medium: Five Artists' Video Installations', *Leonardo*, No. 5, New York, 1995

Long, T., 'Art and Moral Resistance to Simulation', *Art Criticism*, May, 1989

Lyotard, Jean-François, 'Les Inmatériaux', *Art +Text*, Sydney, April, 1985

Martin, Jean-Hubert, *Dan Graham: Pavilions*, Kunsthalle, Bern, 1983

Mayer, R., 'Dan Graham: Past/ Present', *Art in America*, New York, November–December, 1975

McShine, Kynaston, *Information*, The Museum of Modern Art, New York, 1970

Metz, Mike, 'Dan Graham', *Bomb*, New York, Winter, 1994

Metz, Mike, *Dan Graham*, ed. Gloria Moure, Fundació Antoni Tàpies, Barcelona, 1998

Metzger, Rainer, 'Dan Graham', *Flash Art*, Milan, October, 1993

Metzger, Rainer, 'Dan Graham', *Kunstforum International*, Cologne, July–September, 1994

Migayrou, F., 'Bestiarum', *Galleries Magazine*, Paris, October–November, 1989

Migayrou, F., *Dan Graham and Jeff Wall: Children's Pavilion*, Villa Grillet, FRAC Rhône-Alpes, Lyon, 1989

Miller, John, 'In the Beginning There Was Formica', *Artscribe International*, London, March–April, 1987

Mot, J., 'Doch Doch', *Metropolis M*, Utrecht, January–February, 1985

Moure, Gloria, *Dan Graham*, ed. Gloria Moure, Fundació Antoni Tàpies, Barcelona, 1998

Nemser, Cindy, 'Subject-Object: Body Art', *Arts Magazine*, New York, September, 1971

Netter, Maria, *Dan Graham*, Kunsthalle, Basel, 1976

Olivares, R., 'Walker Evans/Dan Graham', *Lápiz*, Madrid, April, 1994

Pacquement, Albert, 'L'Art Conceptuel', *Connaissance des Arts*, Paris, October, 1971

Pagé, Suzanne, *Dan Graham*, ARC Musée d'Art Moderne de la Ville de Paris, 1987

Pagé, Suzanne, *Dan Graham*, Ministerio de Cultura, Madrid, 1987

Pelzer, Birgit, 'Vision in Process', *October*, Cambridge, Massachusetts, Fall, 1979

Pelzer, Birgit, *Dan Graham: Kunst und Architektur/Architektur und Kunst*, Le Nouveau Musée, Villeurbanne, 1993

Piguet, Phillippe, 'Dan Graham', *L'Oeil*, Lausanne, January–February, 1993

Pimlott, Mark, *Dan Graham: Architecture*, Camden Arts Centre, London/The Architectural Association, London, 1997

Piquet, Philippe, 'Dan Graham, Sol LeWitt, Vladimir Skoda', *Flash Art*, Milan, May, 1987

Plagens, P., 'Dan Graham and Mowry Baden', *Artforum*, New York, December, 1975

Reeve, Charles, 'TV Eye: Dan Graham's Homes for America', *Parachute*, Toronto, Winter, 1988

Restorff, J., 'Walker Evans & Dan Graham', *Kunstforum International*, No. 122, Cologne, 1993

Ritchie, Christina, *Dan Graham: Public Private*, Goldie Paley Gallery, Moore College of Art and Design, Philadelphia, 1993

Rorimer, Anne, *Dan Graham: Buildings and Signs*, The Renaissance Society at the University of Chicago, 1981

Rorimer, Anne, *Dan Graham*, Castello di Rivara, Turin, 1991

Saliga, P., 'Dan Graham and Helmut Jahn Reshape Argonne Environment', *New Art Examiner*, New York, Summer, 1983

Salvioni, Daniela, 'Dan Graham: I'll Call Myself a Conceptual Artist, Though I Don't Like Conceptual Art', *Flash Art*, Milan, May–June, 1990

Schottenkirk, Dena, 'Dan Graham and Jeff Wall', *Artforum*, New York, March, 1990

Schwabsky, Barry, 'Non in Codice', *Flash Art*, Milan, January–February, 1988

Schöttle, Rüdiger, 'Louis XIV tanzt, Purgatorium-Inferno-Rette sich wer kann (das Leben). Konzept einer Ausstellung', *Kunstforum International*, Vol. 66, Cologne, 1983

Sekula, Allan, *Walker Evans & Dan Graham*, Witte de With, Rotterdam, 1992

Smithson, Robert, 'Quasi-Infinities and the Waning of Space', *Arts Magazine*, New York, November, 1966

Smithson, Robert, 'A Museum of Language in the Vicinity of Art', *Art International*, New York, March, 1968

Spector, Nancy, 'The Children's Pavilion: Jeff Wall's and Dan Graham's Collaborative Project', *Canadian Art*, Toronto, Summer, 1990

Stemmrich, G., 'Dan Graham's Cinema und die Filmtheorie', *Texte zur Kunst*, Cologne, March, 1996

Sustersic, Apolonija, *Dan Graham*, ed. Gloria Moure, Fundació Antoni Tàpies, Barcelona, 1998

Thompson, W., 'Dan Graham at Marian Goodman Gallery, New York', *Artforum*, New York, December, 1987

Thurn und Taxis, Lilli, 'Spiegelbilder', *Baumeister*, Germany, April, 1994

Tumlir, J., 'Reconsidering the Object of Art', *ArtWeek*, New York, January, 1995

van Assche, Christine, *Dan Graham*, ed. Gloria Moure, Fundació Antoni Tàpies, Barcelona, 1998

van den Boogerd, Dominic, 'De Architectuur van het kinderspel ... , Dan Graham & Jeff Wall: het Children's Pavilion', *Archis*, Rotterdam, June, 1991

van den Boogerd, Dominic, 'Welkom in Suburbia, Dan Graham en de architectuur van de wegwerpwonig', *Metropolis M*, No. 6, Amsterdam, 1992

Volkart, Yvonne, 'Dan Graham's Suburban City and Andrea Zittel's Living Units', *Flash Art*, Milan, Summer, 1997

Von Graevenitz, A., 'Dingen Gebeuren in het Gezichtsveld Uit Gesprek met Dan Graham', *Museumjournaal*, Amsterdam, April, 1976

Wagner, Anne M., 'Performance, Video, and the Rhetoric of Presence', *October*, Cambridge, Massachusetts, Winter, 2000 Wall, Jeff, *Dan Graham and Jeff Wall: Children's Pavilion*, Villa Grillet, FRAC Rhône-Alpes, Lyon, 1989

Wall, Jeff, *Dan Graham*, Art Gallery of Western Australia, Perth, 1985

Wall, Jeff, 'Dan Graham's Kammerspiel, Part 1', *Real Life Magazine*, Nos. 14–15, New York, 1985

Wall, Jeff, 'Zinnebeeldige Procedures van Versterving, Dan Grahams Kammerspiel', *Museumjournaal*, No. 5, Amsterdam, 1986

Wall, Jeff, 'Het glazen huis, Dan Grahams Kammerspiel III', *Museumjournaal*, No. 1, Amsterdam, 1987

Wall, Jeff, 'Dan Grahams Kammerspiel IV', *Museumjournaal*, No. 2, Amsterdam, 1987

Wall, Jeff, 'Dan Grahams Kammerspiel V', *Museumjournaal*, No. 3, Amsterdam, 1987

Wall, Jeff, *Dan Graham's Kammerspiel*, Art Metropole, Toronto, 1991

Wall, Jeff, *Two-way Mirror Power: Selected Writings by Dan Graham on His Art*, ed. Alexander Alberro, MIT Press, Cambridge Massachusetts, in association with Marian Goodman Gallery, new Yrok, 1999

Wallis, Brian, *Rock My Religion: Writings and Art Projects 1965–1990*, ed. Brian Wallis, MIT Press, Cambridge, Massachusetts, 1993

Wechslen, M., 'Dan Graham: Pavilions, Kunsthalle Bern', *Artforum*, New York, October, 1983

Weschler, M; Tazzi, Pier Luigi; Pohlen, Annelie; Groot, P., 'Sculpture in Review: Critics and Curators, What Is Today's Sculpture? Three Views', *Artforum*, New York, September, 1986

Wood, Paul, 'Dan Graham', *Artscribe International*, London, November–December, 1987

Woodard, Josef, 'An Artspace Not for Children Only', *ArtWeek*, New York, October, 1989

Wooster, A., 'New York Reviews: Dan Graham', *ARTnews*, New York, April, 1976

Wooster, A., 'Two Viewing Rooms', *Village Voice*, New York, December, 1980

Zevi, Adachiara, 'Dan Graham: il minimo allo specchio', *L'Architettura. Cronache e storia*, October, 1991

Zevi, Adachiara, *Dan Graham: Kunst und Architektur/Architektur und Kunst*, Le Nouveau Musée, Villeurbanne, 1993

Zevi, Adachiara, *Dan Graham: Architecture*, Camden Arts Centre, London/The Architectural Association, London, 1997

Zevi, Adachiara, *Dan Graham*, ed. Gloria Moure, Fundació Antoni Tàpies, Barcelona, 1998

Zohlen, Gerwin, 'Dan Graham: Café Bravo in Berlin, Germany', *Baumeister*, Germnay, April, 1999

DATE DUE

GAYLORD PRINTED IN U.S.A.